Dedicated to Lesley, Wendy, Holly, George, Nancy and Nell.
Not forgetting Cecil Holmes.

The *Man* who *changed* the *Look of* British Illustration

black dog
publishing
london uk

Brian Grimwood's work has been both conceptual and decorative. It has echoed sources as diverse as Matisse, Klee and Chwast. And it has changed the look of British illustration.

Steven Heller, *Print Magazine*.

Brian *Grimwood*

The *Man* who *changed* the *Look of* British Illustration

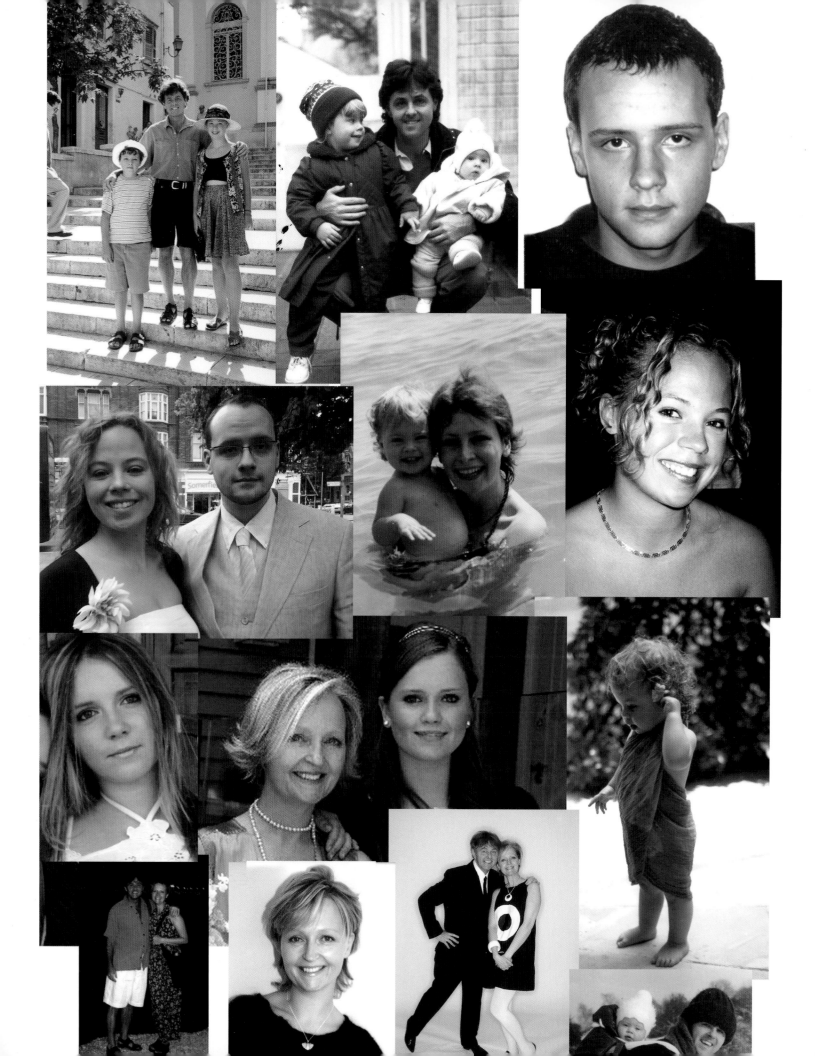

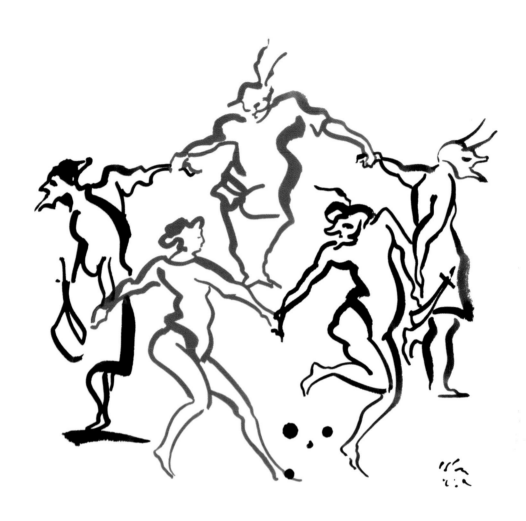

BRIAN GRIMWOOD
THE MAN WHO CHANGED THE LOOK OF BRITISH ILLUSTRATION

PETER BLAKE

I love Brian Grimwood's drawing.
He has glanced at the work of some
of the greatest draughtsmen ever, and
produced his own &v way of drawing which one
might assume to be easy, but those
apparently loose and simple drawings,
can be the most difficult to achieve.

Their is a humour in his illustration
which I very much enjoy, and an
intelligent wit that I envy. His use of
colour is exciting, he is a good ~~soul~~
colourist.

Brian has changed the course of
illustration, both through his own work,
and by almost thirty years ago, starting
the central Illustration Agency.

This is a really nice book

Peter Blake. March 20th 12

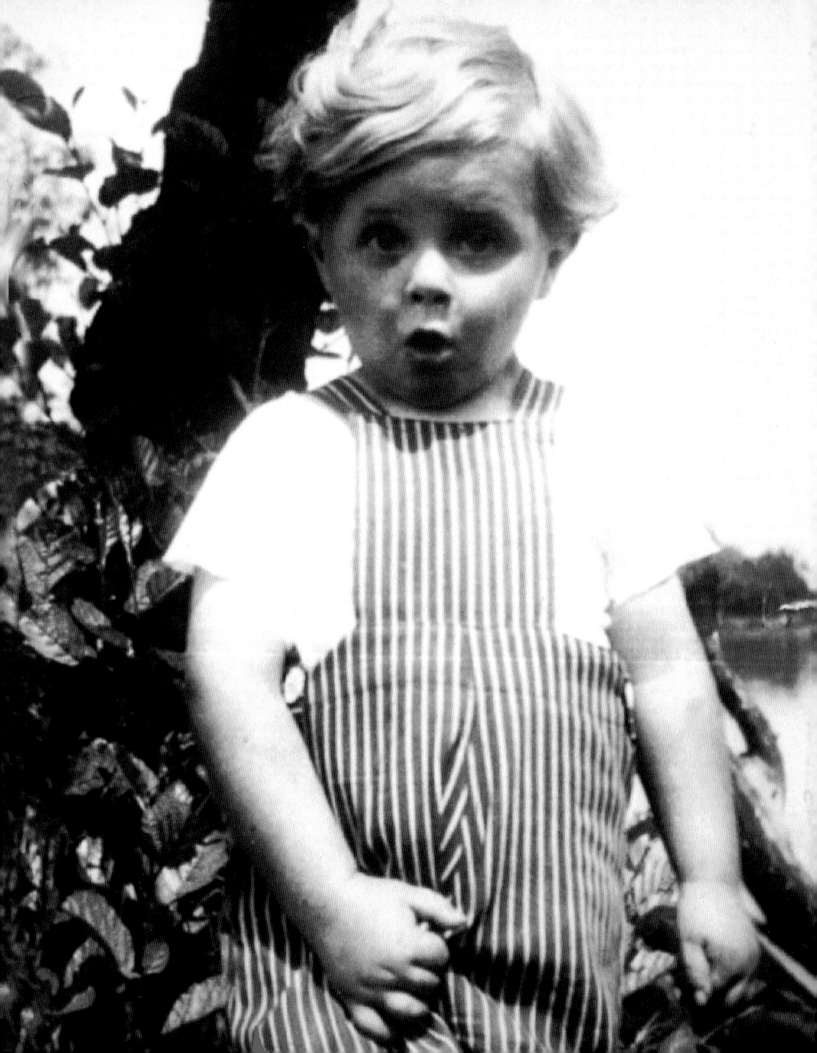

Childhood

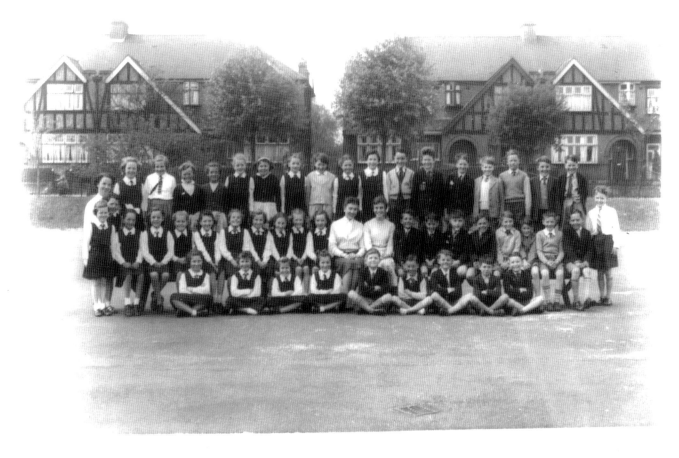

Miss Ivil's class, Stewart Fleming School, 1958.

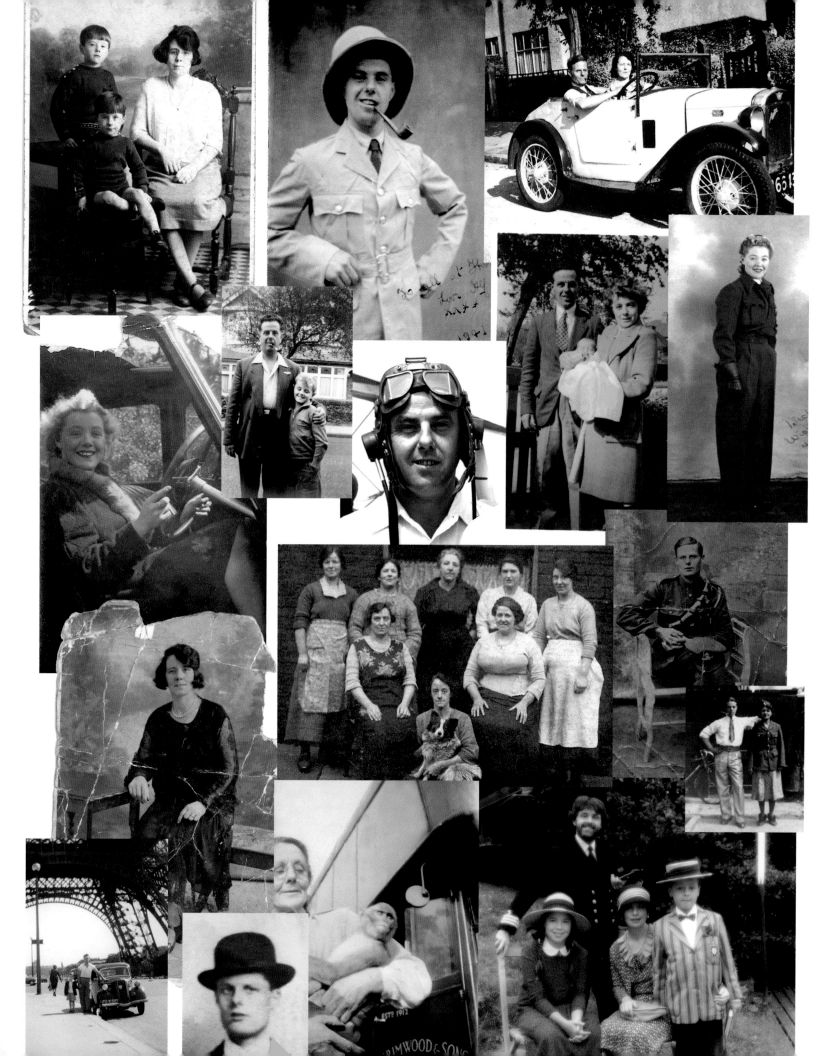

What were your parents like?

My mother, *nee* Anne Riley, was a Lancashire lass from Rochdale. The last of 13 children, she had a broad northern accent which I can mimic perfectly. Being a Virgo, born 1 September 1920, she was fanatical about tidiness. I was bathed three times a day when a toddler. She was a hard worker and joined the RAF packing parachutes (perfect for someone so methodical and obsessive). It was in the RAF that she met my father. Alfred James Grimwood was born 20 March 1920, the eldest of three brothers. His father owned a transport business "Grimwood's Transport" and all three brothers eventually took over the business, which at its peak had over 30 lorries. While in his early 20s, my father joined the RAF and flew Lancaster Bombers as an engineer and navigator. It was here that he met my mother. They were affectionately known as Blondie and Dagwood (a famous cartoon strip of the day), my mother having blonde hair and my father being Grimwood.

After the war, my father joined Croydon Flying Club along with his brother Desmond. They were mentioned in *The Guinness Book of Records* as the first brothers to have flown solo within minutes of each other. My father continued to fly as a private pilot from Biggin Hill into the mid-1970s.

What do you remember about your early childhood?

I can remember being born. Most people don't believe me, but it's true! I travelled extensively around Europe during the 1950s. My father had an old banger and we drove everywhere over the holidays. I remember Paris in the 1950s, fixed in my mind in black and white: cobbled roads, the Eiffel Tower, and seeming so exotic with the all-pervasive smell of garlic and strange tasting food cooked in oil. From Paris our route took us down through Switzerland and over the Gotthard Pass. I remember the sheer drops either side of the road as we drove through the mountain mist. I even remember my father putting snow into the overheated radiator.

As we descended into Italy, I remember how over a couple of hours the weather would change from freezing cold to glorious sunshine. I also remember the grape vines–usually we ended up in Italy around September time. We would stop in a village, buy a loaf of bread, some cheese and a raw onion then drive into the countryside and help ourselves to grapes by the side of the road. Year after year we returned to the same village called Donoratico. Here my father became a member of the coveted Vino Club. Although only seven at the time, I remember sampling the odd glass of wine. I'll never forget the Vino Club membership card with a red wine glass stain stamped on it as this was probably one of my first exposures to graphic design.

This was the 1950s. England was bland. In Italy I encountered REAL ice cream; in England we had Walls or Lyons Maid. The Italians served homemade soup topped with Parmesan cheese. Our soup was made by Heinz and we had Kraft cheese slices! Everything abroad tasted different, stronger. As I discovered later in life, instead of cooking with lard, in Italy and France they cooked with olive oil. The bread in Italy came fresh from the oven–oh the smell. In England we had Hovis!

During the summer holidays most of my classmates had gone to Butlins and arrived back at school deathly white. I would turn up golden brown having had six weeks of Mediterranean sun.

Can you remember when you started drawing, and were you encouraged?

My father used to play a game with me when I was around three or four years old. He would ask me to draw a scribble on a piece of paper, then he would transform my scribble into a recognisable picture. In turn, he would make a scribble and I would transform his into a picture. I can see how much this game has influenced me even today.

I was very neat and tidy at school. I tried to make every lesson an art lesson by writing all my work in italic. I used to put slips of paper in my exercise books for my teachers to write any comments on rather than have them scribble on my work.

I remember being popular with the bullies at Alexandra Secondary Modern School in Penge. They would ask me to draw naked ladies for them in return for a safe passage.

When did you realise or decide that you wanted to make a living by drawing?

When I was three years old I went to Stewart Fleming Kindergarten in Anerley. Every morning I was given a spoonful of cod liver oil and every afternoon, along with the other children, I was put on a camp-bed for a nap. It was here that I was introduced to an easel and paint, powder paint to be precise. My first painting was of a clown, executed with a large brush on white sugar paper using primary colours. From that moment I was hooked… and this manic interest in art and mark-making has never left me. It was never an option that I would do anything else.

When I was aged about 11 I found out from a friend's brother, who worked in advertising, the job title of what I wanted to become: a commercial artist.

What was your earliest exposure to art?

I suppose it must have been through comics and cartoons. Every week I read *The Dandy* and *The Beano*, and of course there was Walt Disney.

I loved going to the library and looking through the large art reference books that were not available to take out on loan. I recall one time taking along with me some thin Bronco toilet paper and a pencil so I could trace over Leonardo Da Vinci's drawings just to experience what it felt like to draw like that. I had not encountered real tracing paper in those days.

I cannot remember ever visiting an art gallery and my parents did not keep books in the house. It was at school that I was exposed to and encouraged in art.

Was drawing always your main interest as you were growing up or were there other things?

Drawing has always been my thing. At school I was chosen to make the frieze depicting the four seasons. At Christmas time I helped with the Nativity play scenery. I also enjoyed swimming and table tennis, and riding my track bike with its cow-horn handlebars.

Do you have any of your childhood drawings?

The earliest drawings that I have are from when I was three or four years old. I also have sketchbooks of my work from between the ages of eight and eleven. I even still have the complete portfolio of work that I submitted for the 13+ exam to gain a place at Bromley Technical High School.

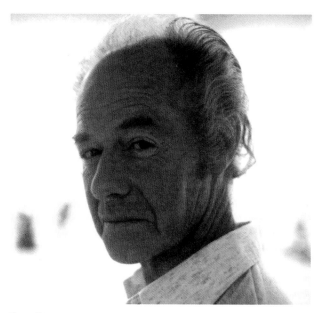

Owen Frampton

Did you enjoy school and was there a particular teacher you remember?

Being an only child I loved school. I made lots of friends there, many of whom I still see today.

Having failed the 11+ exam, I was sent to Alexandra Secondary Modern School in Penge. After two years and having come top of the class (see Report on last page), I was given the opportunity to take the 13+ exam, which I passed. I was given a place on a three-year art course mixed in with a grammar school education at Bromley Technical High School for Boys. This very special course was run by Owen Frampton, father of the '60s rock star Peter Frampton. We were encouraged to use our imaginations and given every opportunity to express ourselves in drawing, painting and graphic design. Owen Frampton believed in me; he inspired and encouraged me. I remember he always encouraged me to draw a definite line, not one that is unsure and sketchy. He also taught me to recognise when a picture is finished, to know when to stop. I owe a lot to Mr Frampton and kept in touch with him right up to his death in September 2005.

Was there anyone who you particularly admired when you were growing up?

Brigit Bardot. I can't think why! My grandad–he was a nice bloke. My parents did a good job and I wanted for nothing. Also, I was lucky to have travelled around Europe with them on long family summer holidays. The Beatles were good role models in my formative years too.

All the way through my school years various teachers encouraged me with my art: Miss Saw/Hazel Webster and, of course, Owen Frampton.

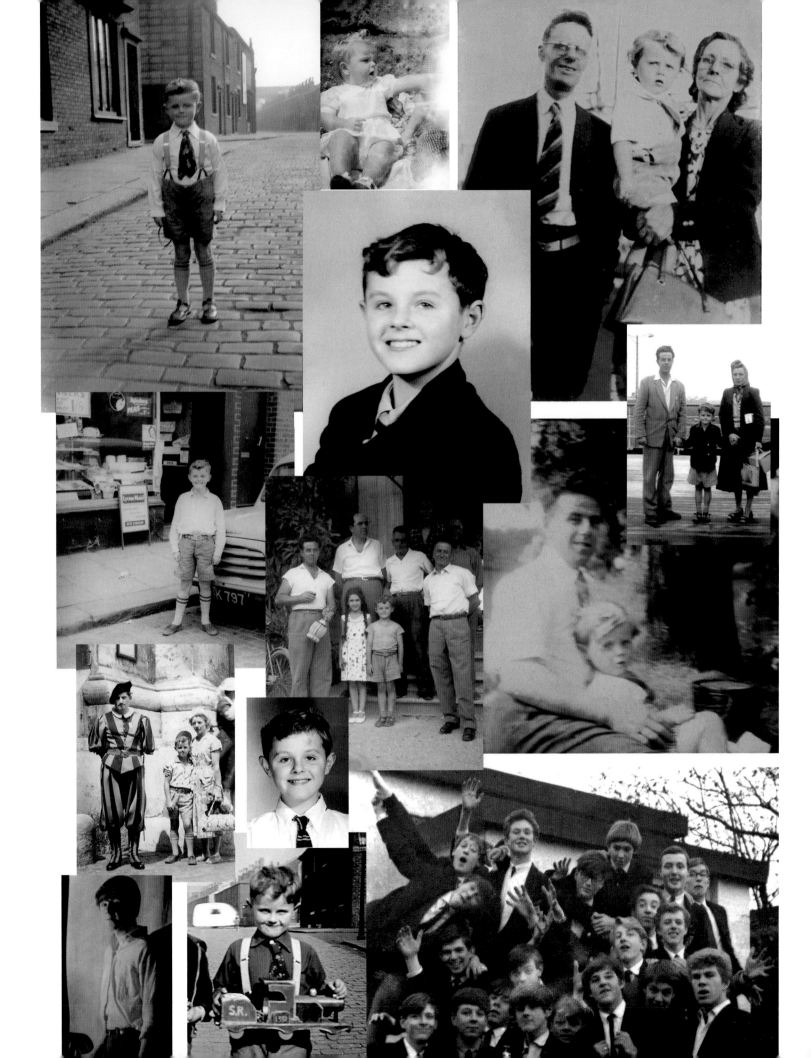

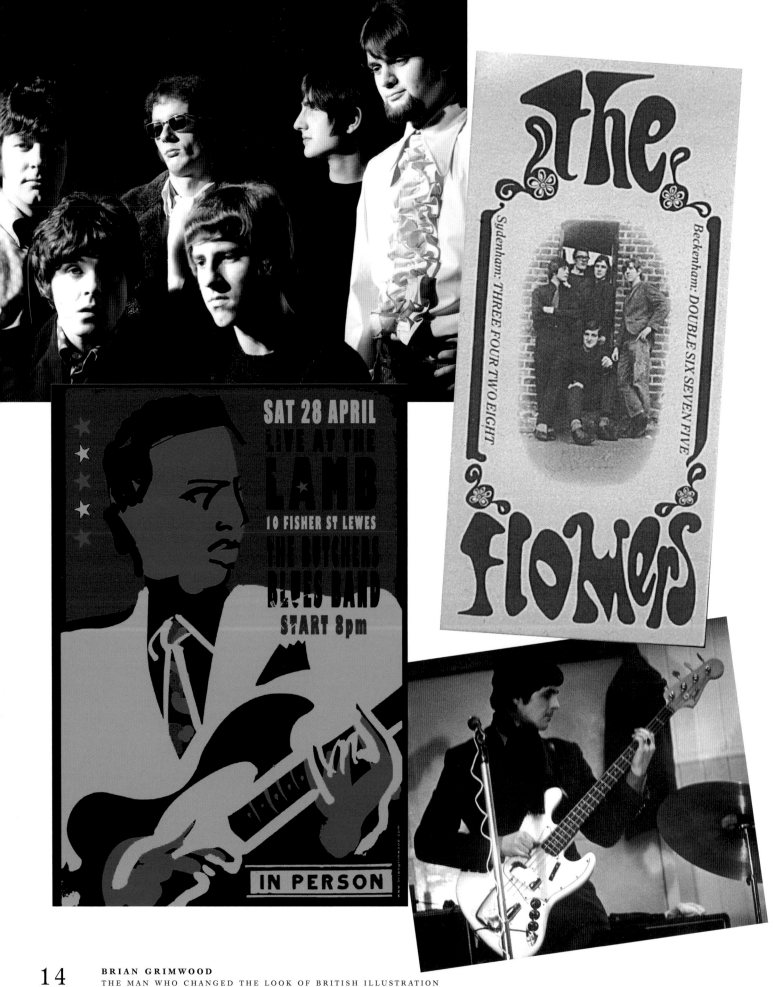

BRIAN GRIMWOOD
THE MAN WHO CHANGED THE LOOK OF BRITISH ILLUSTRATION

What was your teenage life like?

I was a Sixer in the Cubs and progressed to being a Patrol Leader in the Scouts (the Seventh Beckenham Troop). I shared these times with my school mates: Nigel McFall, Roger Butler, Geoffrey Parker, Alan Horlock–all of whom I still see today. Summer Camp was a highlight of my early teenage years.

I played rugby for my school in Bromley. At aged 15, being small for my age, I was put in the under-13 team; a cheat as I was much stronger than the average 13-year-old. I am pleased to have survived my rugby days without a single injury. Around the age of 15 I became interested in music. At first it was Elvis Presley and Buddy Holly and then I discovered the Blues and Sonny Boy Williamson

Being in the art stream at Bromley Tech was like being at art school. We had ten periods of art a week, whereas most other forms just had two periods. We attended life drawing classes twice a week and studied fine art and graphics. In 1962 (before The Beatles were style icons) we had fairly long hair. In those days it was called a "college boy haircut". We were pretty stylish dressers and I still remember wearing dog-tooth bell bottoms. Oh, those were the days! Even while still at school, aged 15 and 16, we enjoyed all-night parties with cheap wine and draught cider. I have never smoked (anything) and I don't even take aspirin for a headache, so the drug culture passed me by.

The Beatles were a huge influence on me. As a teenager, it was their style and innovation that gave me the confidence to be me. By the time I was 17 years' old I was in a Blues band called The Flowers (nothing to do with Flower Power). We later changed our name to Thackery, to sound more serious. I played bass guitar in the band for four years, mainly doing cover versions of early John Mayall tunes along with numbers by Paul Butterfield, BB King, Albert King as well as some rock and roll. It was only when I left the band some years later that I focused my ambitions more on my art.

Whose work did you admire when you were at school?

There was a boy in the year above me called Chris Dyer (affectionately known as Alf at the time). His sister went to ballet classes and Alf invited me to accompany him to a class to sketch the dancers. Watching him work completely changed the way I saw drawing. Whereas I would struggle to achieve a likeness of a pose, Dyer would somehow see his subject as a whole picture. I watched and I learnt. He was my biggest influence. From then on it all came together. Chris Dyer is now an internationally acclaimed theatre and opera set designer and is course leader for the set and stage design

course at Wimbledon College of Art. We last drew together at a rehearsal of one of his productions at the Royal Opera House in Covent Garden.

Did you go to art college and, if so, did you enjoy it?

My art education took place at Bromley Technical High School over three years from the age of 13. At aged 16 I went to work for Carlton Artists Studio in Marble Arch. At the time I fancied the idea of attending art college. In those days they were populated by beatniks wearing baggy jumpers, beards and sandals. But with hindsight, I am glad I didn't go. Over the years I have lectured at many art schools and from what I have seen I realise that I did not miss anything. Instead I gained much valuable experience in the workplace and learnt many skills and techniques first hand from some of the best practitioners. More recently I was given an honorary Master of Design degree by Nottingham Trent University.

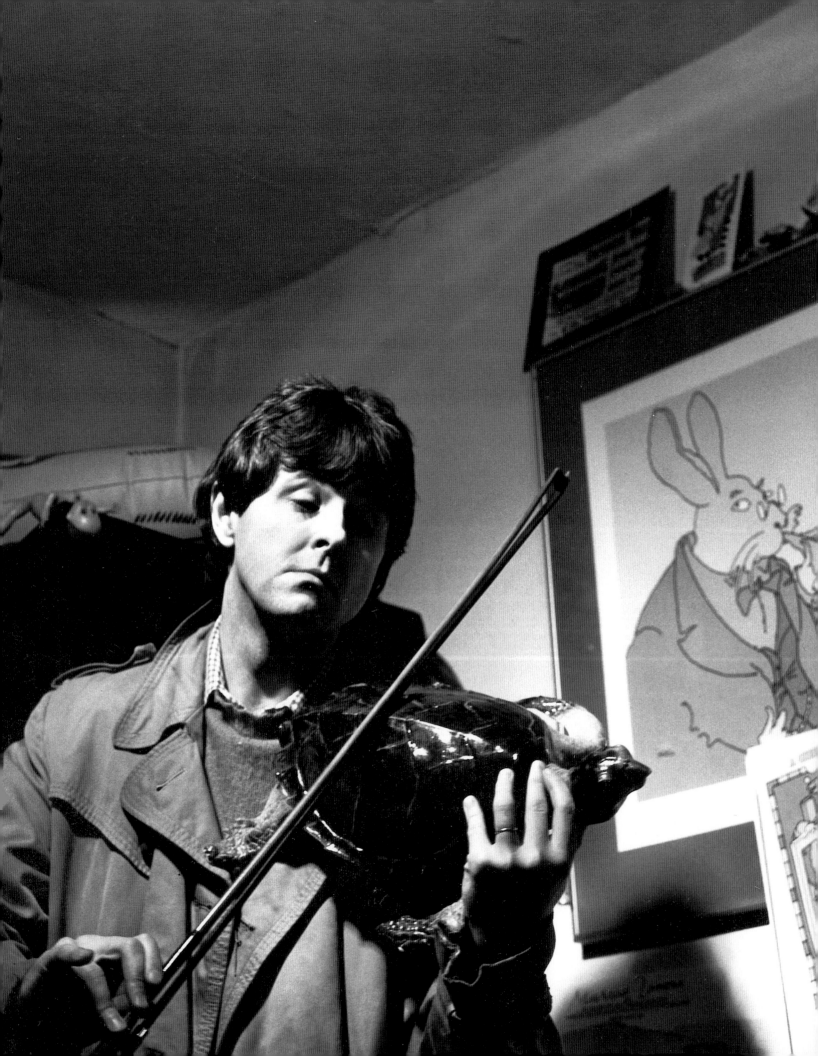

1960–1970

A photo taken in my Wellington Street
studio in 1973, in Covent Garden. At
the time it was shared with Linda Gray,
illustrator, and David Wakefield, an
ace typographer.

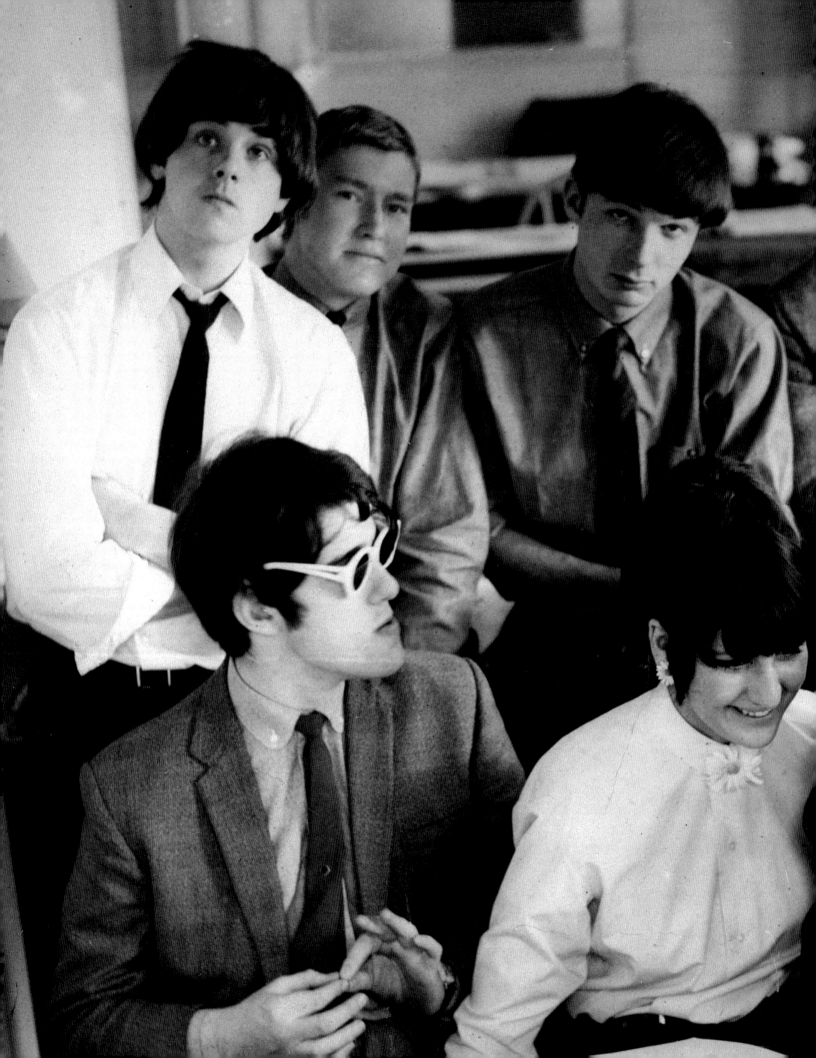

What was your first job?

I left school in July 1964. Owen Frampton [Peter Frampton's father], my tutor, got me my first job at Carlton Artists in Marble Arch. This was a major art studio, the biggest in London, and handled a broad range of design jobs. It had a lettering studio, a scraper board studio, and a studio full of fashion illustrators. As a junior/general artist, one of my duties was to collect in the timesheets. Every evening each artist had to fill out a timesheet so that the jobs they were working on could be costed up. This gave me the opportunity to see how the illustrators worked, to observe what materials they used and their various techniques. I learnt how to paint a flat wash and one of the fashion illustrators used to let me clean off the pencil lines from his artworks and cover them with tracing paper for presentation. I met some wonderfully talented people there and it was an invaluable experience, though I only stayed one year. From there I joined Pye Records.

Pye Records, 1965.

BRIAN GRIMWOOD
THE MAN WHO CHANGED THE LOOK OF BRITISH ILLUSTRATION

W

hen did you decide to go freelance and why?

After Carlton Artists I moved on to Pye Records as an art director working on the Chess Blues label, mostly designing the backs of record sleeves and press advertising for Reprise. At the time album covers were predominantly typographic, using old-fashioned photosetting with the occasional photograph and I learnt a lot about typography and the creative use of white space. Although album covers were on the threshold of something much more dynamic, it had yet to happen and after a year I moved on. I worked in a variety of design studios and advertising agencies for the next few years, changing jobs at least once a year as this was the only way to gain a pay rise and broaden one's experience, I was fortunate to work with some incredibly talented people who were willing to satisfy my curiosity and enthusiasm by sharing their skills and expertise with me. Within a few years I was commissioning illustrators, designers and typographers myself and spending a lot of my time producing visual roughs for clients.

The turning point for me came in 1968 when I saw an exhibition by Push Pin Studios, a New York design group run by Seymour Chwast and Milton Glaser with illustrators such as John Alcorn and Barry Zade. I was familiar with illustrations being used as realistic representations or used to visualise ideas that would then be photographed. This was the first time that I had seen what looked like fine art being used in a commercial way, art that communicated with verve and wit. There was clearly an idea behind each piece and I realised that people were actually making a living from this type of work: it was art but commercial art. This was exactly what I wanted to do.

First Studio shared with Mike Terry in Catherine Street, Covent Garden, 1970.

LEFT: *Image* magazine, photographer, Mervyn Franklyn.

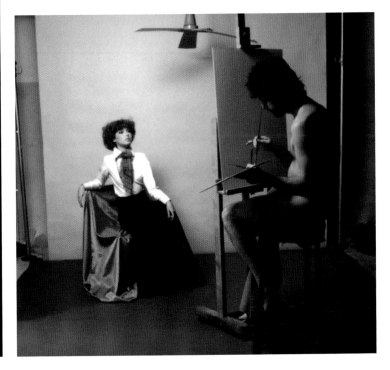

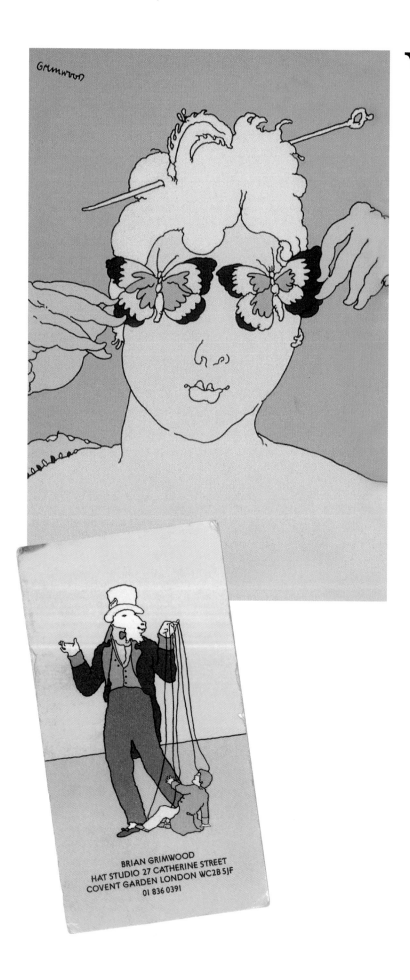

W as it difficult to go freelance?

In 1969, having made the decision to become a freelance illustrator, I spent a year on the dole preparing a portfolio. I was fortunate in that I had no responsibilities at the time: I had a room in my father's house; I was not in a relationship and I'd left the band so I could dedicate myself wholeheartedly to exploring illustration.

Mike Terry, an old friend of mine, was producing illustrations for *Nova* magazine and he let me read the briefs he received and I would work up my own versions. I also set myself briefs that related to various products and different types of magazines to show how I could visualise them in my own style. Having gained a lot of experience as an art director, I knew that to succeed as an illustrator I had to be quick to meet deadlines and to make money, and that I needed a definite style; something instantly recognisable as mine without a signature. I wanted to come up with original thoughts and put them down on paper without having to research reference material. It was always the 'idea' that was the most important factor for me.

Stylistically, I realised my initial doodles were unique to me. They had a special quality and this is what I developed. I experimented with different media and was amazed by what I produced. I got quite hooked on it, especially on the use of colour. I had never worked on paintings in this way before. After I had put my portfolio together, I researched all the publications on the market to see which were publishing the best, most interesting illustrations. I found out the names of the art directors and went along to see them. Early in 1970, on the first day of showing my work, I visited Paul Raymond's *Club International* magazine. On the strength of my portfolio, they gave me 12 full-colour pages to fill on the theme of anatomy. That same afternoon I had an appointment to see David Litchfield at *Image* magazine, which featured illustration and photography and was very popular at the time. They decided to do a ten page feature on me and also gave me the front cover. From that moment everyone seemed to have heard of me. *Image* magazine opened a lot of doors. The time was right. Illustration was in the air: Klaus Voorman had drawn the cover for The Beatles' album *Revolver*; Alan Aldridge was producing some great work; *Butterfly Ball* had just been published. I was ready….

Working from Mike Terry's brief for *Nova* magazine, I produced my first illustration, for an article on stereo equipment.

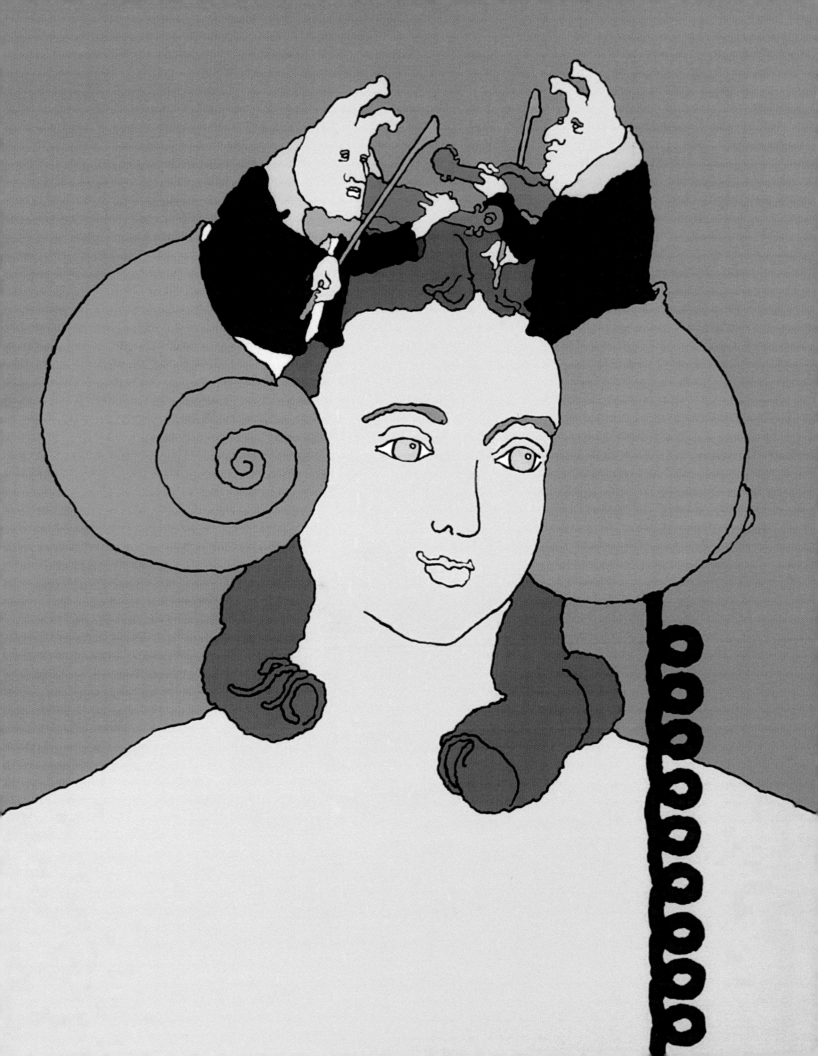

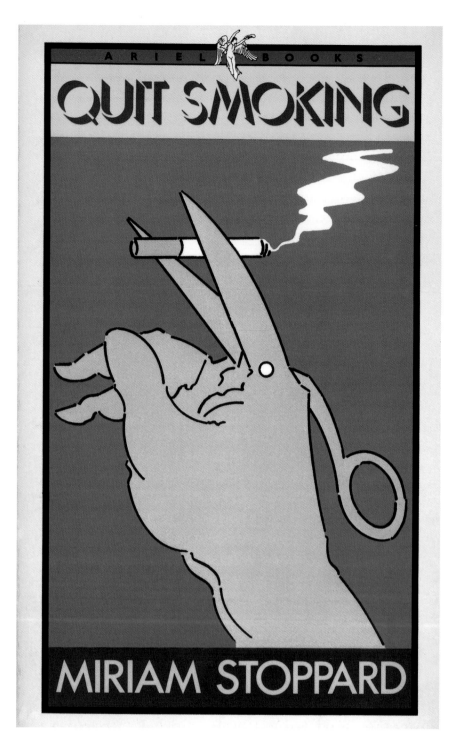

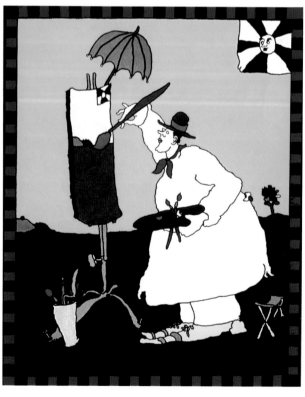

LEFT: An early book jacket for Ariel–ten years before *Edward Scissorhands*!

BELOW: The Artist, circa 1972.

OPPOSITE: One of 12 artworks commissioned by *Club International* magazine for an issue based on the word 'anatomy'.

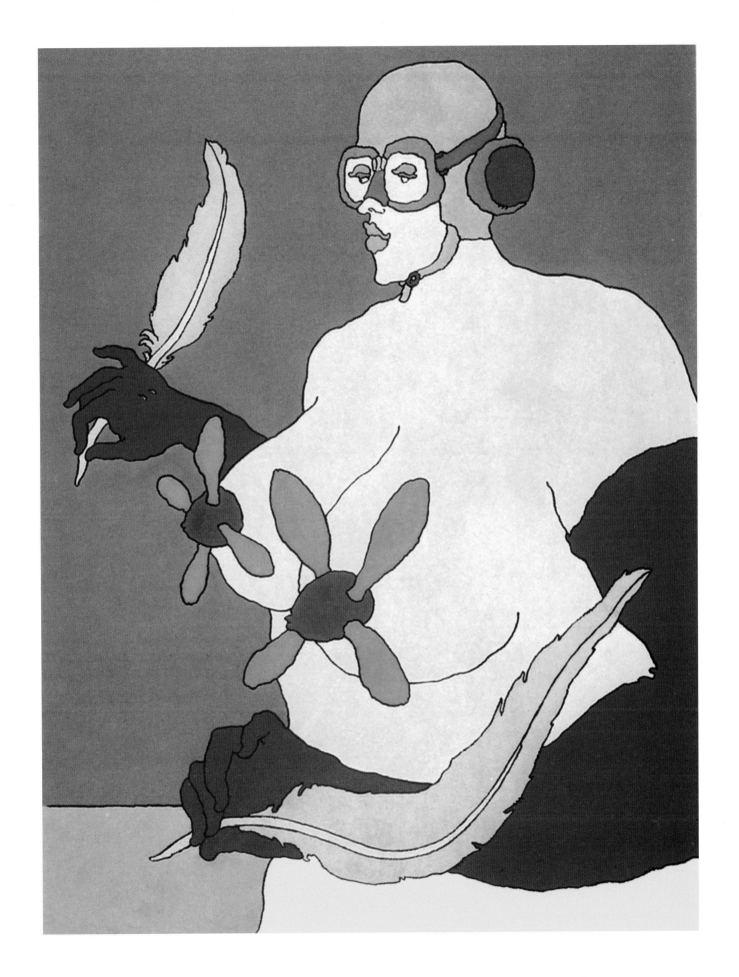

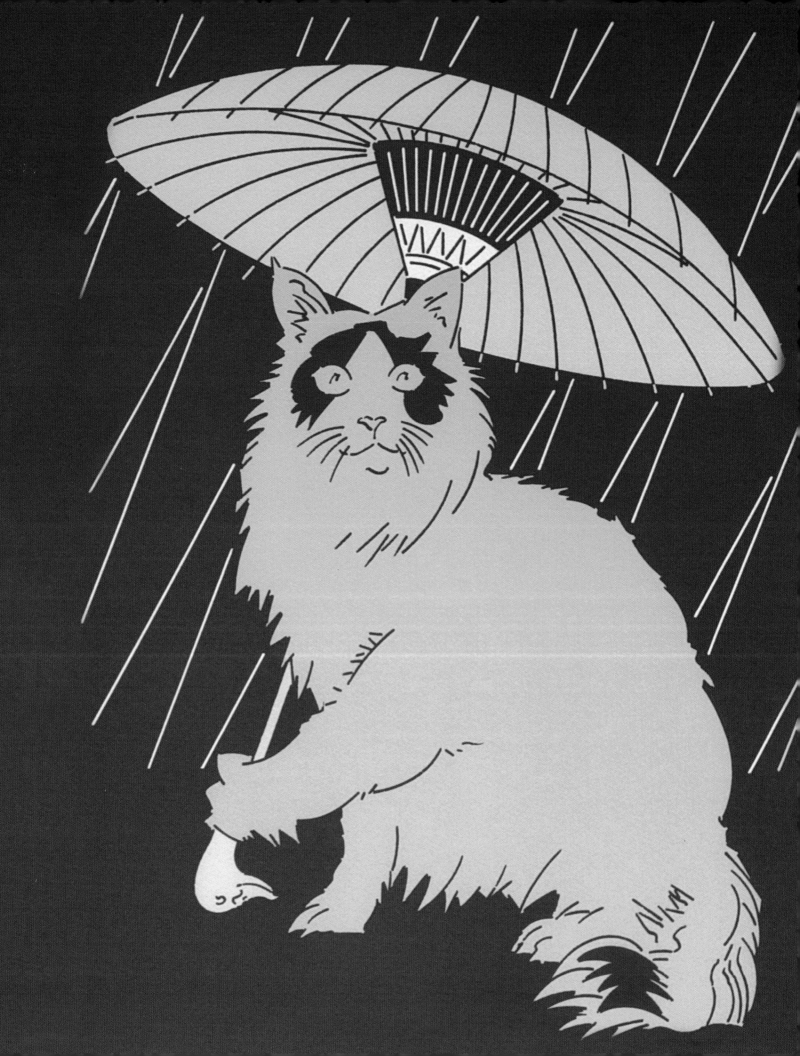

OPPOSITE AND RIGHT: From an exhibition of cat prints at Thumb Gallery entitled Drawn from Scratch.

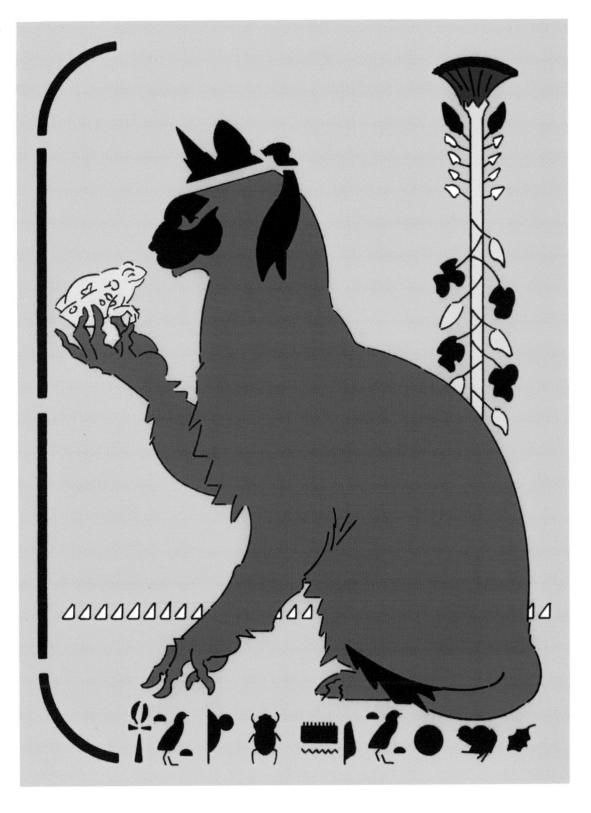

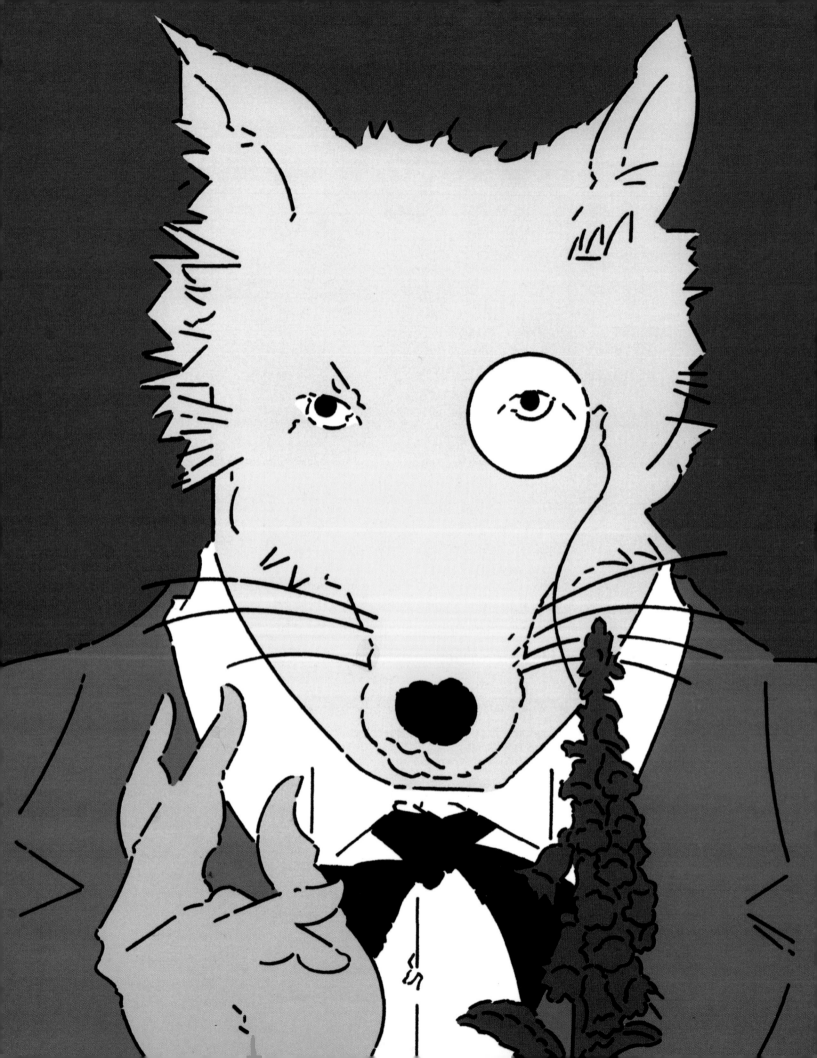

OPPOSITE: The Foxglove as used on the cover of *Grimwood's Tales*, written by Nic Would.

TOP: Originally part of a series based on the seven deadly sins–done for *Good Housekeeping*. This one was "Pride"–my homage to Aubrey Beardsley.

BOTTOM: Marmaduke the cat drawn for a proposed children's book written by Neil French.

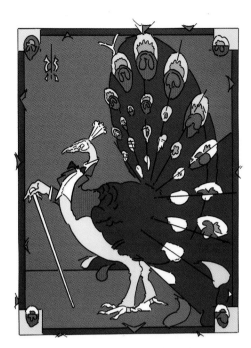

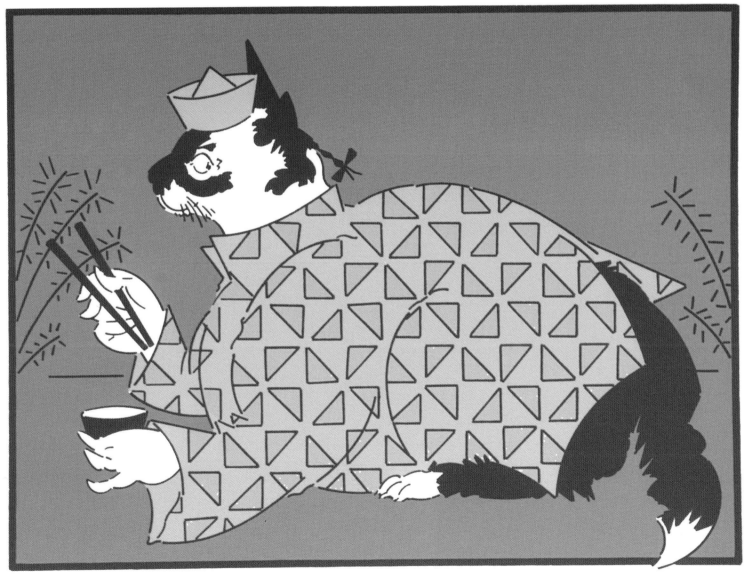

Images from the book *Grimwood's Tales*
illustrating poems by Nic Would.

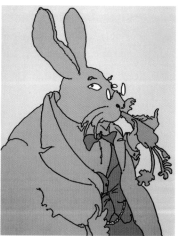

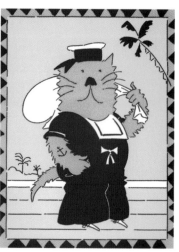

BRIAN GRIMWOOD
THE MAN WHO CHANGED THE LOOK OF BRITISH ILLUSTRATION

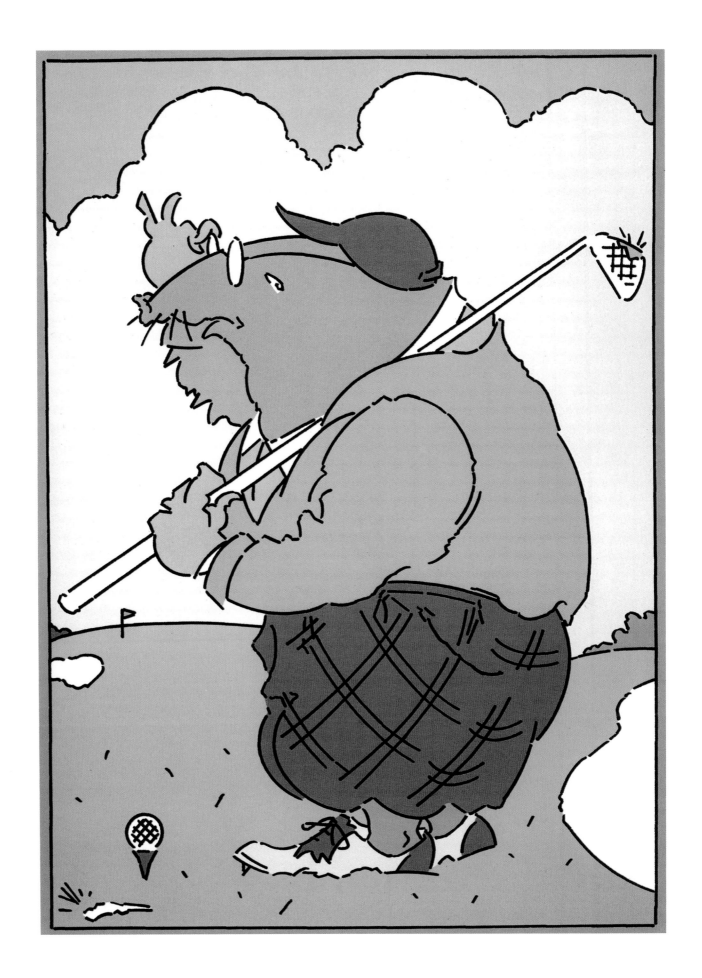

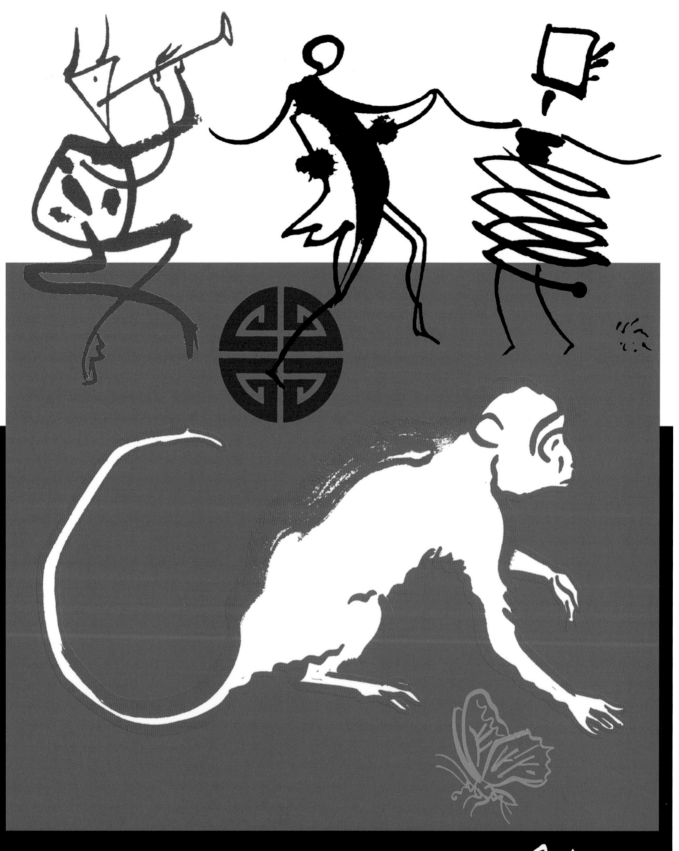

RAKMANINOV · RUBBRA · BRITTEN · SIBELIUS ·
en · Chopin · Weber · MAHLER · DESYATIN
UBERT · WAGNER · MacMILLAN · Chopin

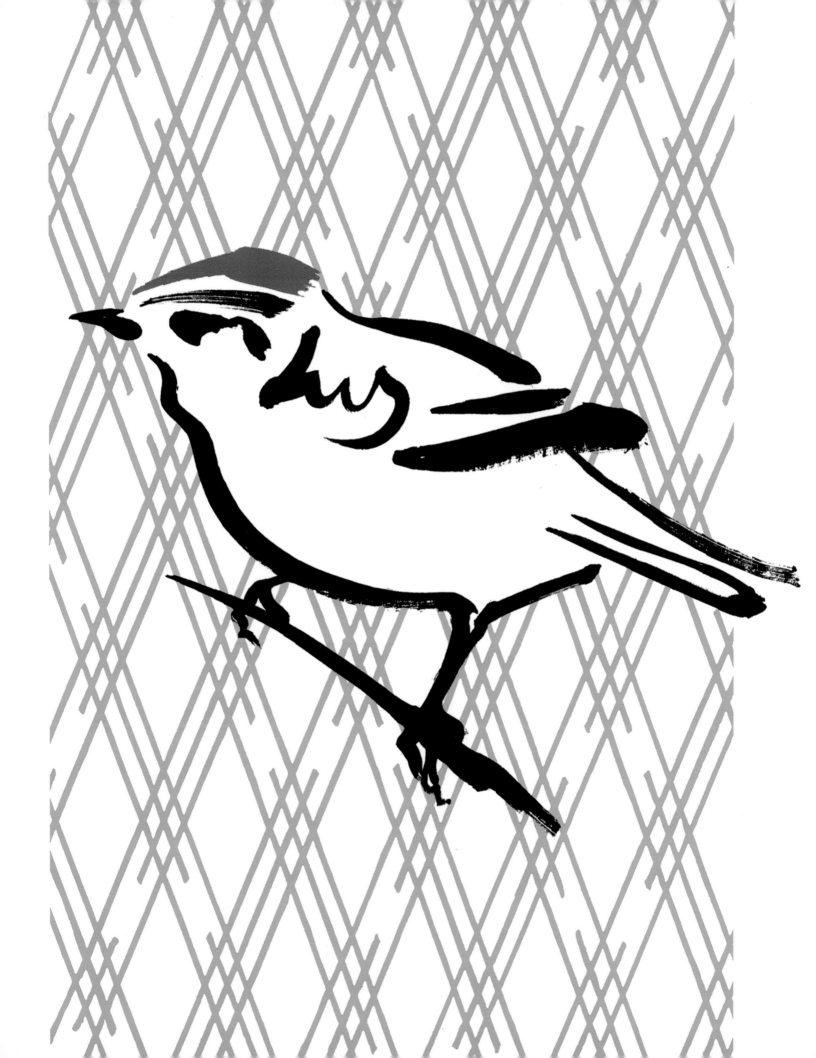

TOP: "Pet deaths" for the *Radio Times*.

BOTTOM: A picture celebrating the last
Volkswagen Beetle made.

OPPOSITE: The Cat/Birds illusion for
Pentagram Design.

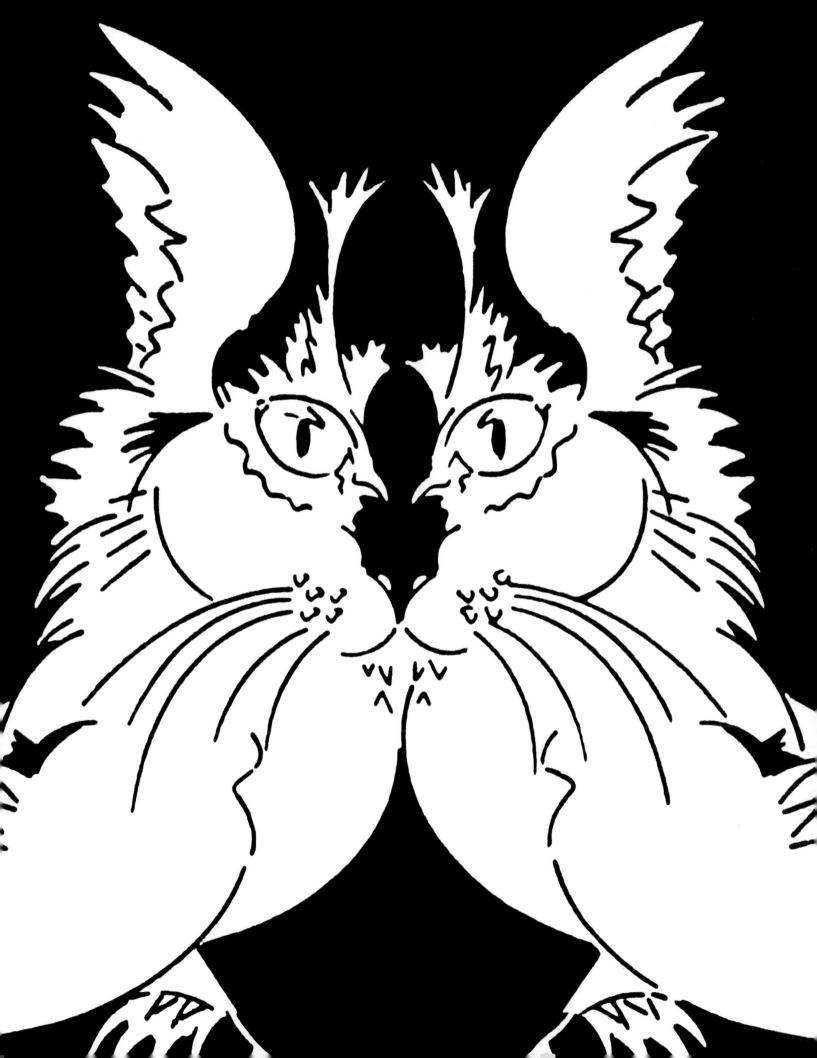

How did CIA start?

The CIA started by accident. I employed Pam Oskam (who is now an art buyer at Grays) to represent me. Within one week I had six or seven phone calls from well-established illustrators asking if I had started an illustration agency. At first I said no, then I thought, why not? So I said yes and the CIA was formed. That was back in 1983; we now represent 90 of the world's top illustrators and have offices in three countries around the world.

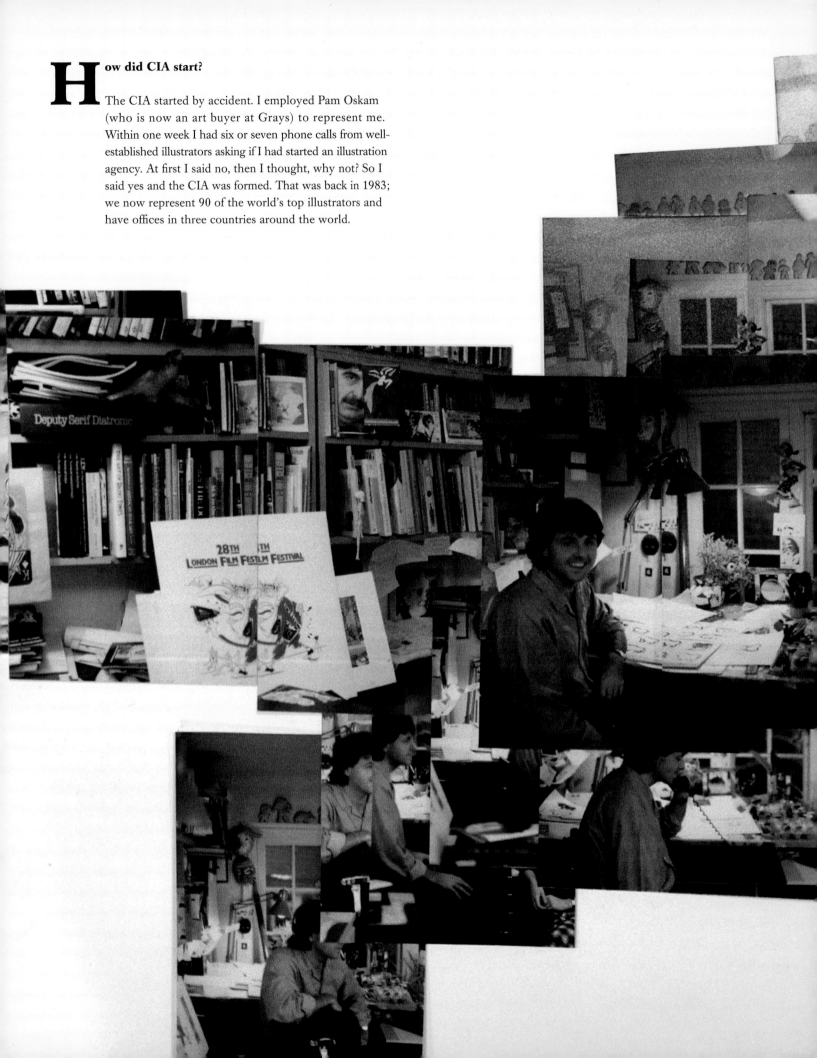

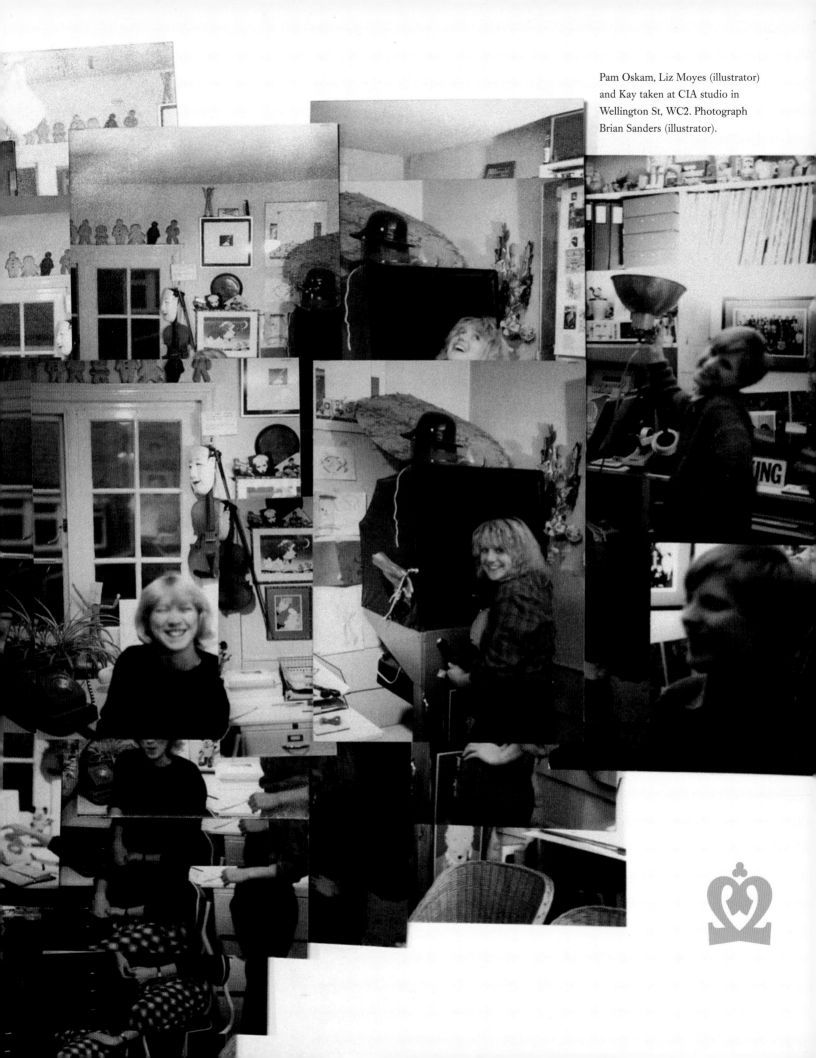

Pam Oskam, Liz Moyes (illustrator)
and Kay taken at CIA studio in
Wellington St, WC2. Photograph
Brian Sanders (illustrator).

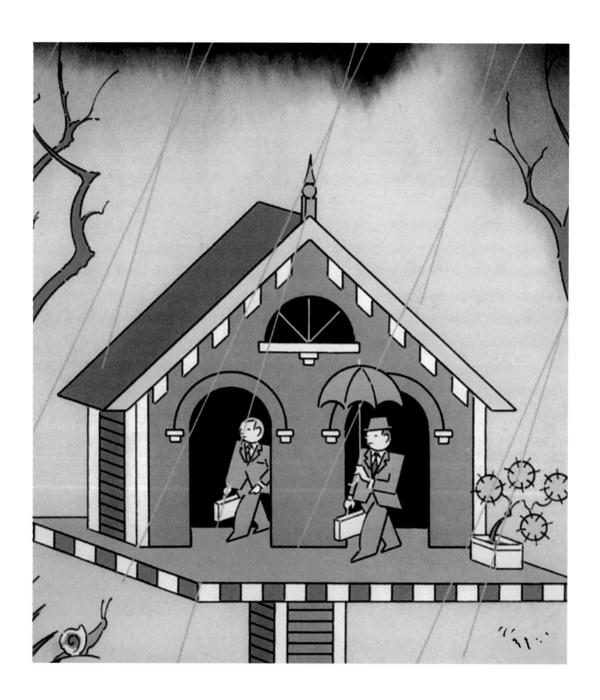

BRIAN GRIMWOOD
THE MAN WHO CHANGED THE LOOK OF BRITISH ILLUSTRATION

1970–1980

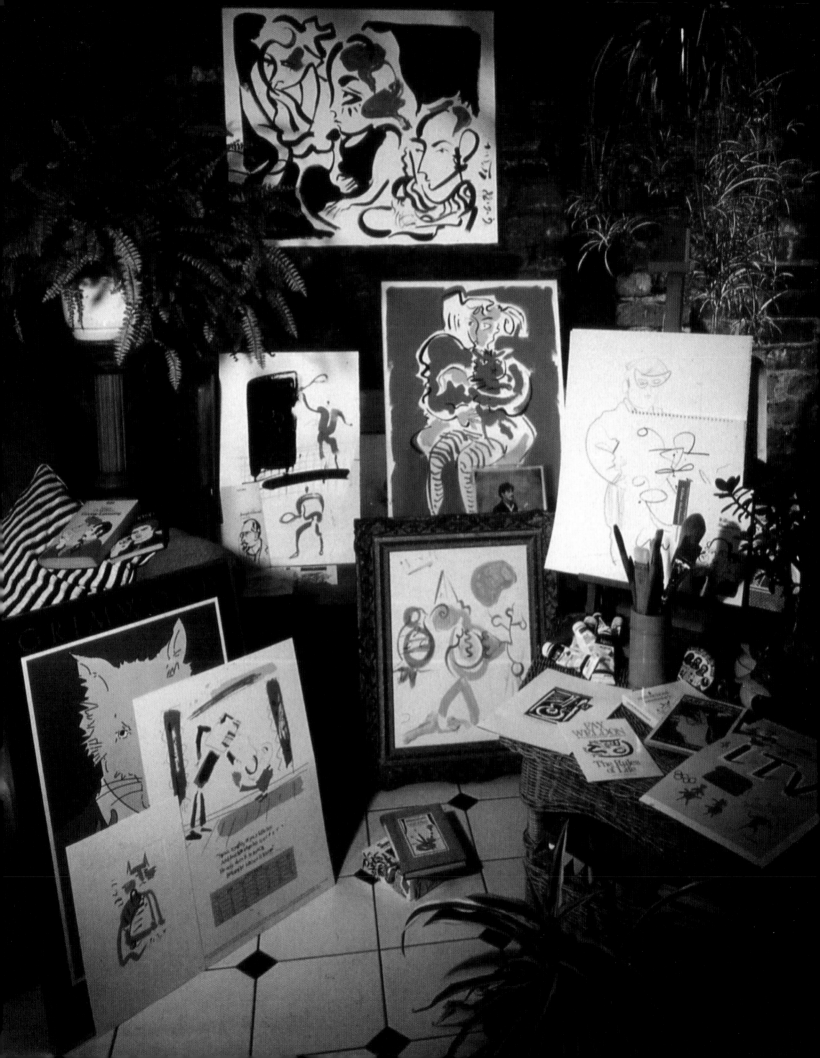

When you look back at your career so far, is there a time you consider particularly good or view with particular affection?

The journey so far has been exciting. I look back on the camaraderie between illustrators in Covent Garden in the early 1970s with great affection. When I started out on my freelance career I shared a studio there with Mike Terry, who was also busy illustrating by this time. We had met when we both worked at Ron Bowden Associates in Soho and shared an enthusiasm for drawing caricatures of our colleagues. We found the room (cheap even in those days at £3.00 per week including electricity) via George Underwood, who was, and still is, David Bowie's best friend from school. He had shared it with Terry Pastor, who with the help of George designed the first two Bowie covers: *Hunky Dory* and *Ziggy Stardust*.

We named the premises Hat Studio and brightened them up by painting the walls sunflower yellow. Situated in the middle of Covent Garden in Catherine Street, we were very convenient for all the IPC magazines whose offices were located round the corner in Southhampton Street. The area had yet to be developed so rents were low, making it popular with other illustrators, designers and photographers. Head Office Studio, run by James Marsh and John Farman, was nearby and always felt like an Aladdin's cave. They were very successful at that time making Plasticine models for various advertising campaigns and their studio was full of their creations in glass cases.

It was a friendly, convivial time and every Friday the illustrators of the day would gather for a lunch-time drink at The French House in Soho.

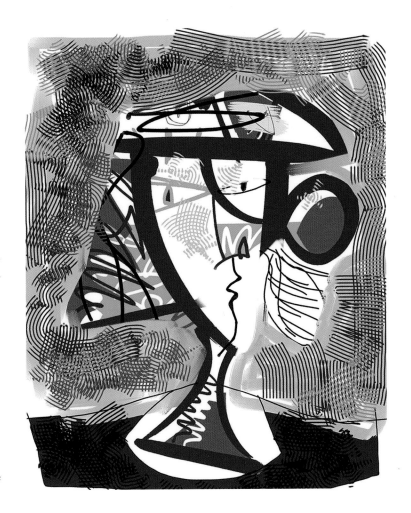

BELOW: For a *Sunday Times* colour
supplement on music books.

RIGHT: Fish bait.

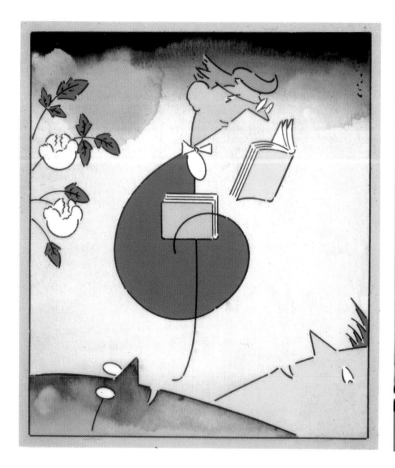

BRIAN GRIMWOOD
THE MAN WHO CHANGED THE LOOK OF BRITISH ILLUSTRATION

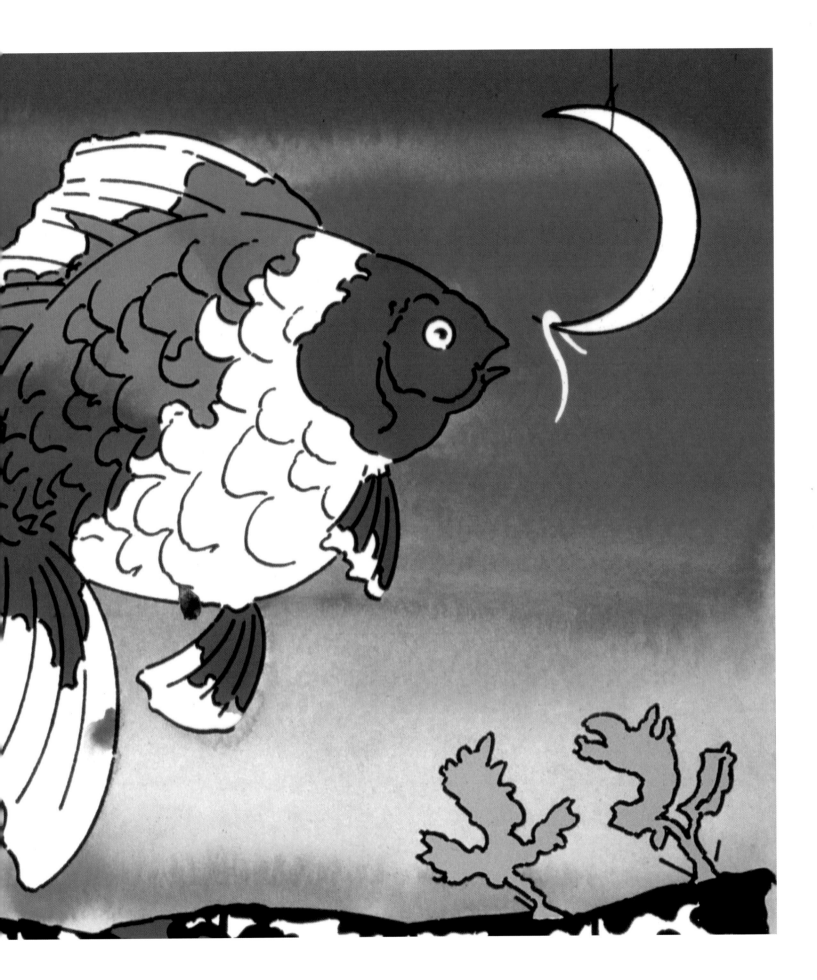

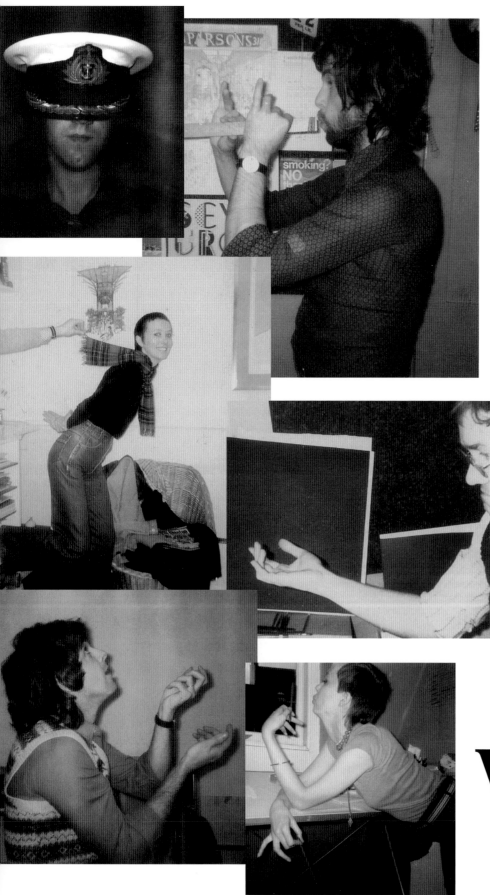

Was there a point in your career when you thought of giving up?

All I have ever wanted to do is make pictures. I would do it whether I was paid or not; it is my burning passion and the concept of 'giving up' is not part of my being. I do what I do for me: as Charlie Chaplin said, "First entertain yourself, then entertain the public."

Contact sheets of the The Flowers, with whom I played bass for four years.

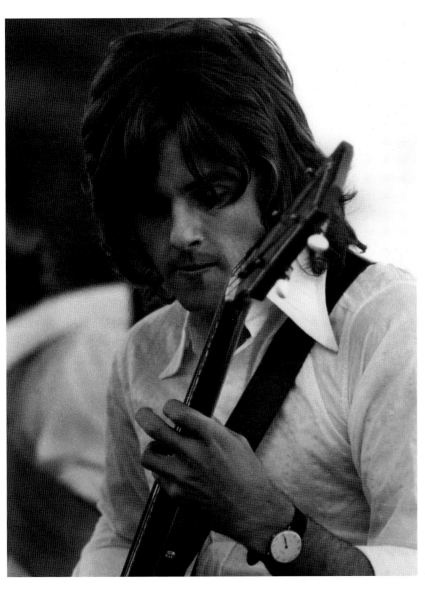

A selection of magazine and book
covers done during the 1980s.

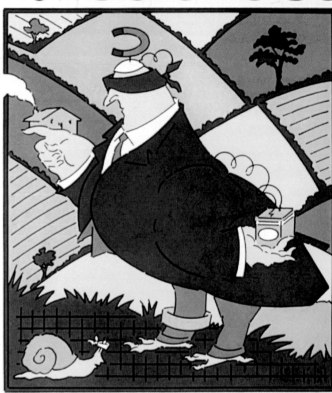

U.S.A. (by air) $2.70 ISSN 0028-6664 18 September 1980 Vol 87 No 1219 Weekly 50p

new**scientist**

Compass in the brain – a new human sense

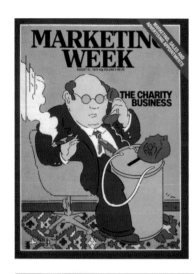

MARKETING WEEK

JUNE 18, 1982 50p VOLUME 5 No. 16

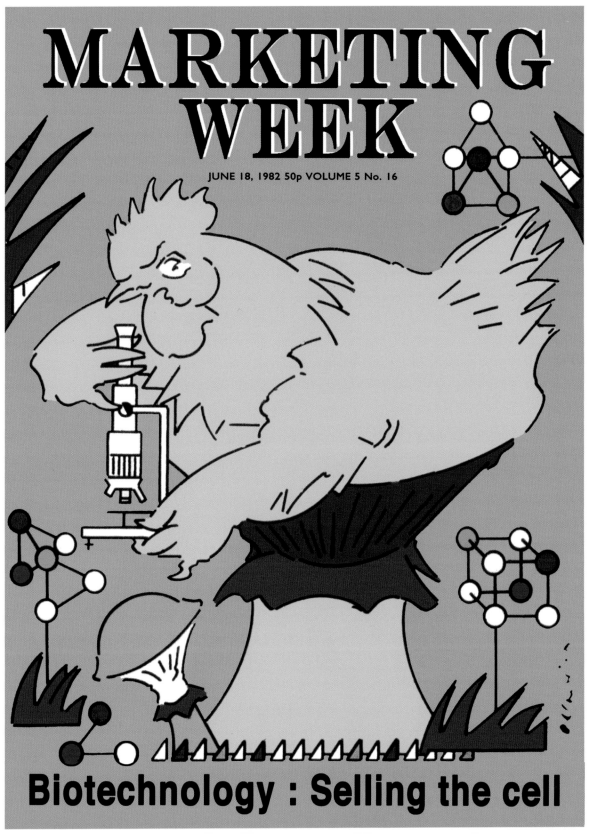

Biotechnology : Selling the cell

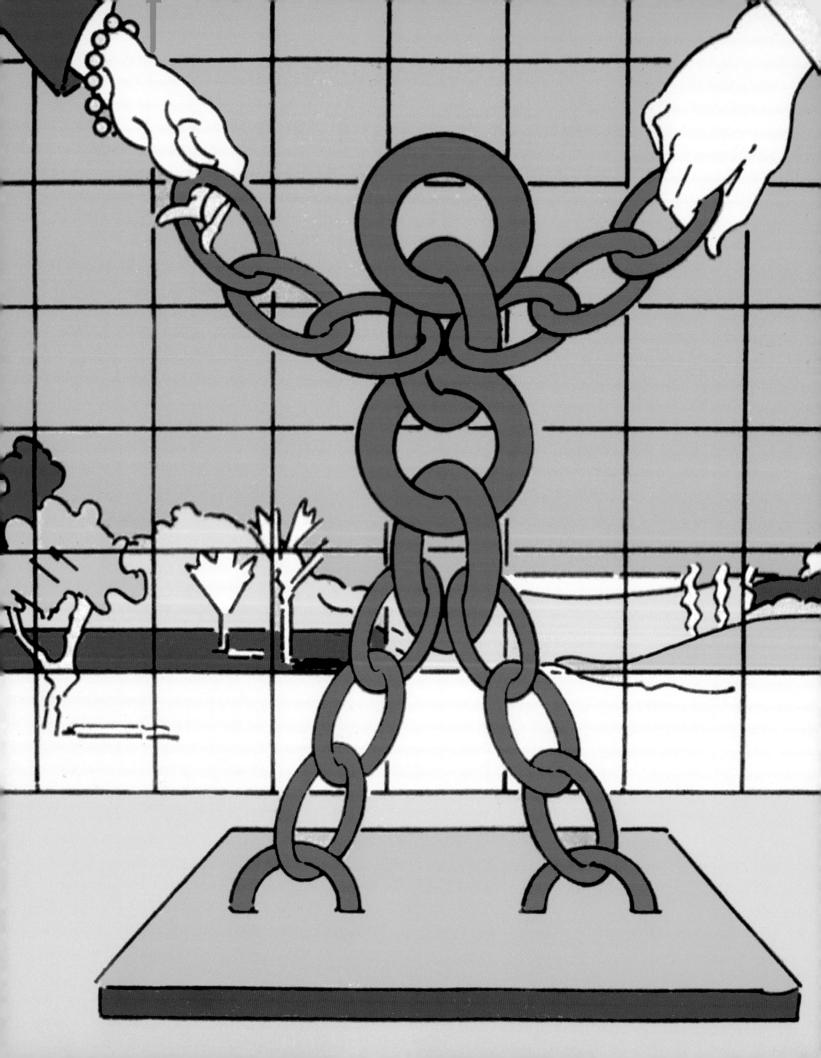

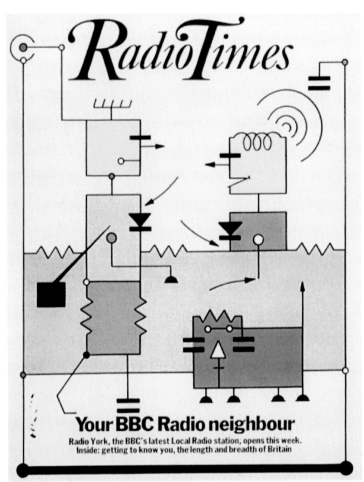

Your BBC Radio neighbour
Radio York, the BBC's latest Local Radio station, opens this week.
Inside: getting to know you, the length and breadth of Britain

PACKAGING AND DESIGN

GOLDEN SYRUP

A MARKETING WEEK SPECIAL REPORT

Opposite: Illustration about how children keep families together pending a divorce.

A selection of magazine covers done during the 1980s.

Strike a light note
Saturday sees the start of the 'BBC International Festival of Light Music' at London's Royal Festival Hall; Radio 2 will be there. Back feature: Steve Race asks, 'What is light music?'

ATV HOME & GARDEN TIME

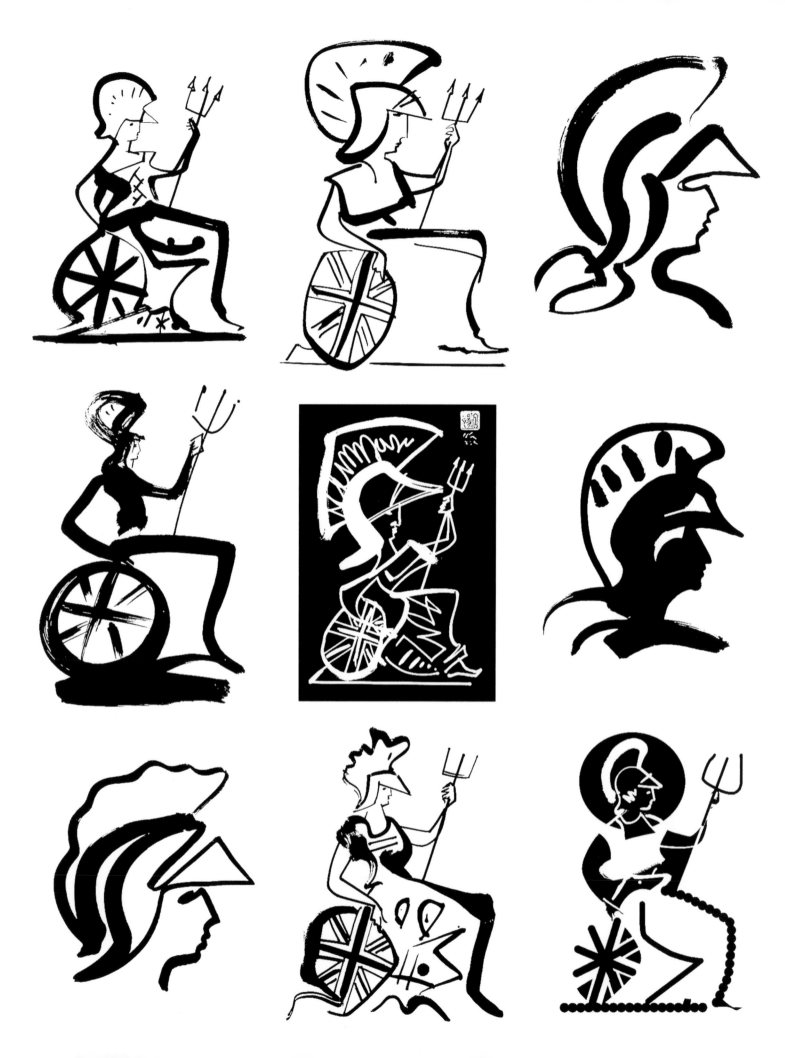

1980–1990

LEFT: Original rough that spawned my 'new', loose brush style of work.

OPPOSITE: Actual cover *Design* using the 'rough' opposed to my previous style of work.

Has your illustration style changed since you started out?

I entered the market as an illustrator having developed my style of images with black outlines and flat colour which proved popular with magazines and advertisers from the outset. After I had been illustrating for about ten years, *Design* magazine commissioned me to do a cover. When the art director came to the studio to pick up the artwork he noticed a painted rough that I had produced for another job. He admired it and asked if he could see my rough of his cover illustration. I showed it to him and he decided immediately that he would print the rough as the cover. Afterwards I was inundated with commissions for this 'new' fluid style. To my delight it was much quicker for me to produce and it really took off. I have never looked back.

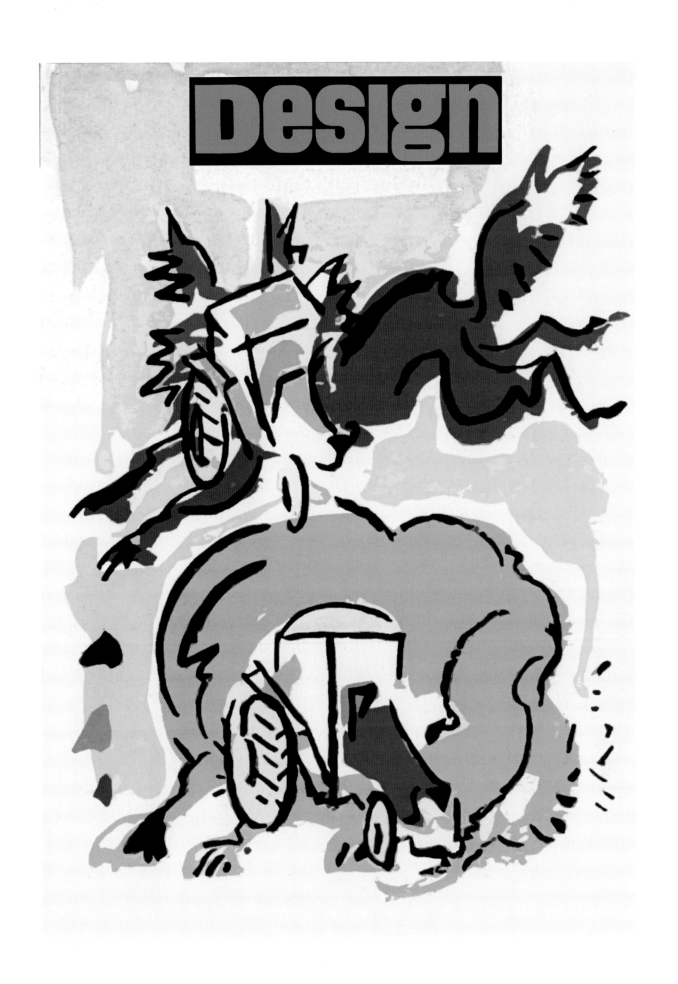

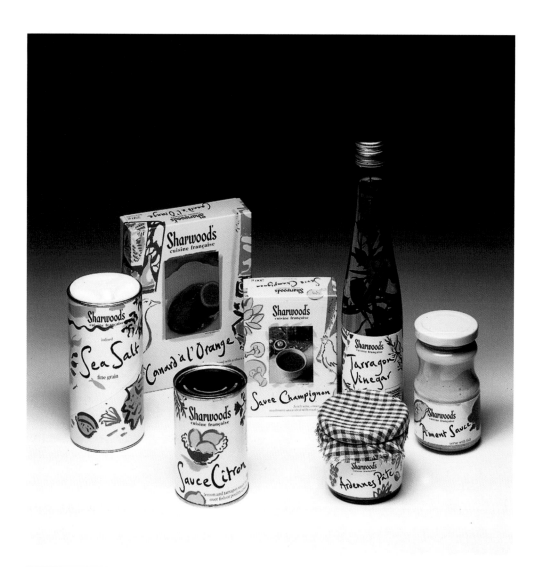

BRIAN GRIMWOOD
THE MAN WHO CHANGED THE LOOK OF BRITISH ILLUSTRATION

LEFT: The first job after *Design* magazine in my 'new' style was for Sharwood's, commissioned by Howard Milton of Smith & Milton. For the time it looked very different and was given a prestigious award by D&AD.

OPPOSITE: A poster promoting a tennis event, sponsored by NABISCO.

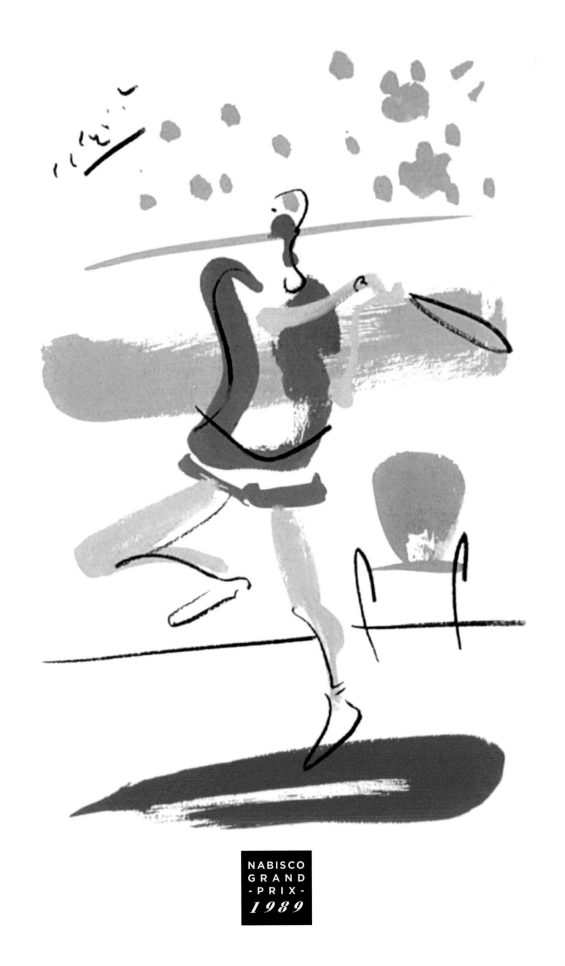

NABISCO
GRAND
- PRIX -
1989

Logo for the Edinburgh Festival and
Scotland on Sunday cover.

OPPOSITE: Menu cover for a restaurant in
Oslo. Artistic Director: Morten Saether.

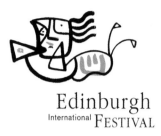

Edinburgh
International FESTIVAL

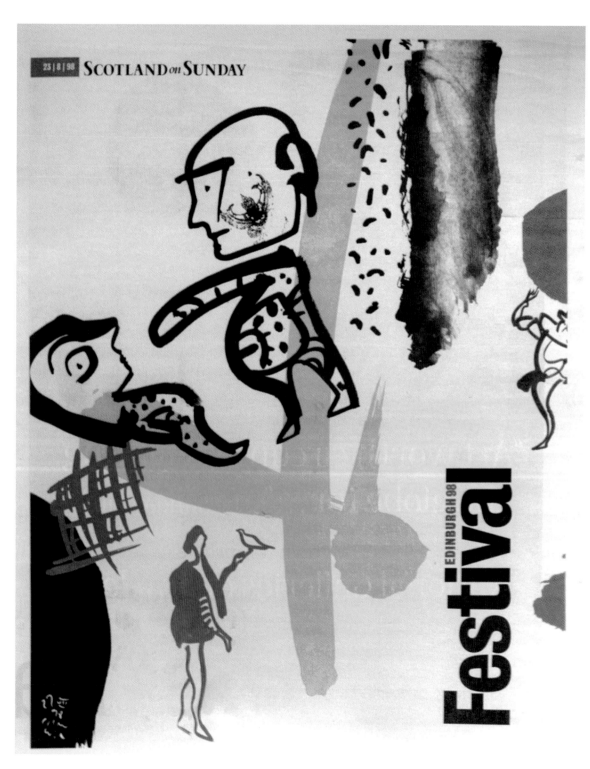

BRIAN GRIMWOOD
THE MAN WHO CHANGED THE LOOK OF BRITISH ILLUSTRATION

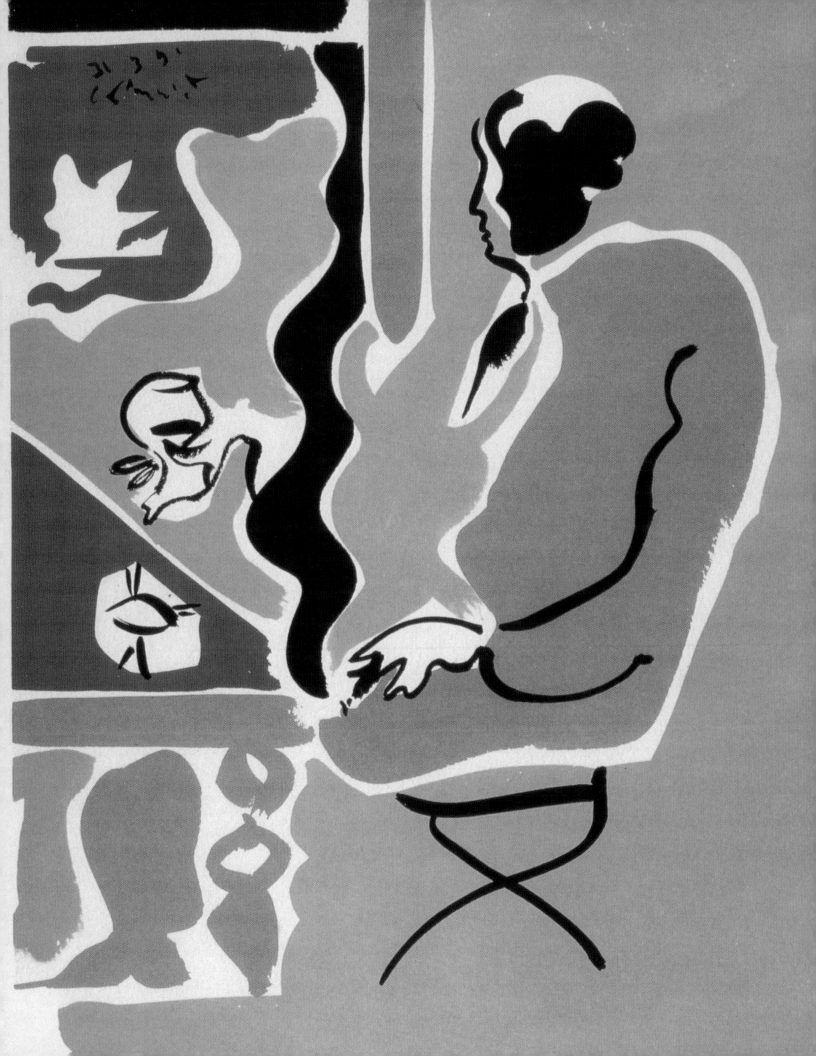

A drawing of my daughter with her cat, Willow. From this drawing I was asked to do an etching, and from the etching a rug was made.

OPPOSITE: A cover drawing for *Accountancy Age*, featuring pensions.

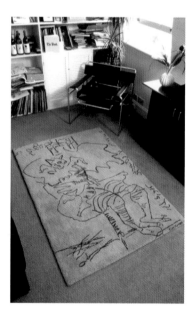

BRIAN GRIMWOOD
THE MAN WHO CHANGED THE LOOK OF BRITISH ILLUSTRATION

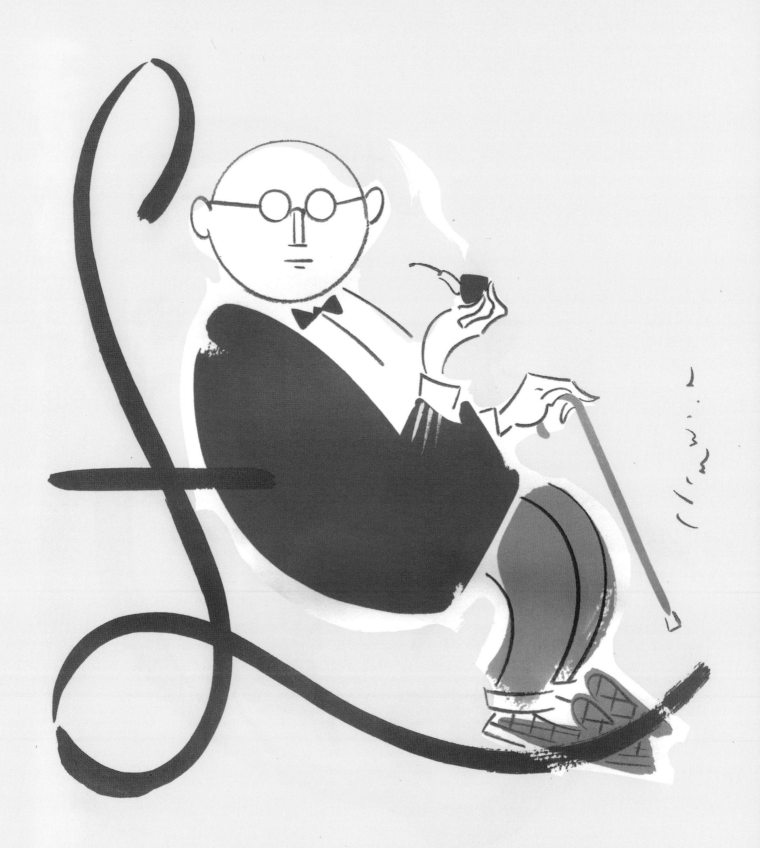

A quick portrait done of the late Charlie Riddle. It was this portrait that Beatle George Harrison saw and from which he commissioned me to do his portrait for his *Live in Japan* album cover.

OPPOSITE: A brochure cover for The London Electricity Board.

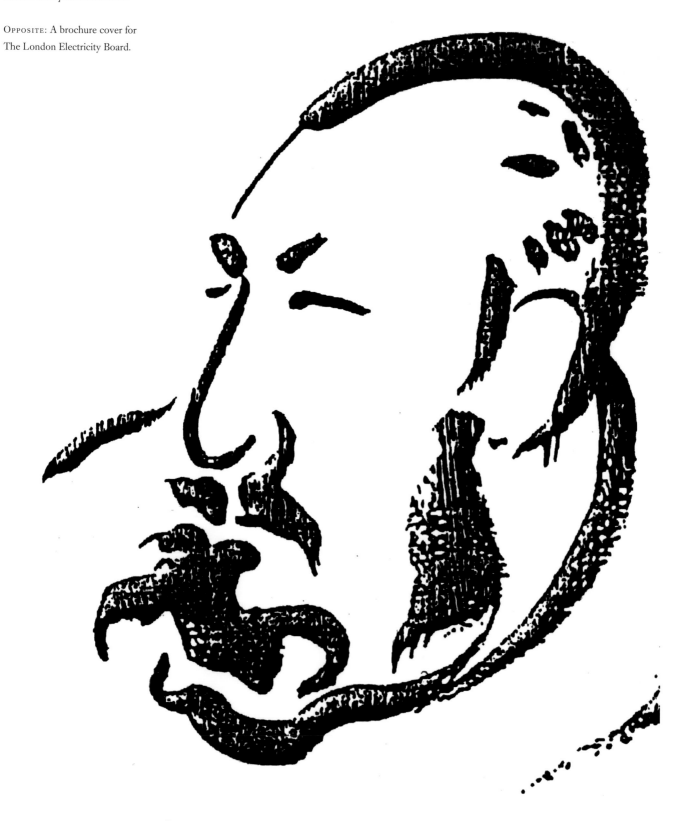

BRIAN GRIMWOOD
THE MAN WHO CHANGED THE LOOK OF BRITISH ILLUSTRATION

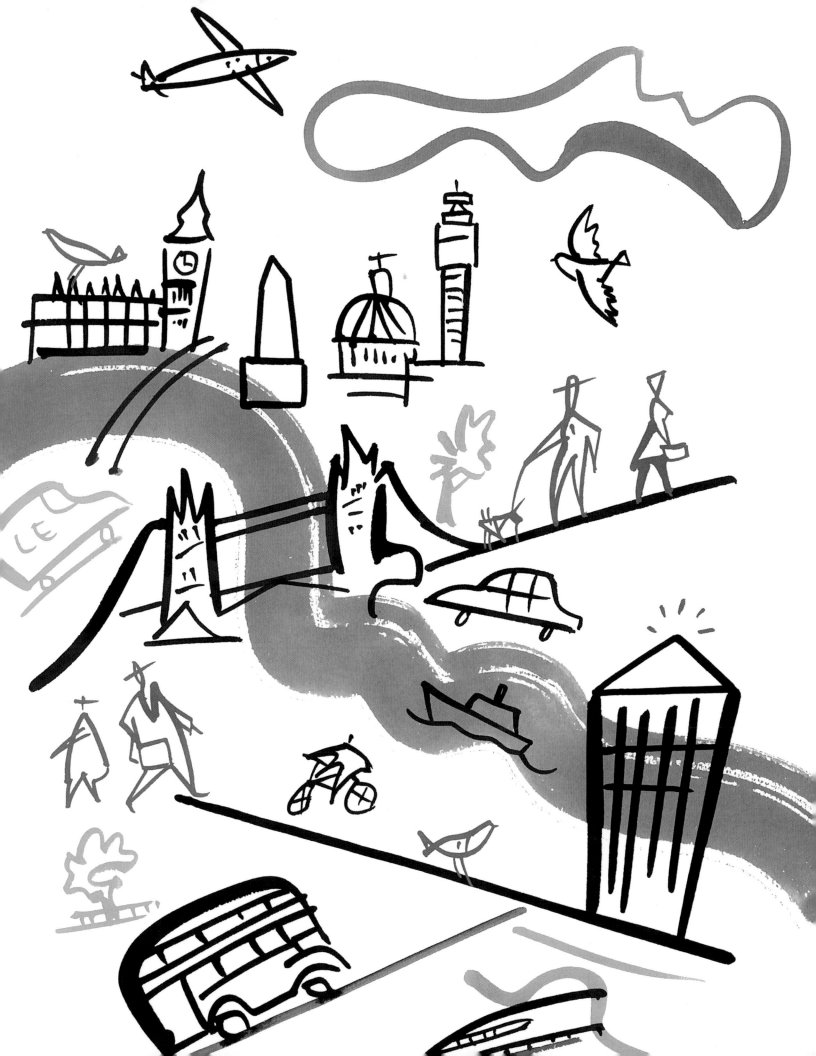

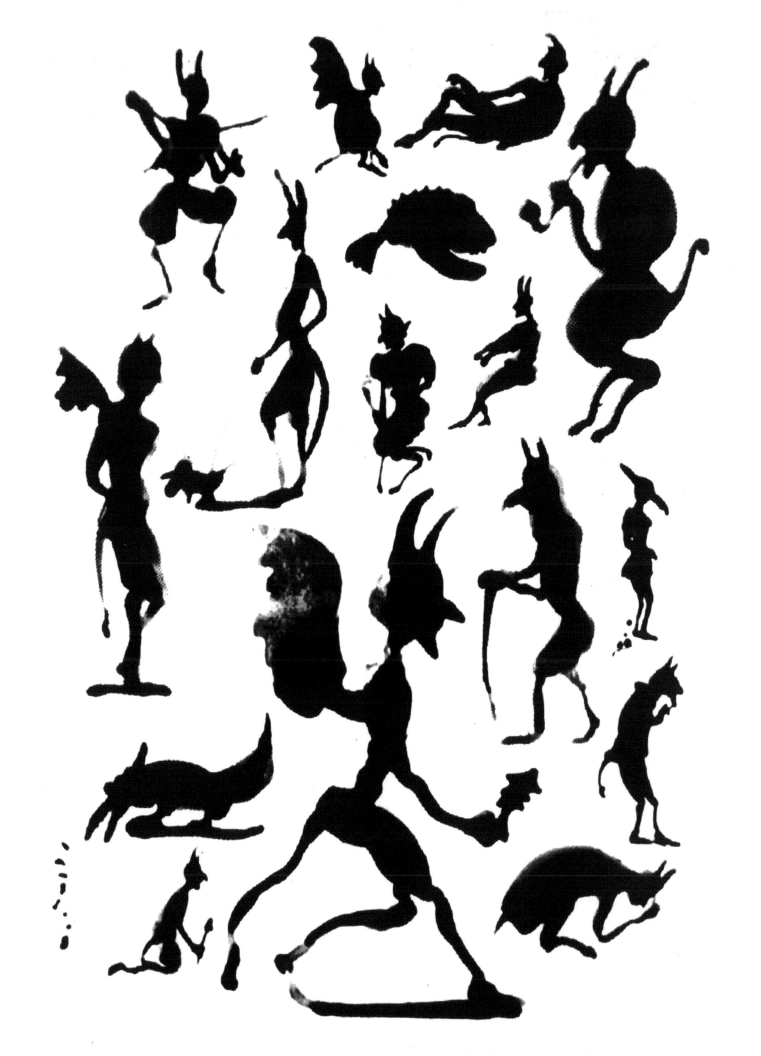

OPPOSITE: A personal Christmas card
–NO HELL.

A sketch of my mother, 1989.

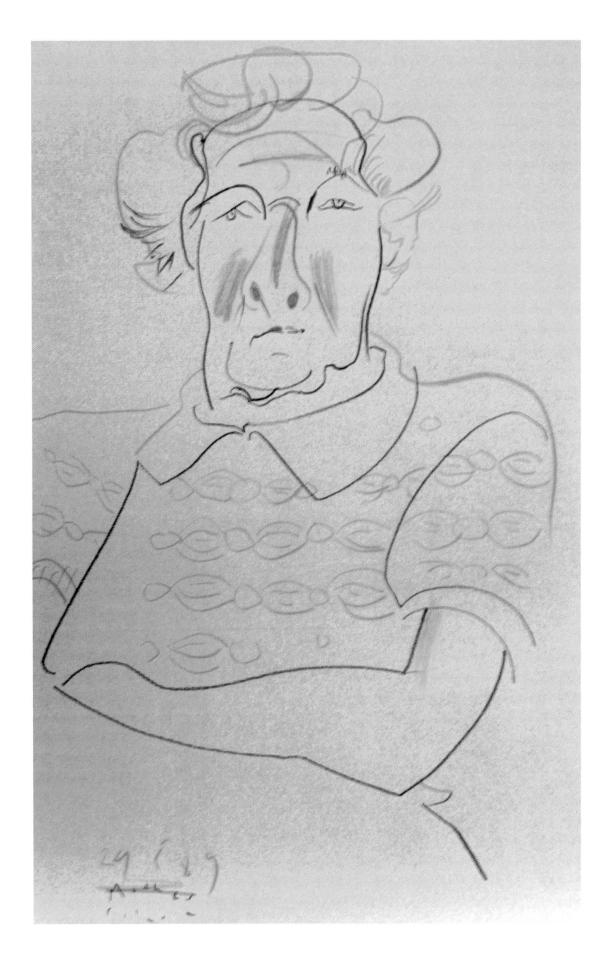

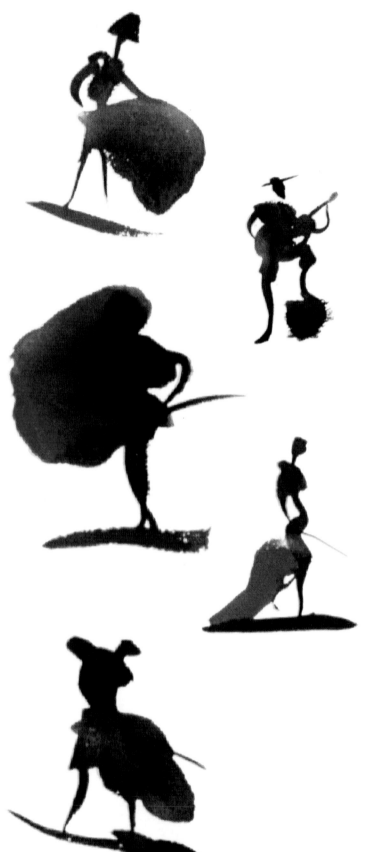

Do you think that illustration has changed during your career?

Since the introduction of the computer, the look of illustration has changed dramatically. There was a time when it took a few years to develop a technique that would make one's work look professional. In my case, actually putting down flat colours using gouache was revered. But now, of course, with the use of a computer you can drop in a flat colour in seconds and then, if you wish, change it within seconds. The computer has allowed almost anybody to achieve a slick result and its ascendance seems to have wiped the slate clean of so much of the history of illustration. It surprises me how many young illustrators today seem to have never heard of Milton Glaser, Ronald Searle or Alan Aldridge, or any of the other leading illustrators of the last century.

As more work has become computer-generated, it seems that I see fewer conceptual ideas. For me, illustration has always been about the idea. Much of the work around in the early 1990s seemed to lack any drawing skills and was nothing more than decoration. At least that awful phase of tracing round a photo then dropping in a flat colour at last has passed. Lateral thinking and craft are back–thank goodness.

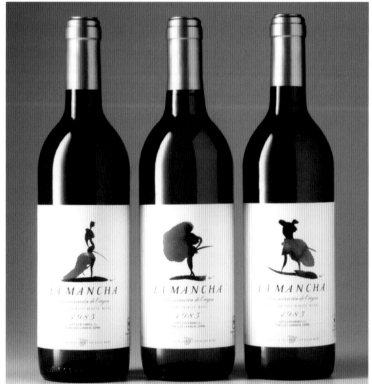

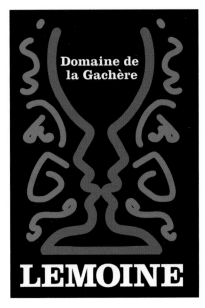

OPPOSITE: My first attempt at the blobby style, initially done for fun and then used by Mary Lewis at Lewis Moberly for wine labels. They looked much better with the typography and ended up winning an award in America. This was in 1985–early days for illustrated wine labels.

Presentation and promotional poster for the new wine label of twins Alain and Gilles Lemoine in France, created on my iPad 3, June 2012. Art Director: Morten Saether.

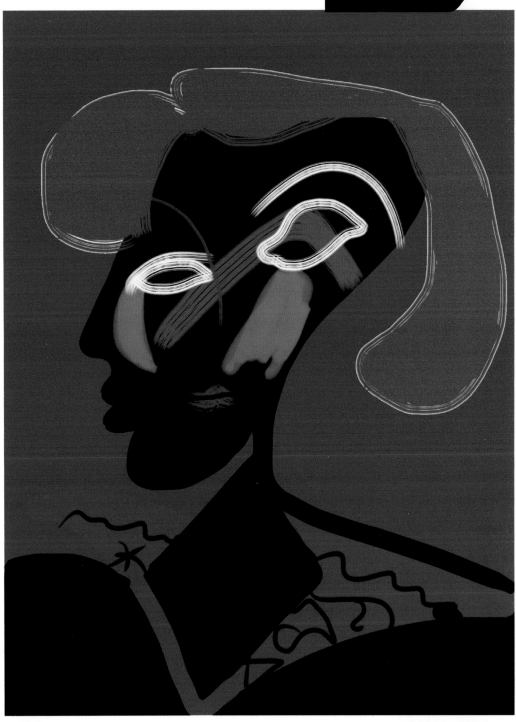

Tous les vins produits par Alain et Gilles Lemoine sont élaborés à la propriété avec une attention particulière en y apportant tout le savoirfaire depuis trois générations et le souci de restituer la noblesse des cépages et de leur donner une authenticité unique.

Domaine de la Gachére
VIN DE PAYS DU VAL DE LOIRE
MIS EN BOUTEILLE AU DOMAINE
par Alain et Gilles Lemoine
Vignerons
79290 Saint-Pierre-a-Champ
Product of France
www.gachere-lemoine-vins.fr

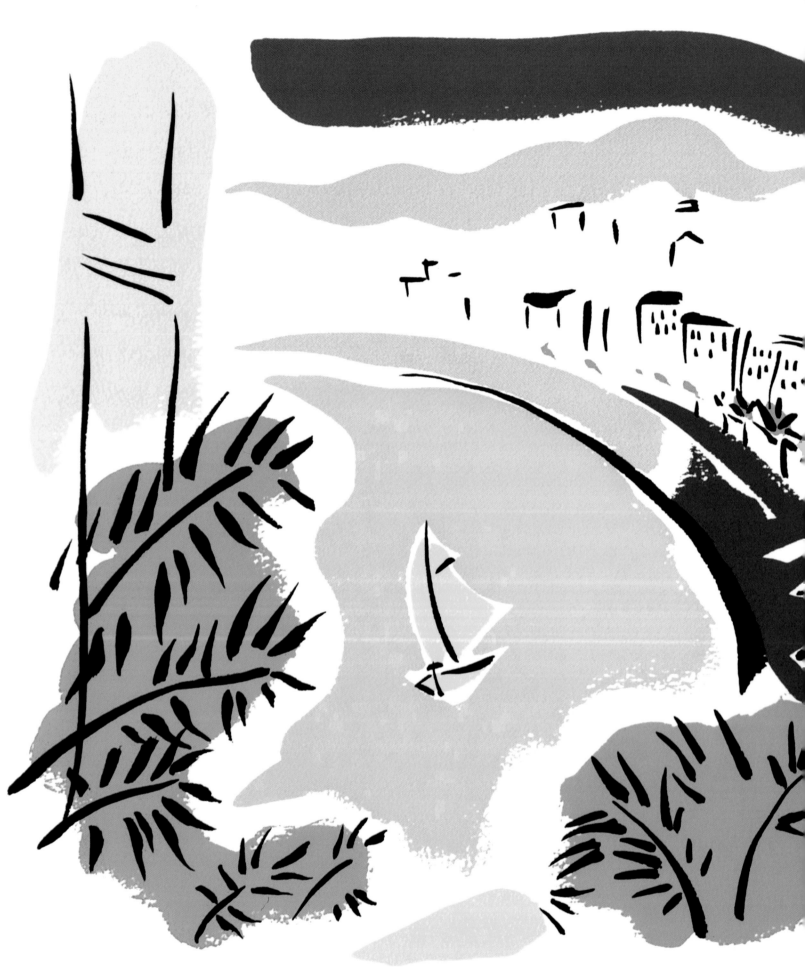

BRIAN GRIMWOOD
THE MAN WHO CHANGED THE LOOK OF BRITISH ILLUSTRATION

When you started out as an illustrator, were you happy to follow an art director's directions and take on board their requests?

From day one I was determined to interpret briefs my way, in my style, and if clients didn't like it I saw it as their problem. Fortunately they almost always did like what I produced and it was not long before they would request that I "do a Grimwood". I started out as an illustrator having decided that I would do exactly what I wanted to do because when I was an art director myself, my work was continually compromised.

On occasions art directors have given me problems to solve that I haven't tackled before and this can push me into a different way of working. Art directors who have worked with me before usually give me a pretty free rein. New, young art directors, who tend to be less experienced at commissioning illustration, often try and give me a tighter brief and this is much less inspiring. I'd rather not do the job if I'm going to be told what to draw.

A commission from Marks & Spencer for their "Cooler" range. It was printed directly onto the tin.

Development of DE FENIX logo.
Art Director: Phil Cleaver.

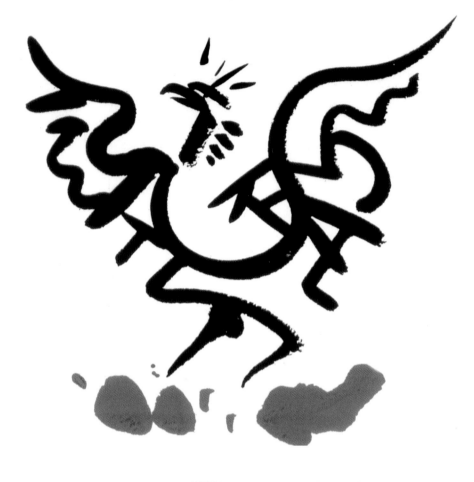

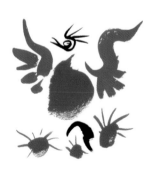

 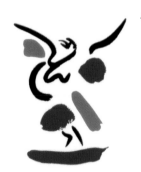

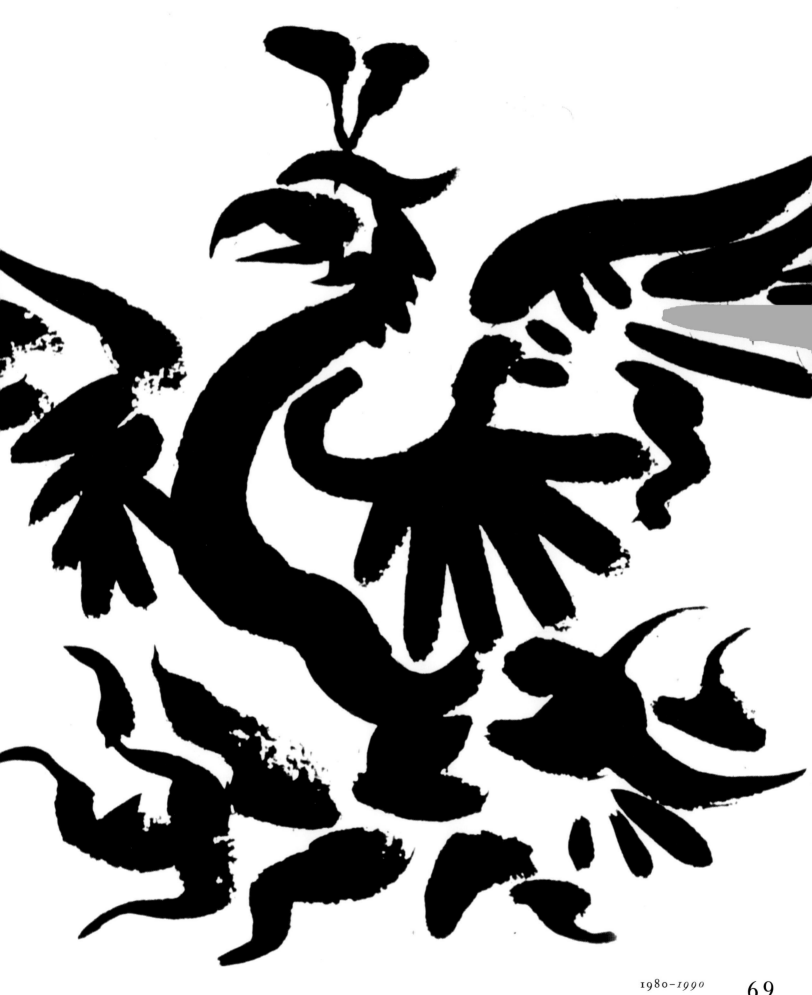

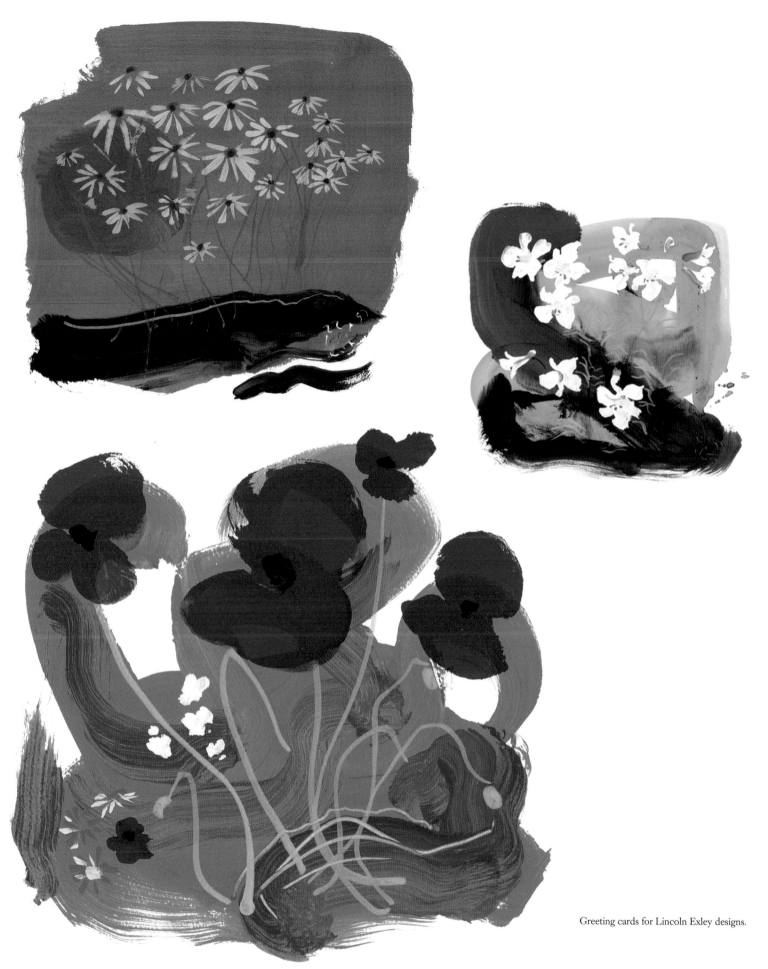

Greeting cards for Lincoln Exley designs.

BRIAN GRIMWOOD
THE MAN WHO CHANGED THE LOOK OF BRITISH ILLUSTRATION

What do you consider to be your best piece of work?

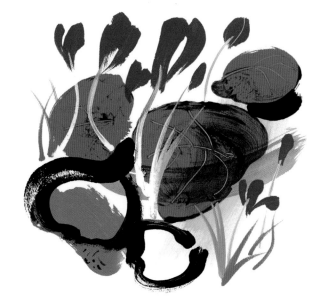

The last time I counted I had produced over 7,000 pictures. I know it's a *cliché*, but in this business you are only as good as your last job. Currently I am working on a fabulous job for The Folio Society who have asked me to produce 40 full-colour drawings to illustrate the works of WH Auden as well as a colour foil blocked cover on any cloth of my choice. I feel honoured to have been asked as over the years The Folio Society have only ever commissioned the best.

I have also had four one man art shows. One of the most successful was held at The Portland Gallery in St James', London. The theme was flowers in vases and I decided not to sell one piece to remind me how I did it.

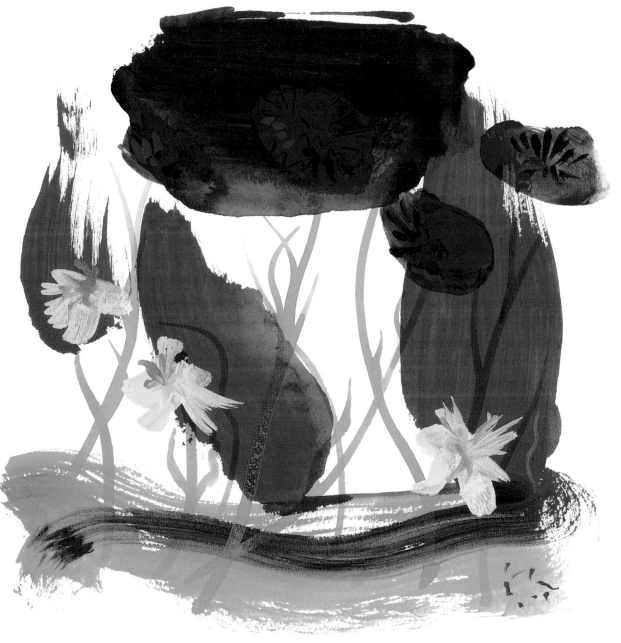

Originally illustrating an article about the idea
that "everyone has a book inside them", now
used by my script writer son as The Grim
Word logo.

How do you see yourself in ten years' time? Do you envisage your working life changing?

In the past I have always had a ten year plan and fortunately
most of my plans and dreams have been realised.

The next ten years? Now, because of the computer,
broadband and email, I can work from anywhere for
anyone. So… in ten years time I can see myself spending three
months of the year abroad painting and illustrating.

In my last one man show Inside her heart, as I was finishing
the last painting of the 40 that I produced, I felt that I was just
getting somewhere. It gave me some sense of how much effort
it takes to do a 'great' painting. I am looking forward to spending
more time painting. I also love the idea of pushing the barriers
on the computer–what an exciting prospect!

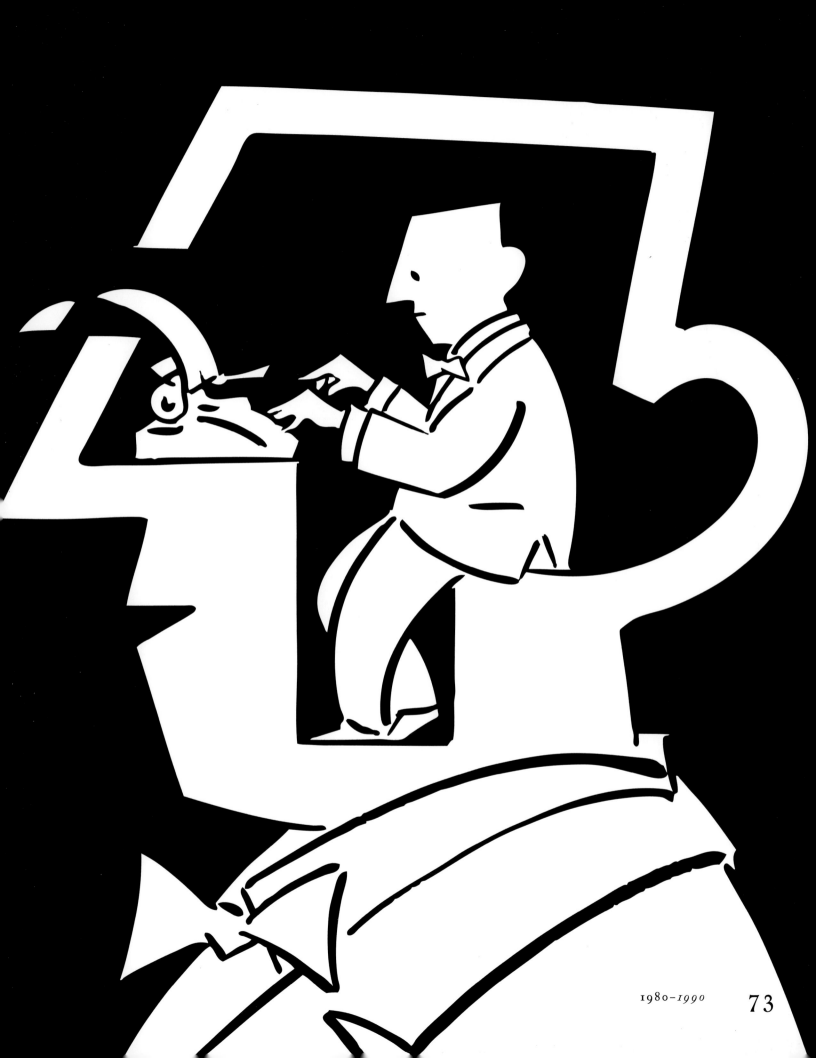

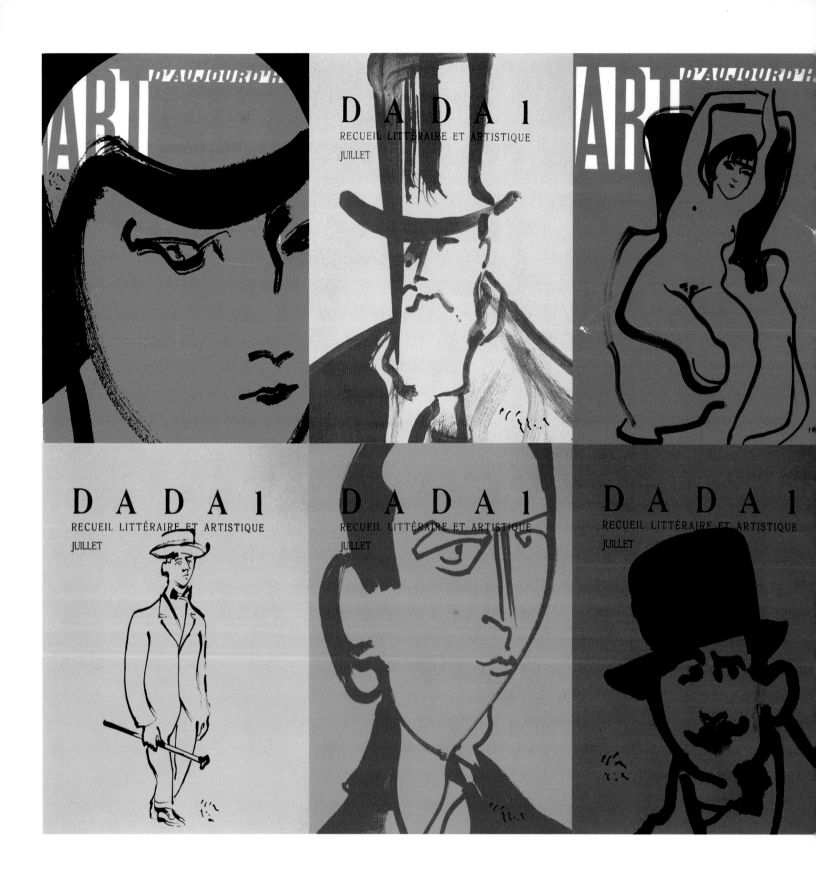

BRIAN GRIMWOOD
THE MAN WHO CHANGED THE LOOK OF BRITISH ILLUSTRATION

How has technology affected illustration? Is it difficult to combine the traditional with the digital?

In the year 2000 I realised that I had to master the computer as an illustration tool so I offered free desk space in my Covent Garden studio to Peter Parker. The deal was that in return he would teach me Photoshop. As someone who is not technologically minded I realised that this was going to be a steep learning curve for me. I seemed to hit a problem every five minutes, but Peter was patient with me and slowly I progressed. Photoshop is THE perfect tool for me. It is like silkscreen printing: each colour is a separate layer and in Photoshop each layer can be tweaked. I used to work out the colours beforehand but now I just go straight in and put them together on the screen. Hue and saturation is my all-time favourite Photoshop tool.

I still work in a traditional way at the start, either with a pen or brush on paper, sticking mainly to an A4 size to accommodate my scanner. I use a lightbox to create my layers, scan them in individually and then play with them on screen. The computer is an incredible graphic tool and I am so happy that I am around to experience it. Every week I seem to learn a new trick.

A selection of personal calling cards, printed by Moo.com.

An image from the WH Auden book.

Opposite: The WH Auden book cover.

Do you work in the same way as when you started, or has this changed over time?

Some parts of the process have changed drastically over the past 30 years, especially since the advent of the computer. When I started illustrating all my work was done on CS10 fashion board. Now most of my work is produced with the constraint of an A4 scanner. But the first and most important part of the process is still to think of an idea that will fulfil the brief. Sometimes it is funny and sometimes not. I enjoyed visual puns a lot in the early days.

I always put my first thoughts down quickly as rough doodles. I've never been interested in using references, nor do I use realistic colours, shadows or perspective. From the start I was aware that whatever I drew, it had to be my own personal vision. I would ask myself how I would draw a cat; how I would draw a car, and so on. We each have a unique way of seeing, and illustration for me was like learning my own visual language. I found that the truer I was to myself, the more the pictures actually reflected the way I looked at the world, my own vision. People used to say that I looked like my pictures. Another observation about my early work was that everything I did had a smile.

Because my style was, and still is, linear it was an obvious progression to fill it with a flat colour. Flat colours became an obsession. I would spend hours mixing and remixing paints. I discovered that if I add a little permanent white gouache to each colour, it helps to blend the colours together and make them lie flat. Another trick is to add a little lukewarm water to the colour mix.

Once I had worked up the doodle, I would trace it onto CS10 board using red carbon paper. Then, with my old post office dip pen, I drew the black line. This line work had some quirky nuances particular to me, often referred to as my "wiggly line".

After I had the line on the board I coloured in the spaces, not unlike painting by numbers (as a child I hated painting by numbers!). When all the painting was complete, I redrew the line. At that time it would take me a day to complete a finished picture. I worked out that it took me around seven years to perfect a style.

Since the computer entered my life the process has changed. Now all my drawings are considered as layers and most of these are no bigger than A4. I still draw or paint the lines in black or white, but now I build up the elements in pieces and put them together on the computer. I can create and send a full-colour illustration anywhere in the world within minutes via email. Most days I produce three or four illustrations.

One downside of the computer is that there is no finished original at the end. The way I compensate for this is by working towards an exhibition of paintings in acrylic on canvas. Painting has become my real passion—recently I have made a series of 'Blues' images (pages 204–207) working in acrylics in a very painterly way then scanning them into the computer.

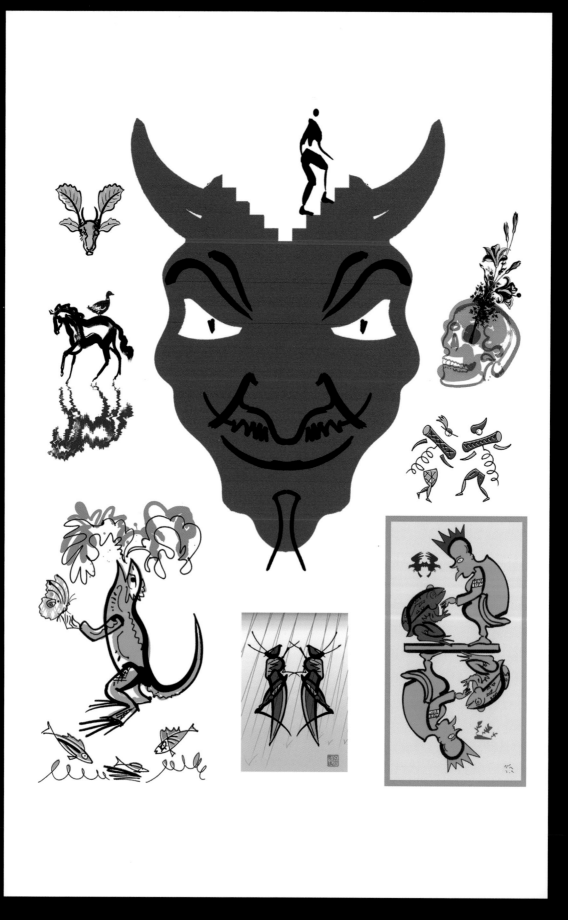

BRIAN GRIMWOOD
THE MAN WHO CHANGED THE LOOK OF BRITISH ILLUSTRATION

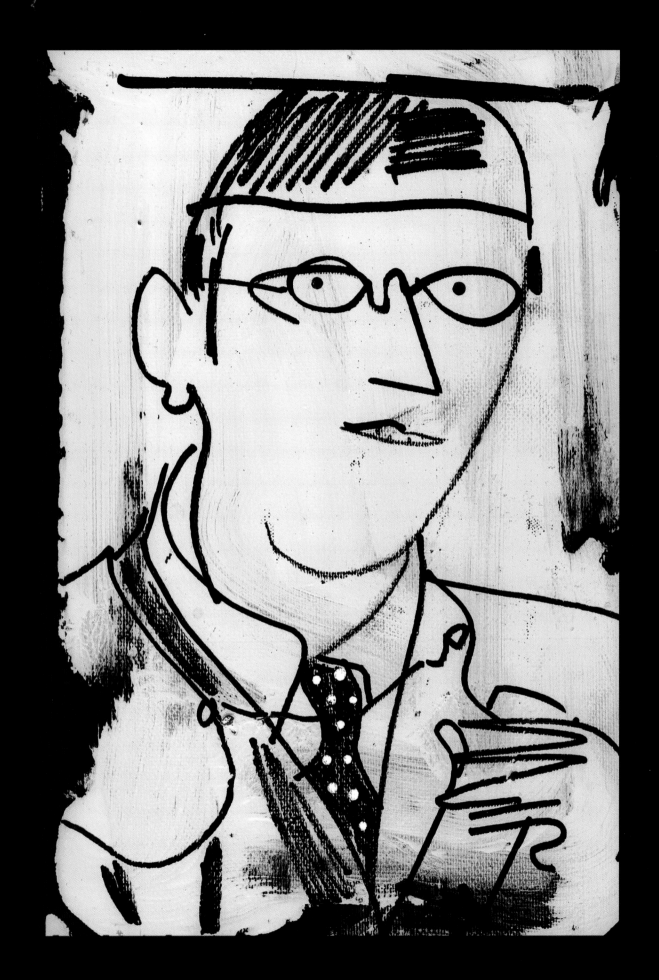

Do you enjoy working with some media (ink, watercolour, pencil, computer) more than others? Do you stick to particular 'favourite' colours?

When working on the computer I originate all the layers in black and white. Sometimes I use brush and paint, sometimes a black pen. In the early days I used an old dip pen 'borrowed' from the local post office.

In the late 1980s, after working only with flat colour, I became interested in texture. For my painting exhibitions I worked with acrylic on stretched canvas as it produced more textured experiments. During the 1970s I worked mostly in pastel tones. It became my trademark. Slowly I started to understand colour. Sometimes I would play by restricting the colour palate to see what would happen. After a few years of using mainly pastel colours, I decided to go darker. I remember at one time the colourways in carpets had a big influence on the way I put colours together. My experience mixing colours with paint has helped enormously when playing with colour on the computer.

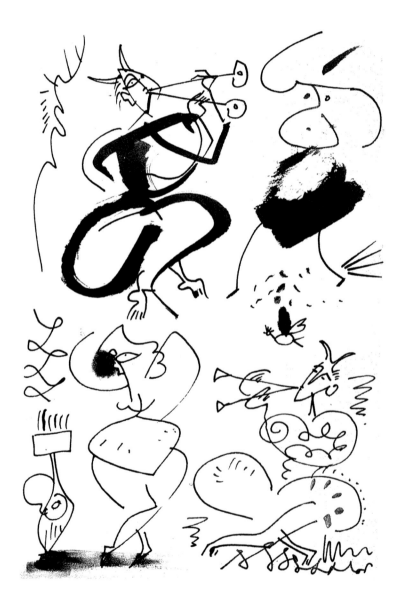

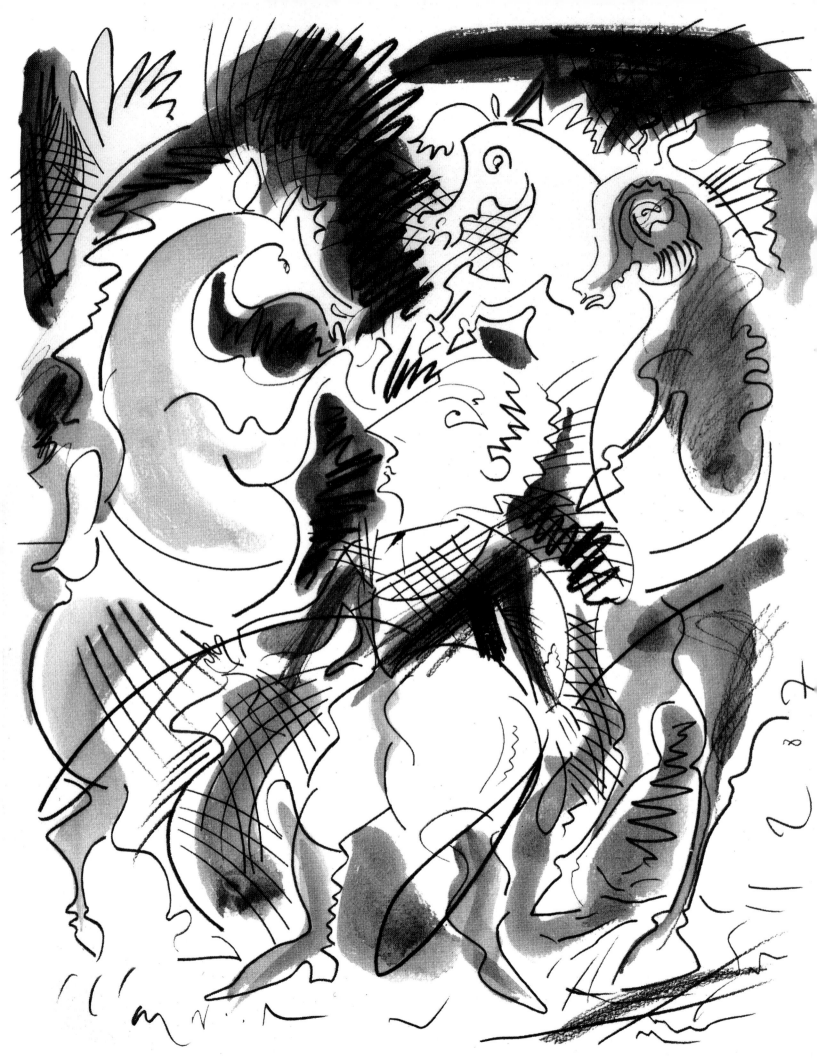

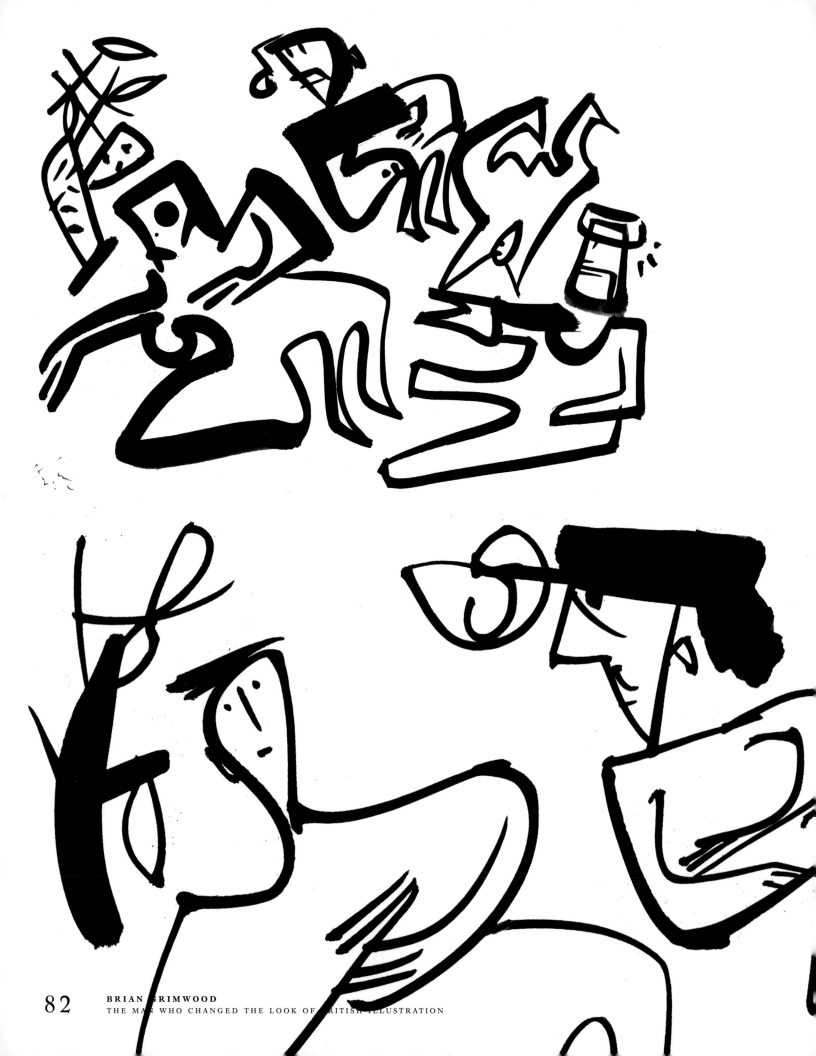

BRIAN GRIMWOOD
THE MAN WHO CHANGED THE LOOK OF BRITISH ILLUSTRATION

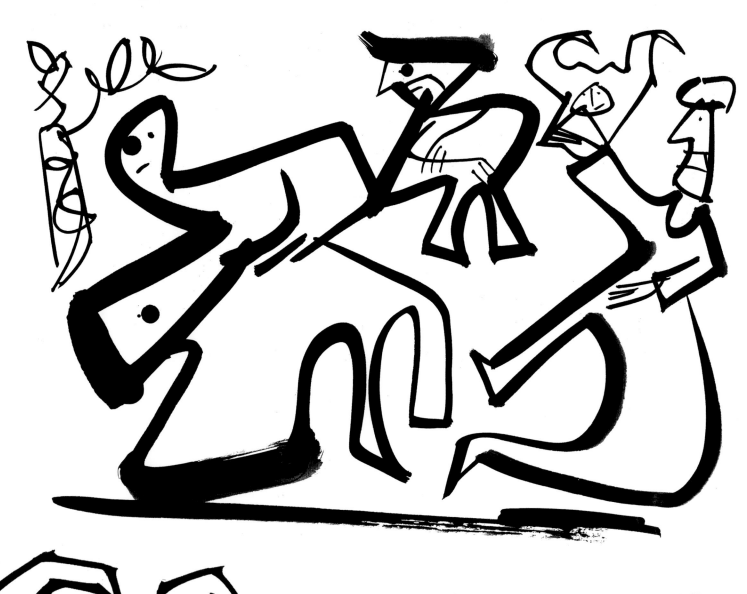

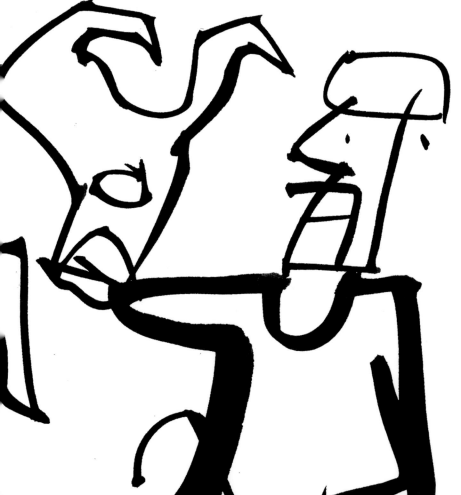

These drawings were done for Hankle Tissue, a Swiss kitchen roll manufacturer. The drawings appeared as they are here, in two colours, on every sheet of the kitchen roll, and on the packaging.

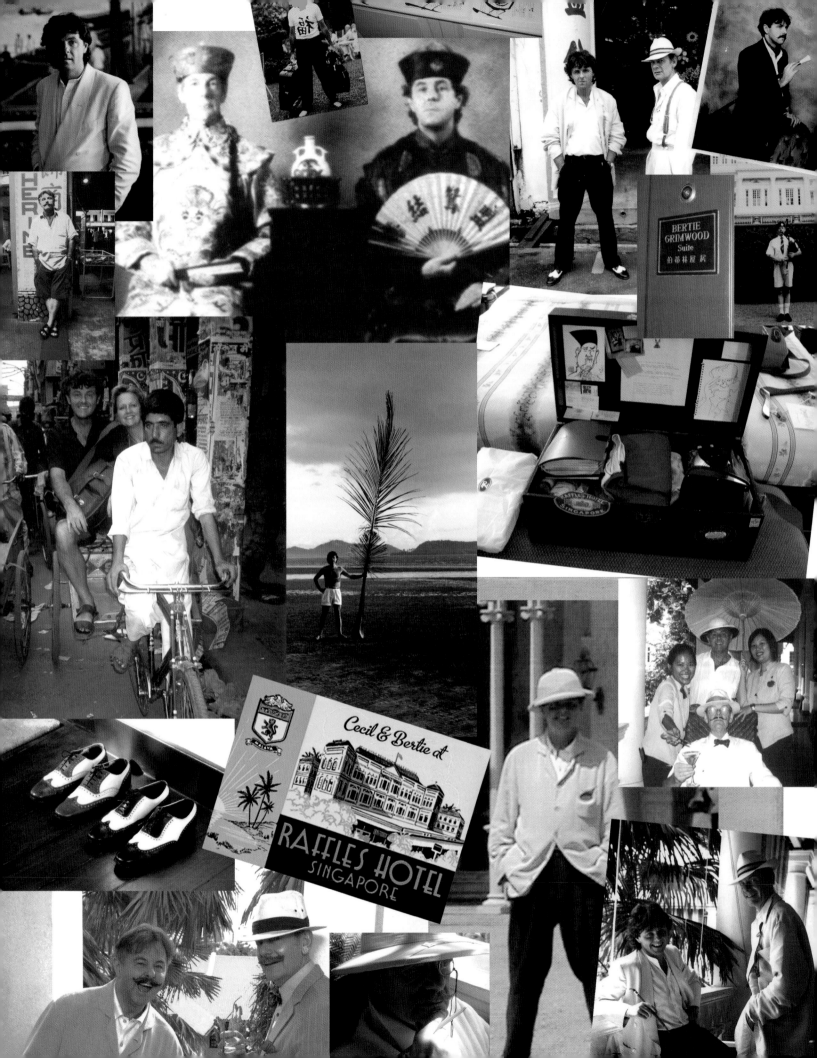

What inspires you?

Travelling inspires me, especially in the Far East. I go to Singapore on a regular basis, staying at the wonderful Raffles Hotel since I designed all their new merchandising when it was refurbished in the early 1990s. Visiting Japan is like going to another planet. I love the look of it, especially the food and the packaging. I always enjoy a trip to New York and go there often as the CIA is affiliated with B&A Illustration Agency. I visited China recently and was knocked out by their book cover designs.

I find that travelling influences my work as well as inspiring and refreshing me. It frees up my imagination and subconsciously I take new things on board. Always when I go away I send postcards. I take blank postcard-size watercolour paper and paint or draw something reminiscent or where I am. Over the years friends have collected them and one friend has even suggested having an exhibition one day.

I am a big fan of outsider art; people like Mose Tolliver, whose work I have in my collection, Howard Finster, Alfred Wallace, Sam Doyle, RA Miller, Bill Traylor and Carlo Zinnelli are all inspiring.

The interior of my suite (room 233) at Raffles Hotel in Singapore.

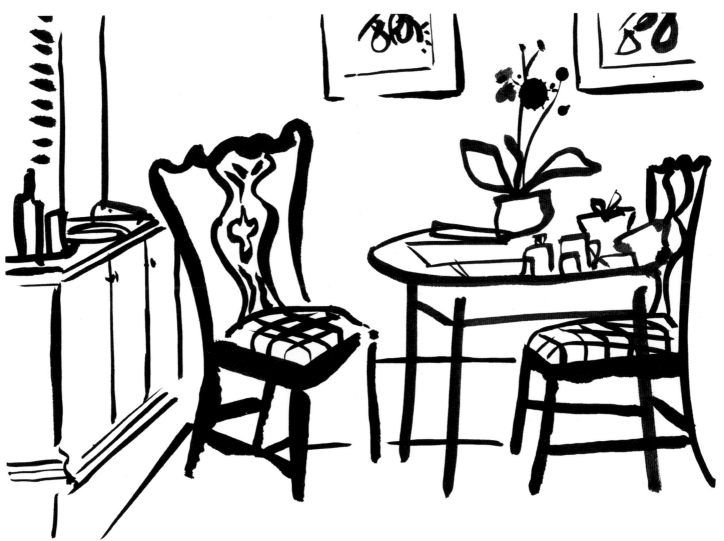

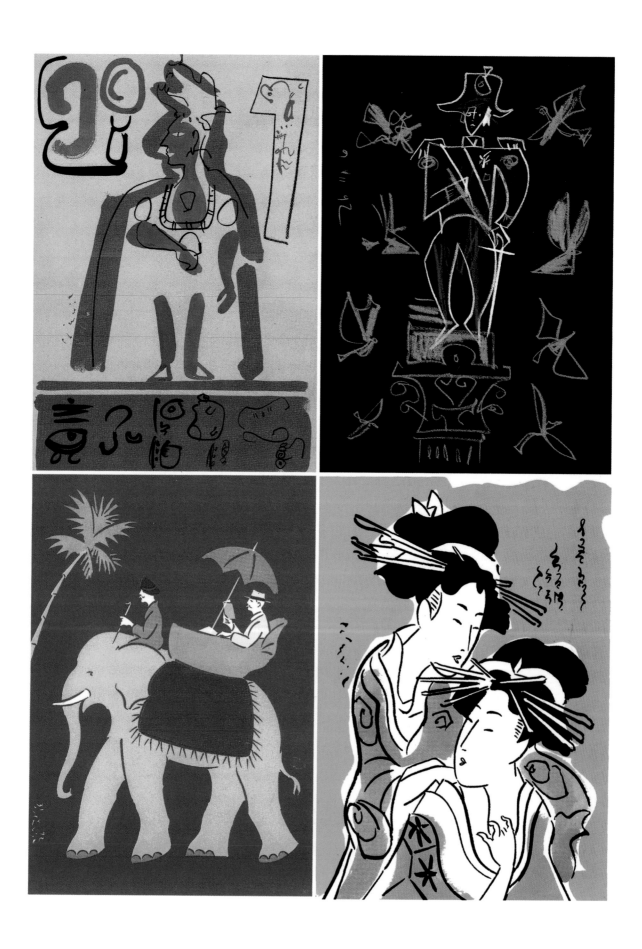

BRIAN GRIMWOOD
THE MAN WHO CHANGED THE LOOK OF BRITISH ILLUSTRATION

1990–2000

Do you carry a sketchbook to jot down ideas?

I have always had a sketchbook on the go since I was a little boy and I have kept a visual diary since 1975. At first this existed mainly as an ideas notebook but I also recorded the surreally fantastic images that could spring into my mind at any time. For example, I once watched a woman in a bar exhaling cigarette smoke but I drew her blowing out a cloud of butterflies. Another time I was driving along a motorway when I noticed some sandbags along the side of the road. They looked like turtles and that is what I drew. I have probably filled over 50 sketchbooks and they are a great record to look back on. Now I use my sketchbook more as a visual journal. After a meal out I like to sketch the person I have dined with. I draw all the time....

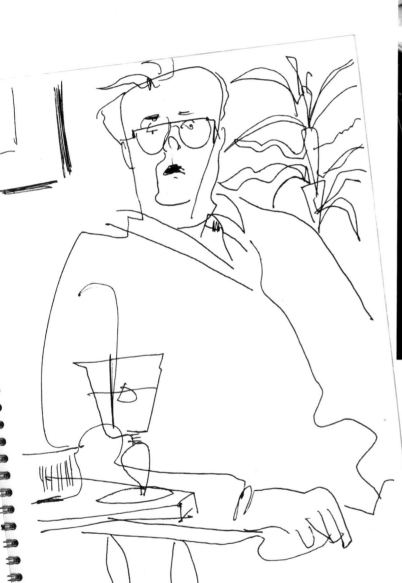

Do you have different styles for different jobs?

The problem dictates the solution, and the solution dictates the style. I have eight or nine different ways of working. Fortunately I am told that they all look like my work.

Apart from when I was first getting started, style has never interested me. I see style as repeating one's successful accidents. It is always the idea that has been important to me.

BRIAN GRIMWOOD
THE MAN WHO CHANGED THE LOOK OF BRITISH ILLUSTRATION

A bag design for a Parisian boutique.

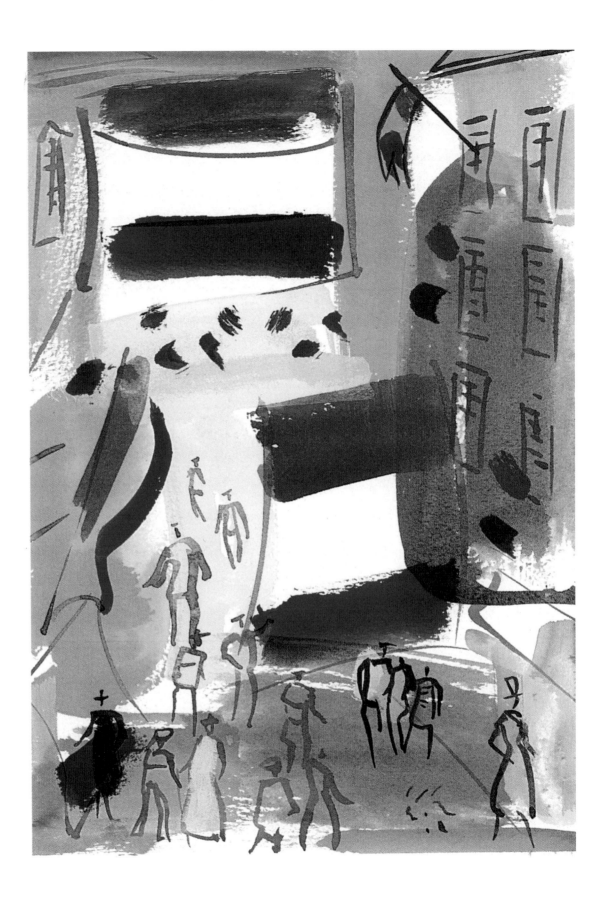

From a range of greeting cards
based on cats.

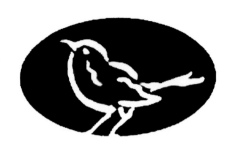

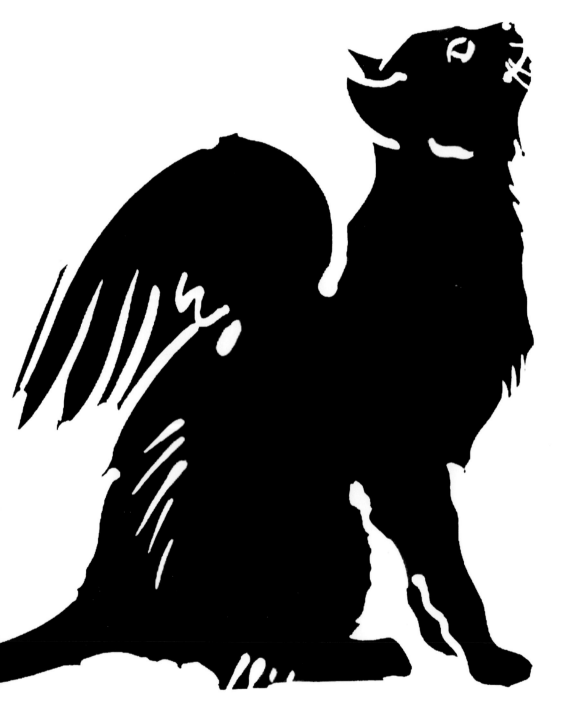

BRIAN GRIMWOOD
THE MAN WHO CHANGED THE LOOK OF BRITISH ILLUSTRATION

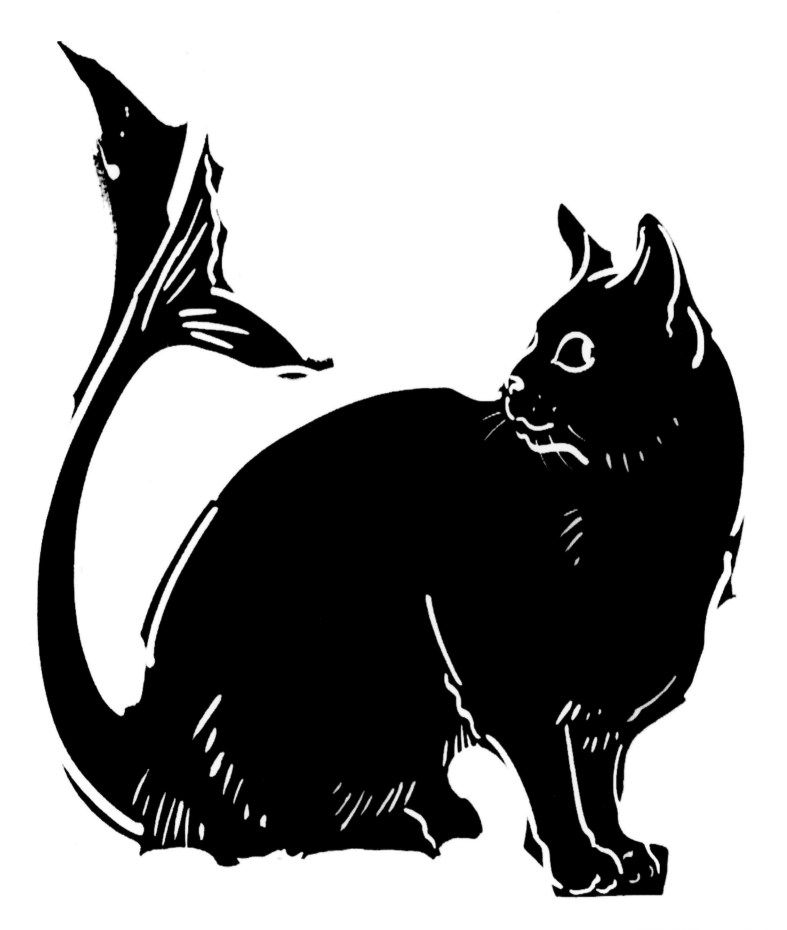

How long does it take from concept to finished work?

I split myself into three different people. There is the person who comes up with the ideas (usually at night, so I sleep with a notepad beside my bed). Then, during the day I draw up the ideas, continually experimenting on the computer. I can produce up to ten different compositions and colourways per illustration. And then I'm the person who promotes what I do.

But to answer your question, it varies depending on how long it takes me to come up with the illustration idea. Once I have the concept worked out I can produce finished artwork within an hour. In the days before email, rumour had it that I would order a courier to pick-up before I even started a job.

OPPOSITE: My grandparents had a monkey, Joey, as a pet. This is Joey's portrait.

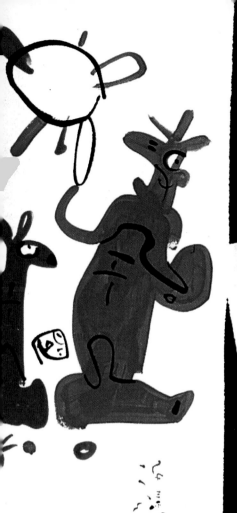

BRIAN GRIMWOOD
NEAL STREET
LONDON WC 2
UNITED KINGDOM
ROYAUME UNI

.9 SEP 1994 4 8 P 10 PCY

MAD

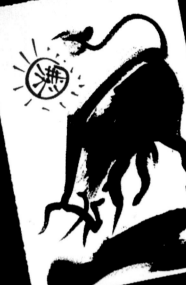
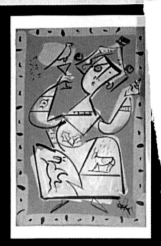
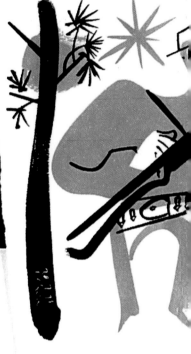

ROYAL
NATIONAL
THEATRE

COLM
TÓIBÍN

W H SMITH
WILLOW
CHARCOAL
20 MEDIUM
STICKS

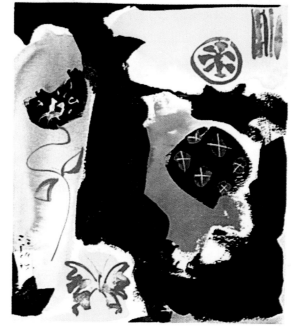

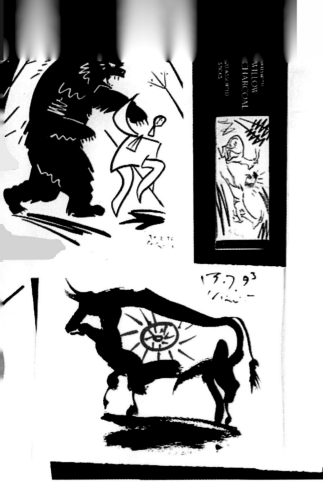

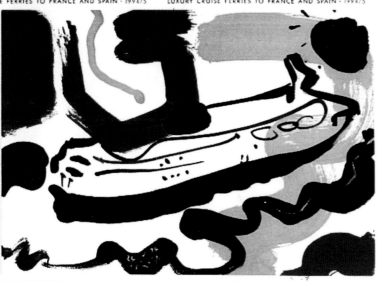

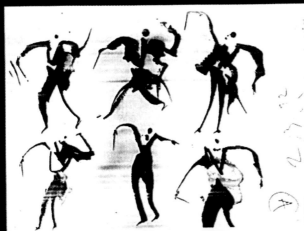

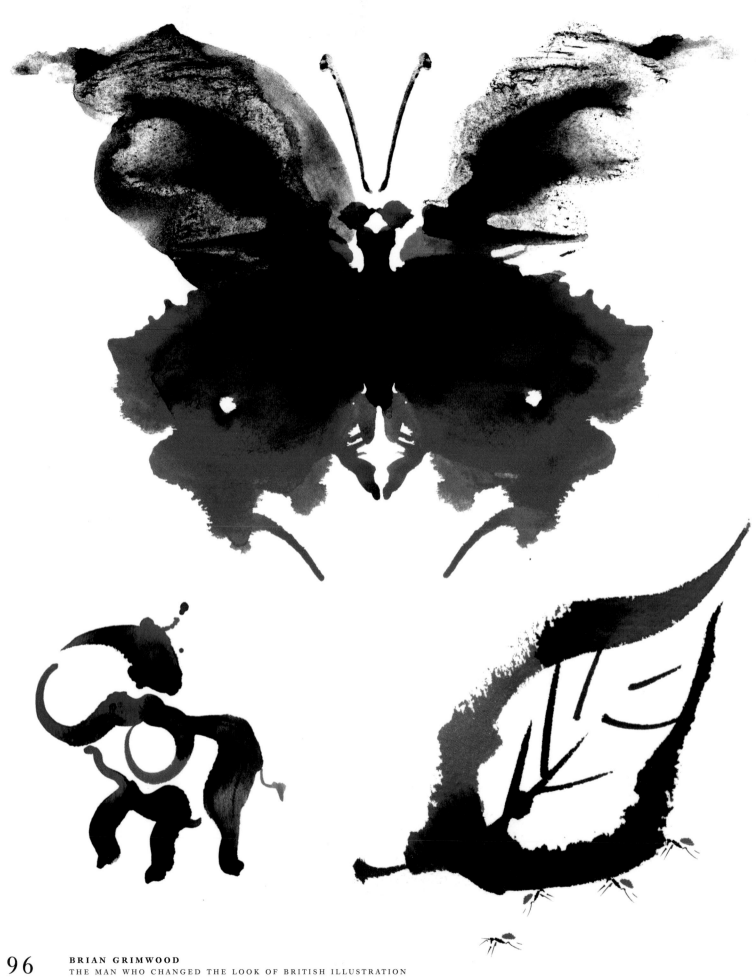

BRIAN GRIMWOOD
THE MAN WHO CHANGED THE LOOK OF BRITISH ILLUSTRATION

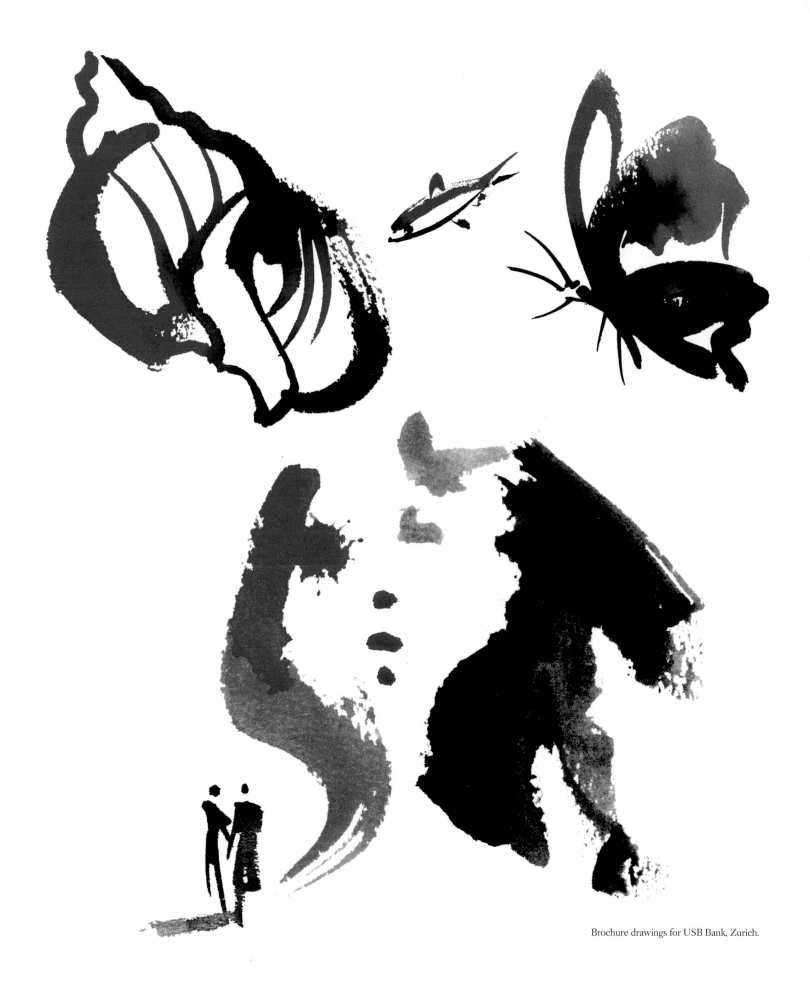

Brochure drawings for USB Bank, Zurich.

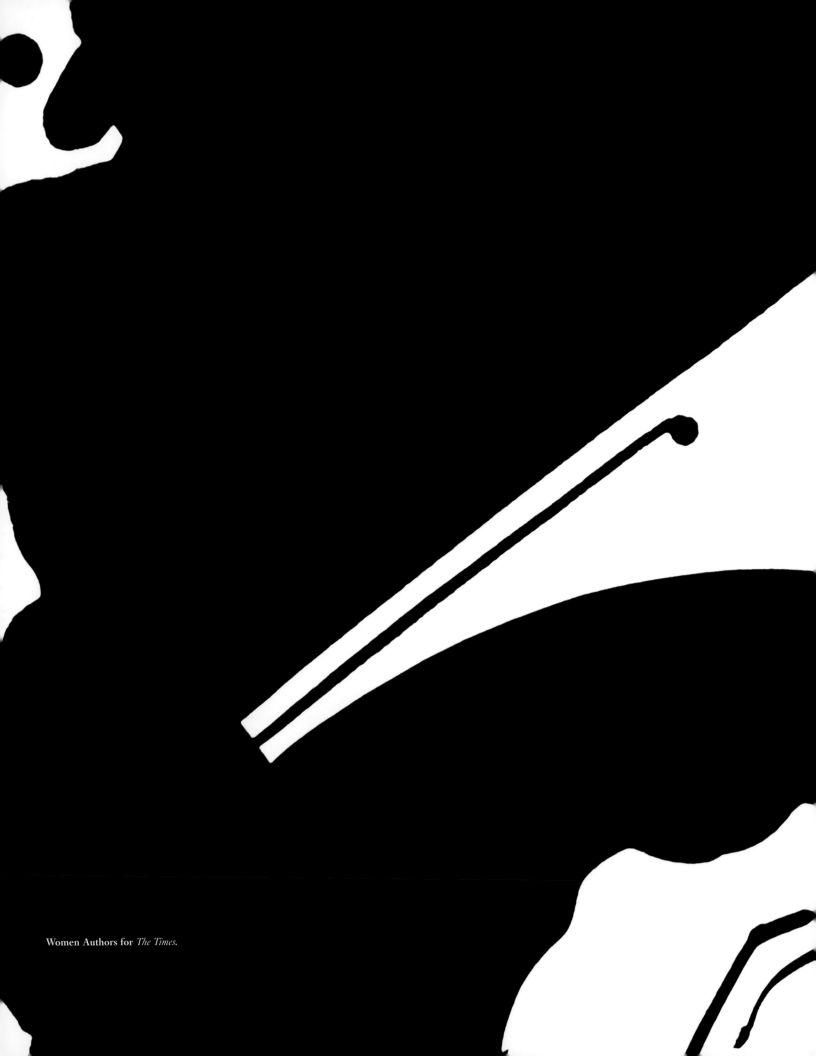

Women Authors for *The Times*.

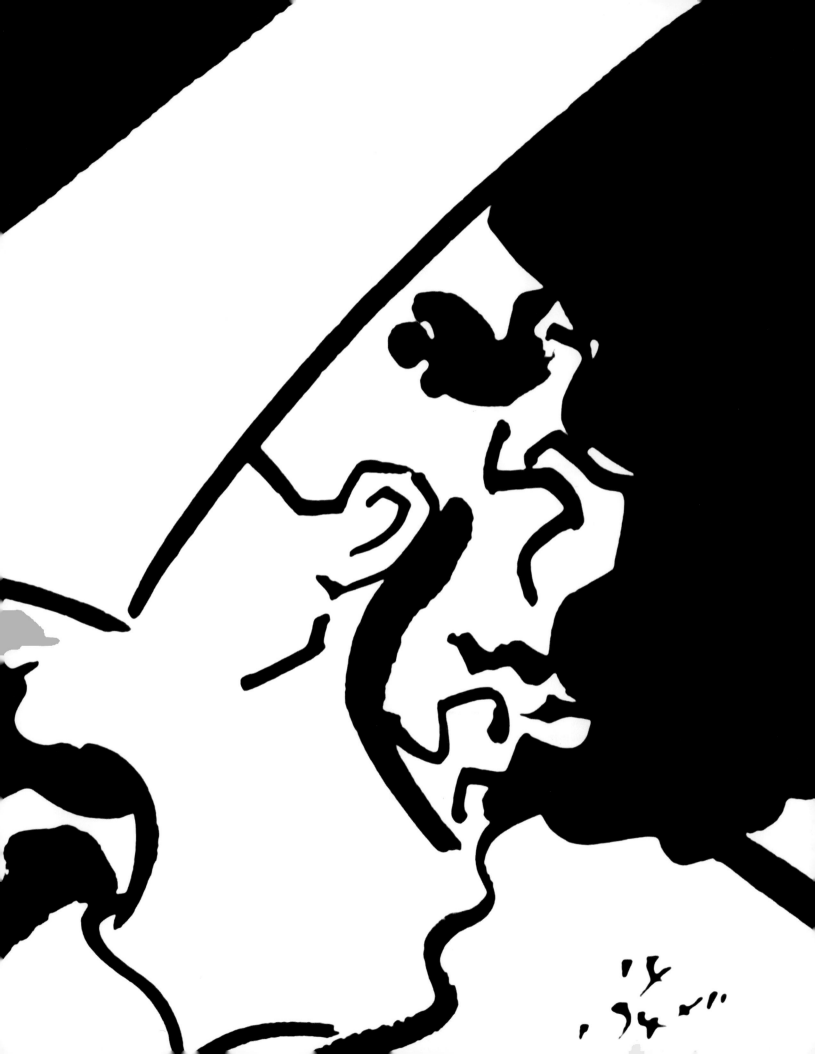

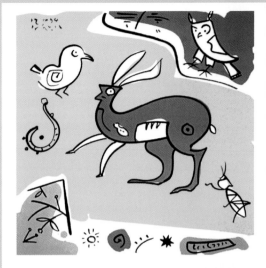

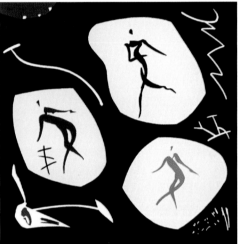

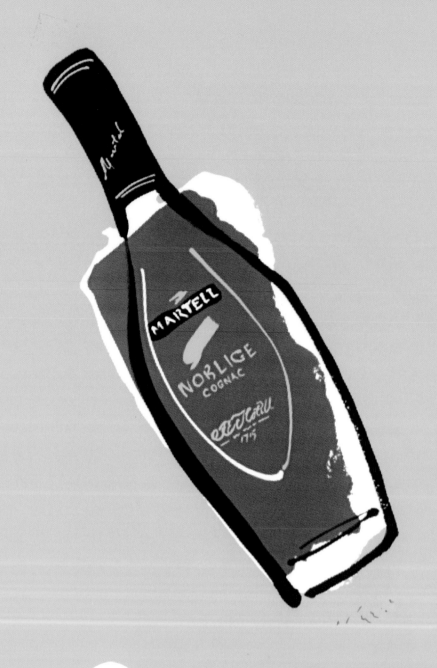

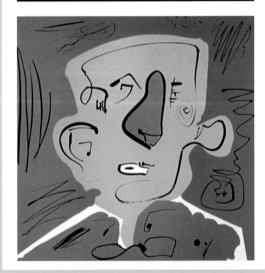

If you could redraw one of your earlier works, which would you most like to redraw?

Funnily the 'Stereo Lady' (see page 23). It was the first illustration I ever did. Originally drawn as a sample for my portfolio it was inspired by an article in *Nova* magazine, I later made a screen print of it which sold out. About ten years ago I tried to revisit it as a picture but found that I could not improve it. Somehow the style and idea were from another time.

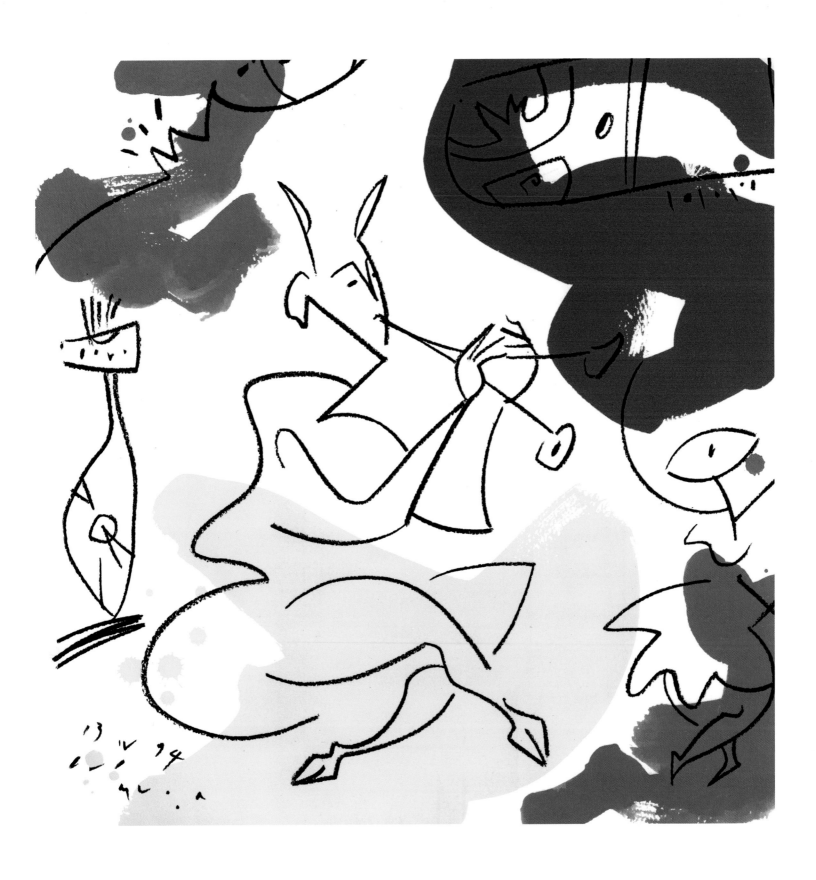

A series of silk head scarves to promote
Martell brandy.

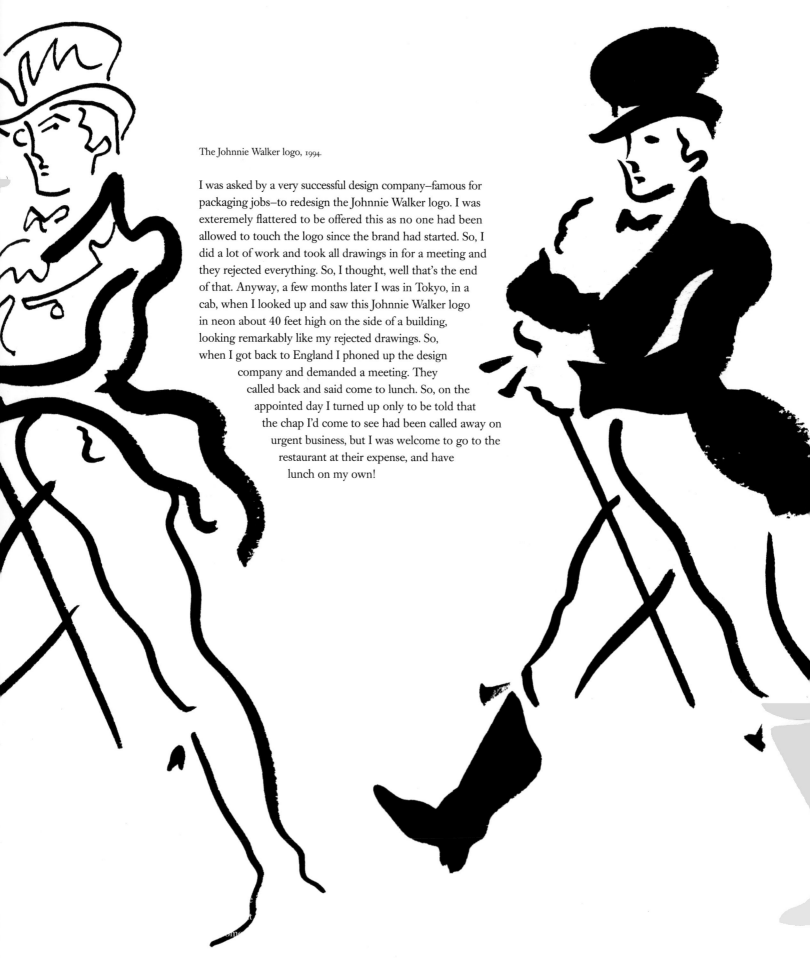

The Johnnie Walker logo, 1994.

I was asked by a very successful design company–famous for packaging jobs–to redesign the Johnnie Walker logo. I was exteremely flattered to be offered this as no one had been allowed to touch the logo since the brand had started. So, I did a lot of work and took all drawings in for a meeting and they rejected everything. So, I thought, well that's the end of that. Anyway, a few months later I was in Tokyo, in a cab, when I looked up and saw this Johnnie Walker logo in neon about 40 feet high on the side of a building, looking remarkably like my rejected drawings. So, when I got back to England I phoned up the design company and demanded a meeting. They called back and said come to lunch. So, on the appointed day I turned up only to be told that the chap I'd come to see had been called away on urgent business, but I was welcome to go to the restaurant at their expense, and have lunch on my own!

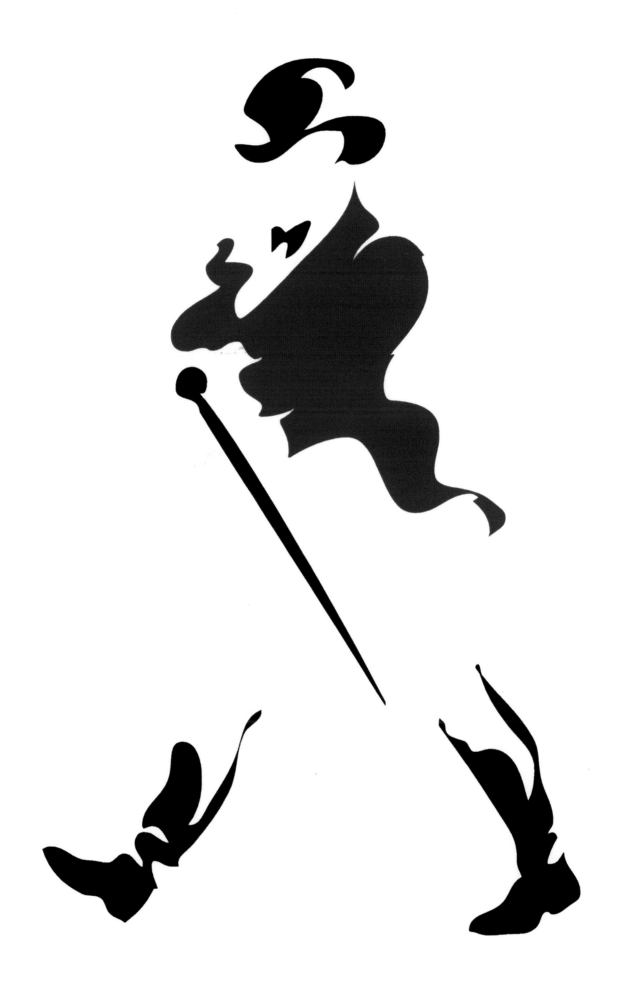

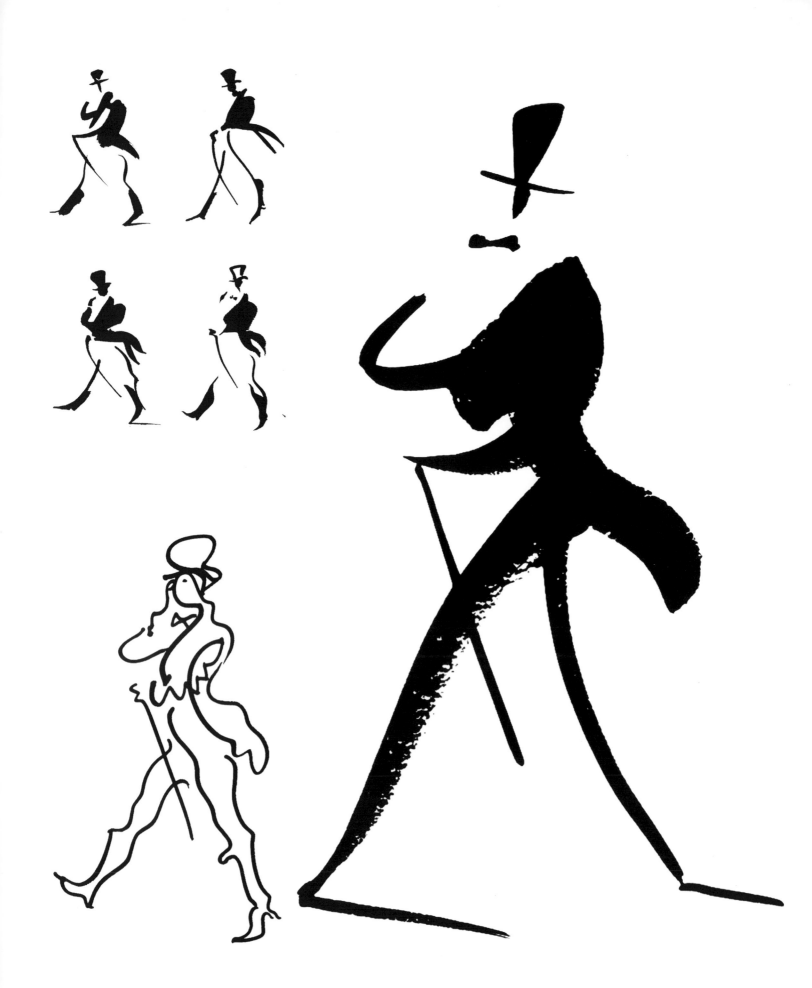

BRIAN GRIMWOOD
THE MAN WHO CHANGED THE LOOK OF BRITISH ILLUSTRATION

How do you present ideas to your clients when your finished pieces are so spontaneous?

I rarely do roughs. I usually produce several versions of my idea and generally art directors are pleased to be given this choice. Sometimes I work up two or three versions at the same time, questioning the composition and colour as I go.

OPPOSITE: Some of the many drawings done to develop the Johnnie Walker logo.

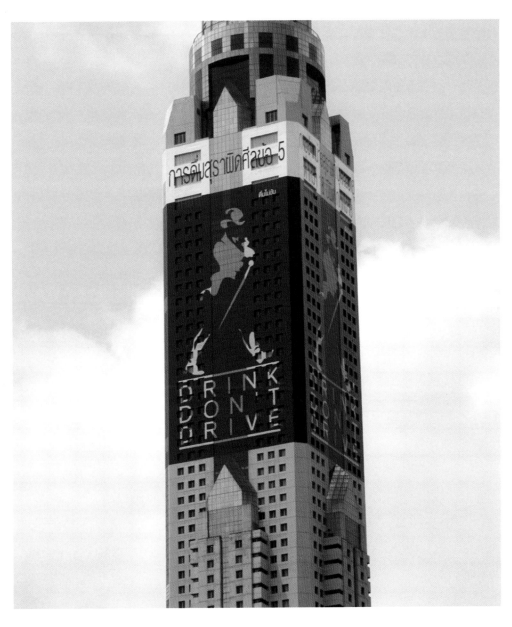

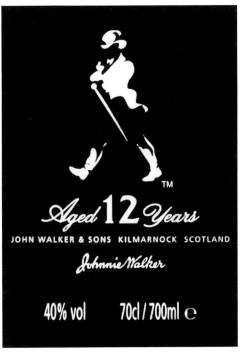

Drawings for a commission from Peter Saville at Pentagram Design for proposals for the redesgn of the logo for leather goods company Mandarina Duck. They were never used.

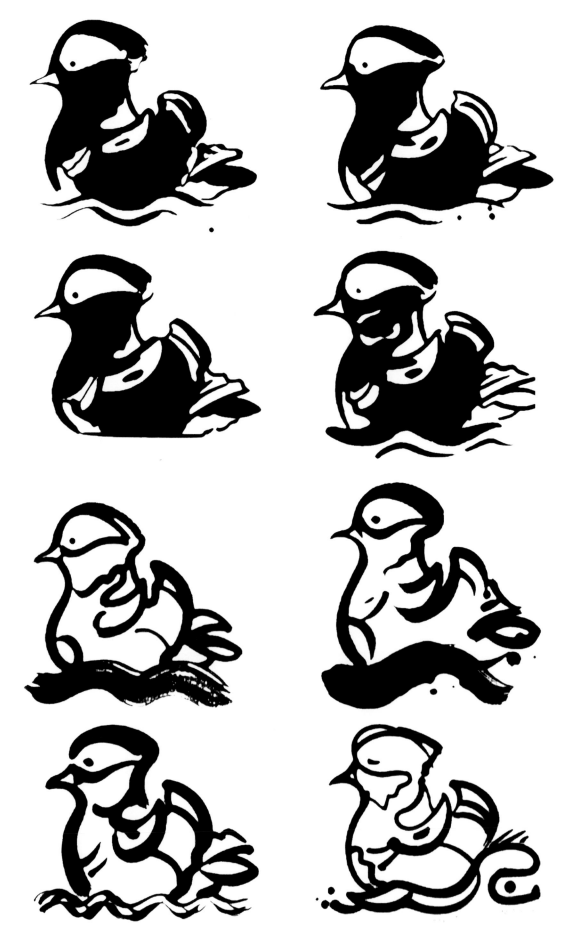

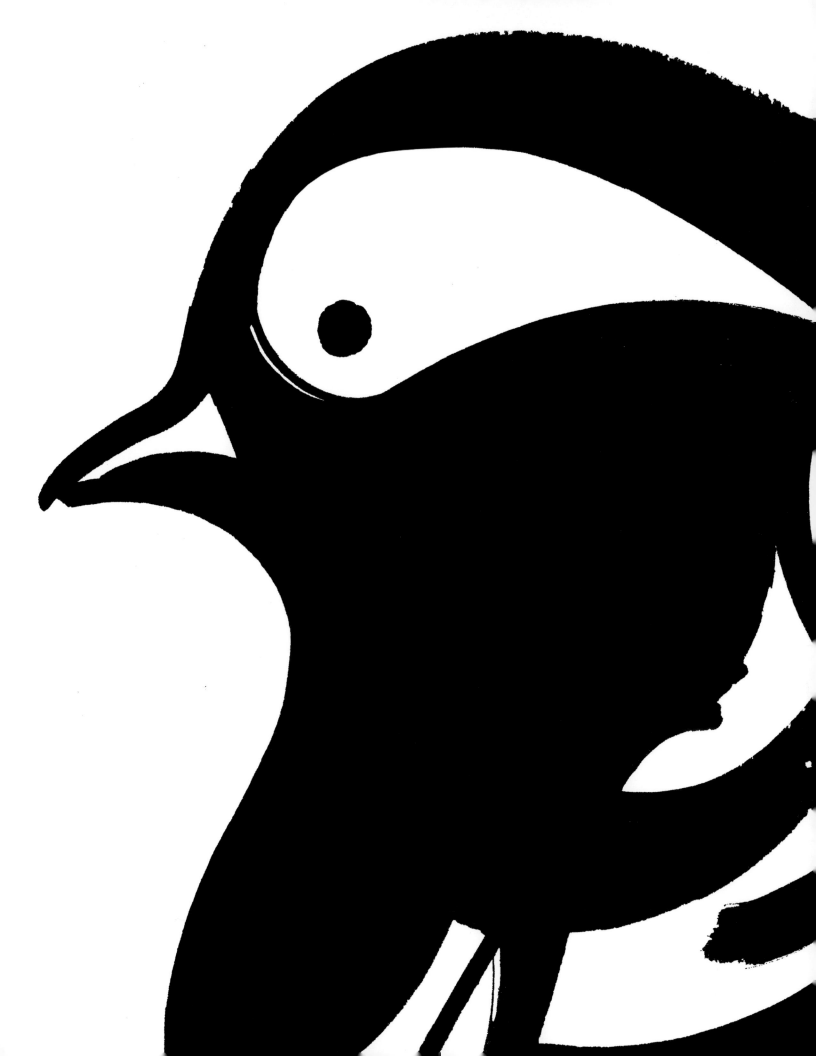

Do you work on several projects at once?

At any one time I am working on six or seven projects. I usually have three or four illustration jobs on the go as well as working on my own personal work. I love painting and it is not unusual for me to start a painting late at night. I have a butterfly personality and like to flit from one thing to another. I am always surrounded by books that can send me off on any train of thought. And, of course, I am also responsible for the CIA and many of the decisions required there.

Singer Songwriter.

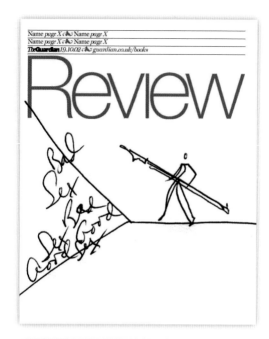

Naughty Novels.

Opposite: A page from a book published
in Germany about exotic smells.

What has been your greatest professional disappointment?

I was asked by the designer Richard Ward to propose some ideas for the packaging of *The Beatles Anthology*. I was in good company: other artists asked to submit work were David Hockney (apparently he was too busy at the time), Humphrey Ocean, who had toured as the resident artist on McCartney's Wings over America Tour, and Klaus Voorman, who illustrated the *Revolver* album cover. I produced 16 paintings, roughs and ideas. Unfortunately for me Klaus won the job. Apparently it was worth £100,000; but more than the money, I would have love to have been involved. Although I never got to work for the The Beatles I did the portrait of George Harrison for his *Live in Japan* album and one year I produced a Christmas card for Paul McCartney.

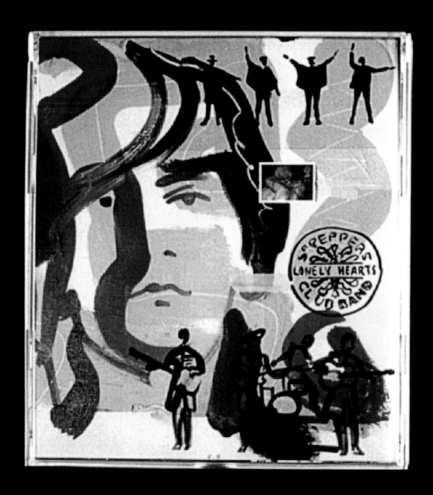

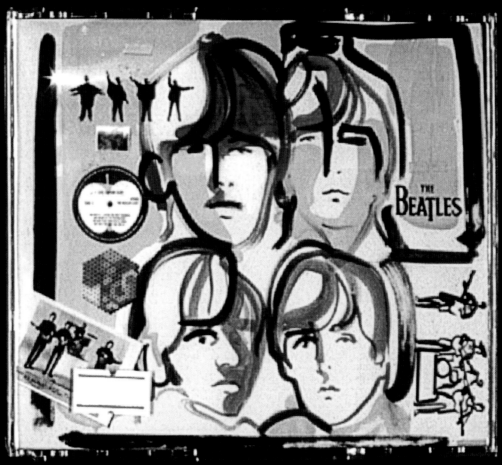

A clock design for a Formica promotion.

OPPOSITE: An article about Mexico.

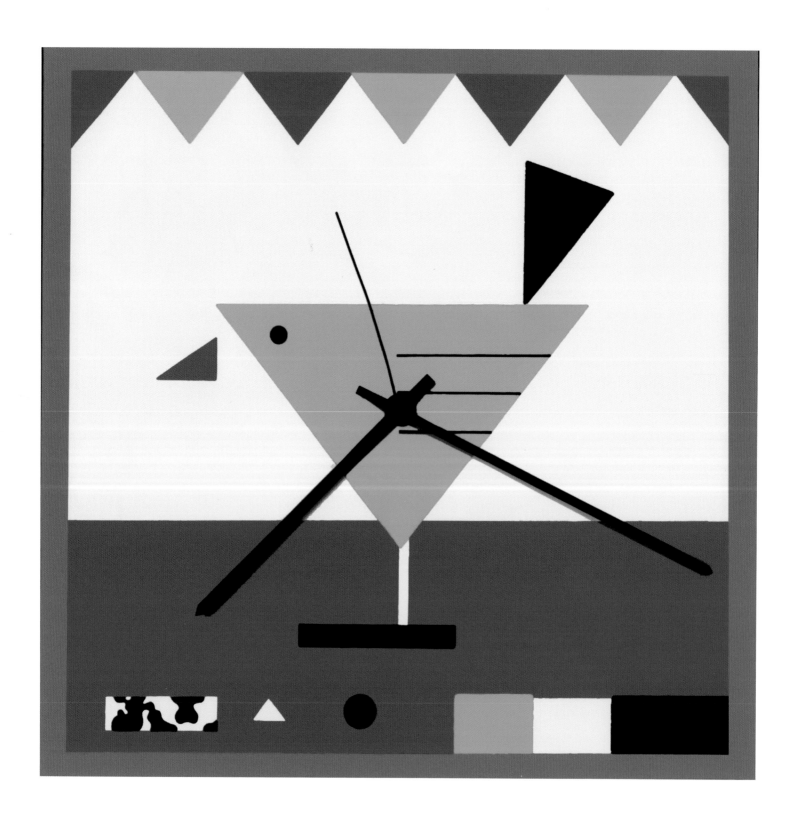

BRIAN GRIMWOOD
THE MAN WHO CHANGED THE LOOK OF BRITISH ILLUSTRATION

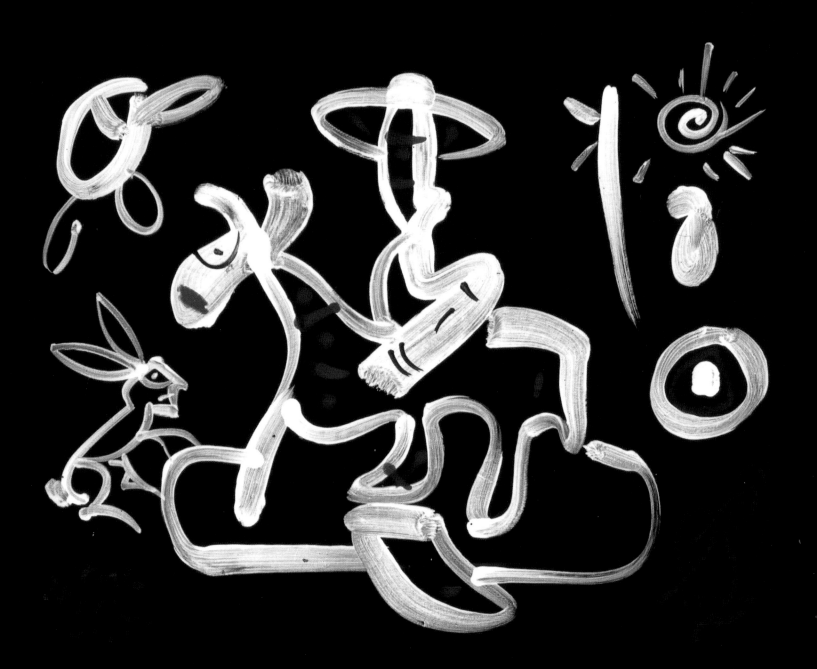

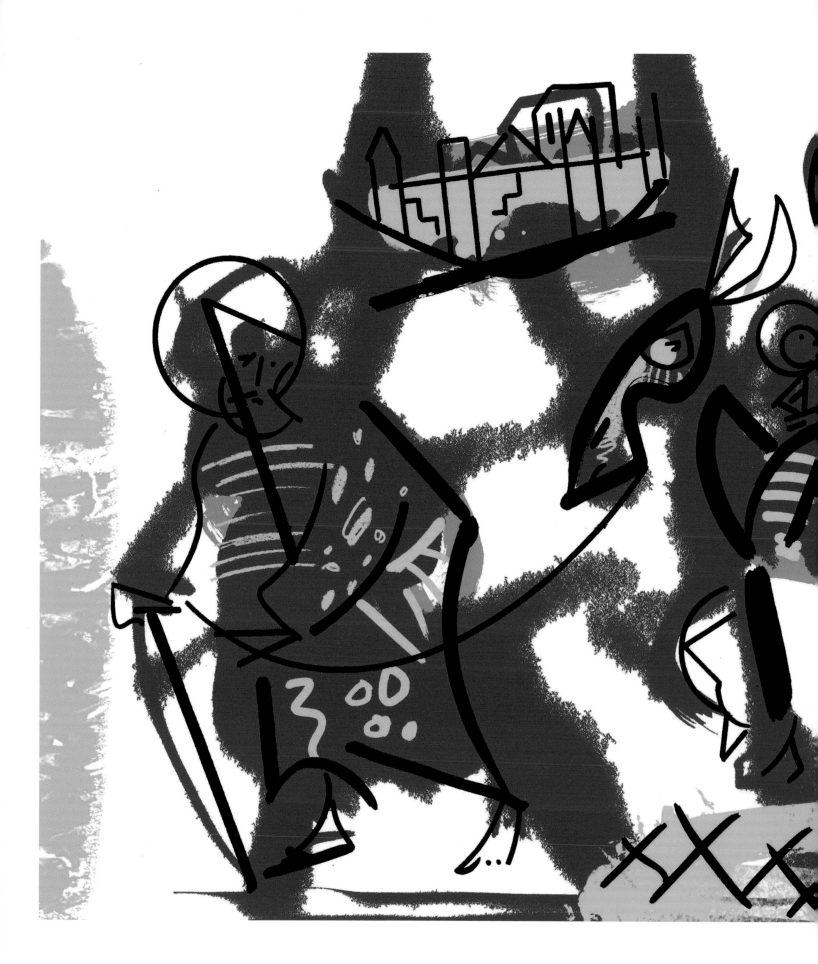

BRIAN GRIMWOOD
THE MAN WHO CHANGED THE LOOK OF BRITISH ILLUSTRATION

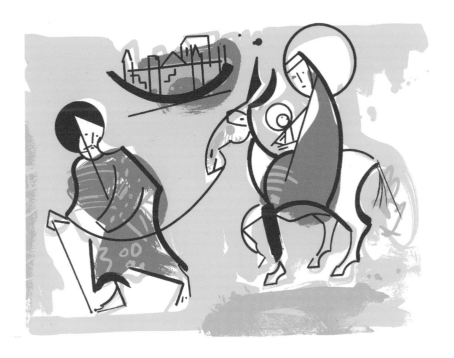

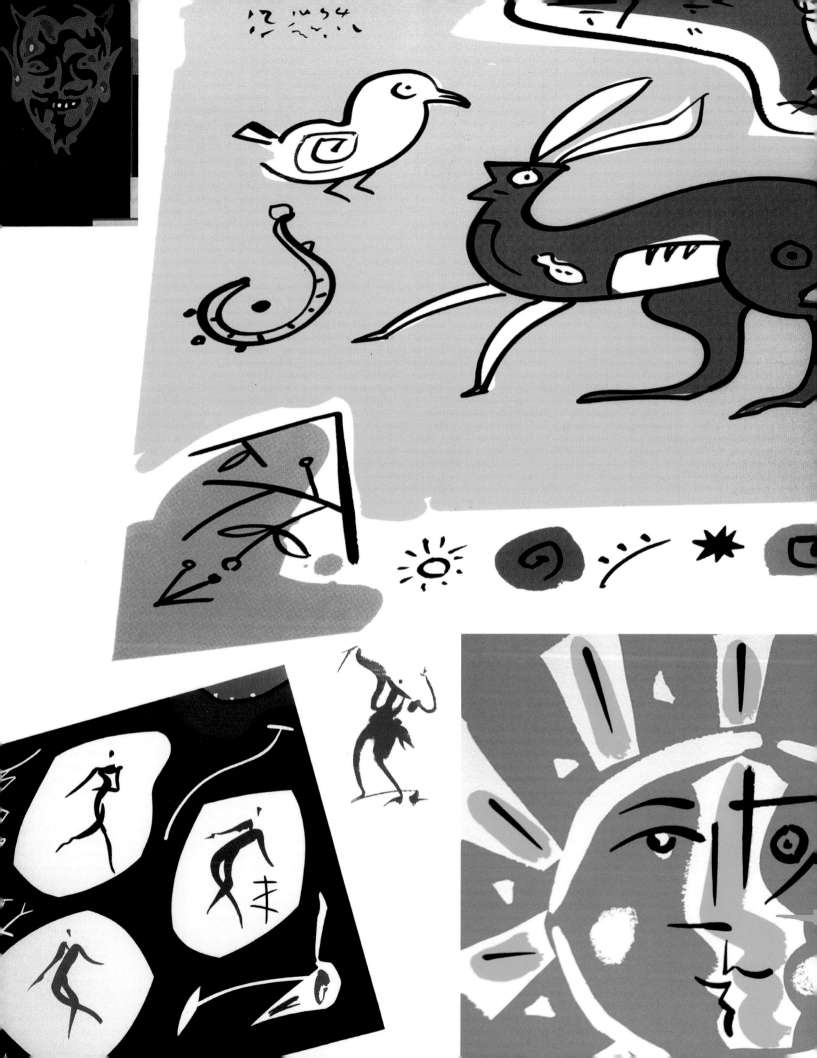

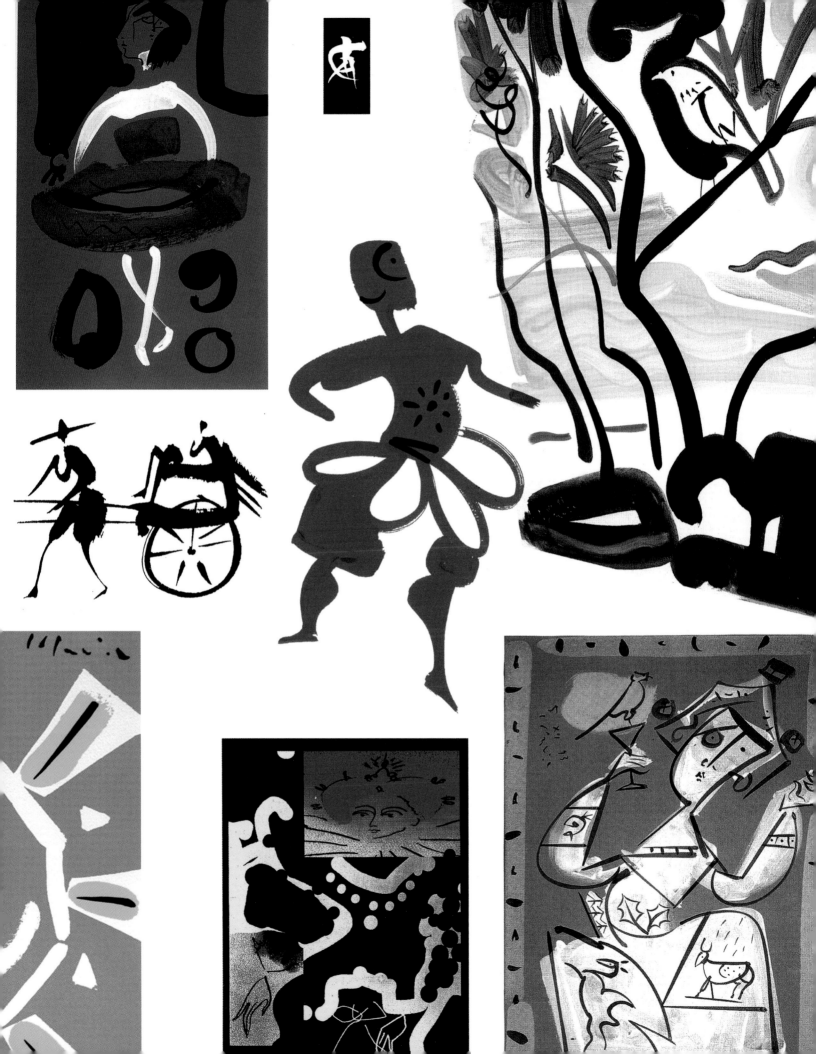

BRIAN GRIMWOOD
THE MAN WHO CHANGED THE LOOK OF BRITISH ILLUSTRATION

W

hat's your best kind of commission?

The best commission is when I am left entirely with the responsibility to solve the problem. Usually this is the case.

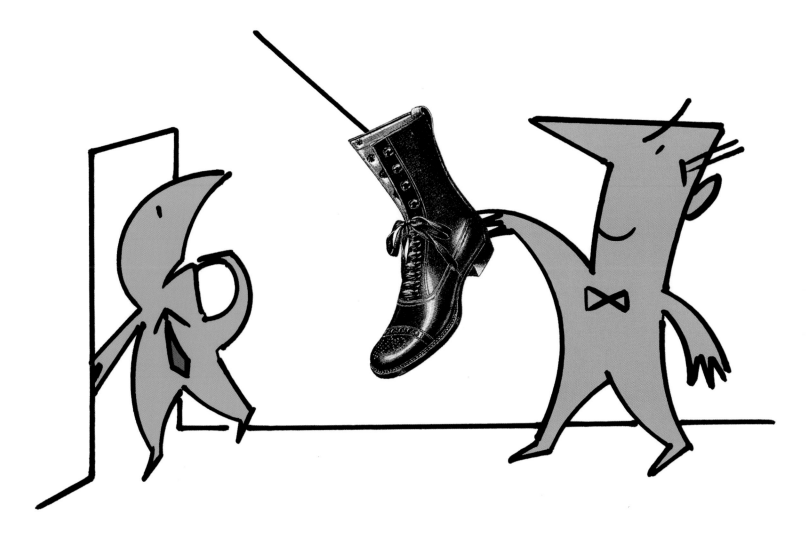

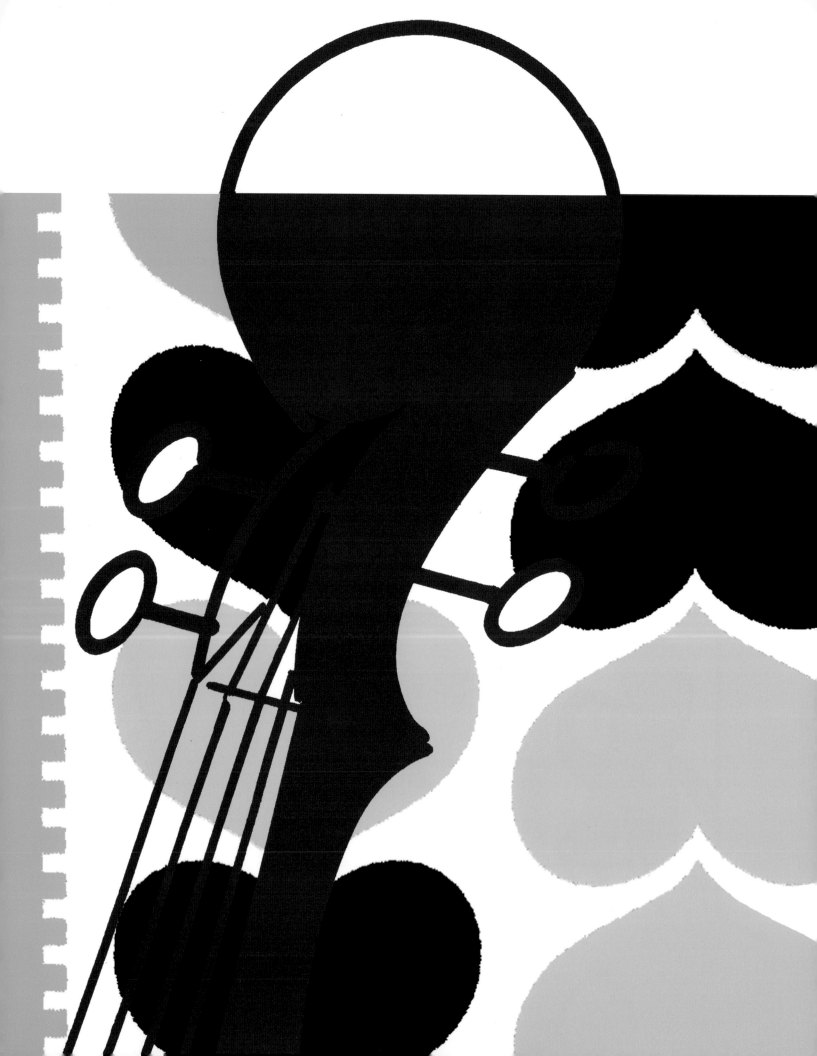

OPPOSITE: A bag idea for the Proms.

RIGHT: The bag idea used.

BELOW: Mouse mat for the Proms.

PROMS
18 JULY – 13 SEPTEMBER 2003

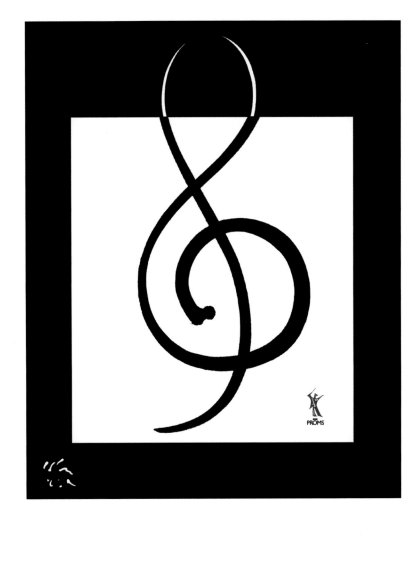

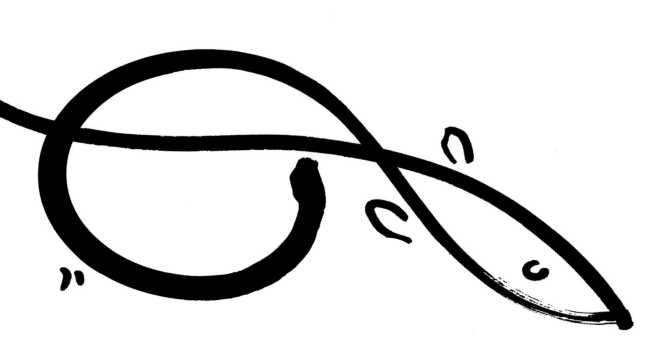

BRIAN GRIMWOOD
THE MAN WHO CHANGED THE LOOK OF BRITISH ILLUSTRATION

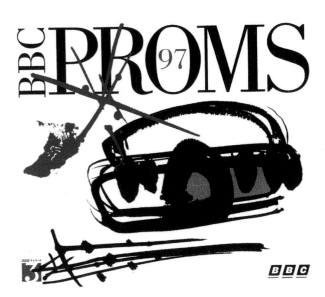

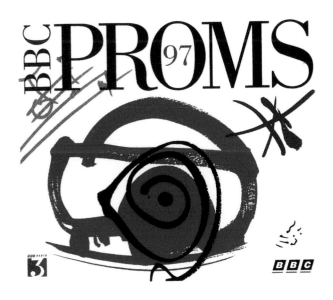

What advice would you give to an illustrator just starting out?

I believe in the maxim "Fake it till you make it". Think big, be confident, draw in a way that is honest to you. Whatever it takes, make sure that your work looks good and is exciting. Be influenced, reflect the time that you are in. Do your homework to find out who the best people are to approach. Show that you are willing, flexible and reliable. Develop a thick skin and bully art directors into using illustration. Try never to leave a building without getting a job.

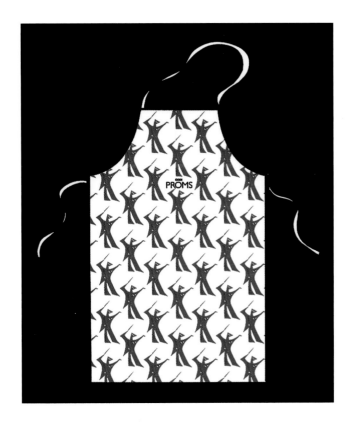

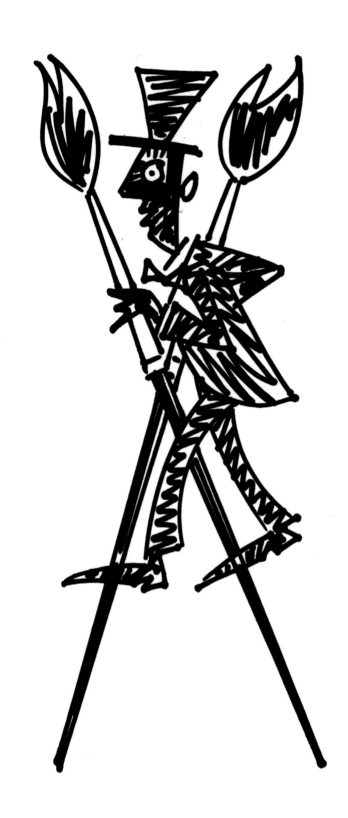

BRIAN GRIMWOOD
THE MAN WHO CHANGED THE LOOK OF BRITISH ILLUSTRATION

2000–
Present

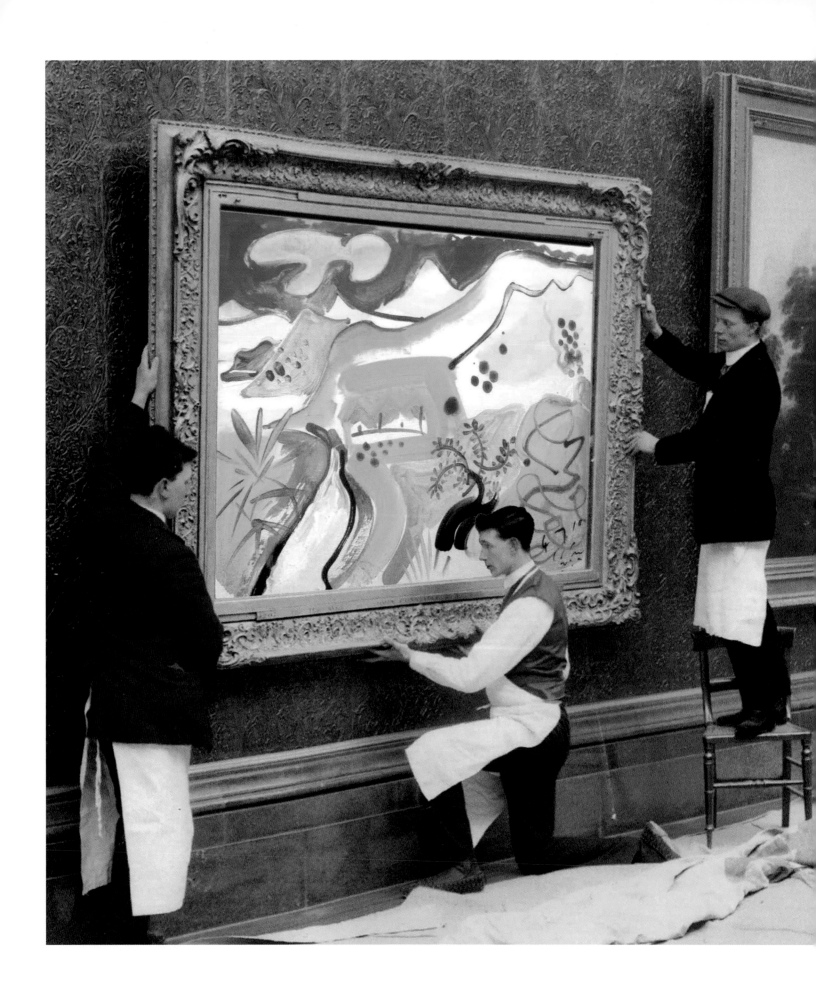

BRIAN GRIMWOOD
THE MAN WHO CHANGED THE LOOK OF BRITISH ILLUSTRATION

Of your contemporaries, whose work do you admire?

This could be a long list as I am such a big fan of illustration, and of course I see a lot of work as Director of The Central Illustration Agency.

Seymour Chwast: One of the founder members of Push Pin Studios. I can relate to his linear style and, in my formative years, his use of flat colour.

Nelly Dimitranova: A special young lady I met 20 years ago when she had just arrived from Bulgaria. A great artist.

Christopher Corr: Over the years I have had the great pleasure of working alongside him, actually working together on the same canvases. The results produced some of the best work I have been involved with–like playing jazz. I rate Chris very highly. He is a wonderful colourist with a unique vision.

Alfred Wallace: An old Cornish man who did wonderful child-like paintings. Based in St Ives, he said he painted for company, and I've always thought that was a wonderful approach.

Linda Gray: An illustrator's illustrator. We shared a studio together in the early 1970s. She makes beautiful uncompromising illustrations.

David Holmes: As well as being my dearest friend, David has continued to inspire me with his wonderful use of watercolour.

Jeff Fisher: A legend and a friend, he single-handedly defined the look of Bloomsbury publishing amongst many other notable commissions.

David Hughes: A one-off original, he produces fantastic portraits and more recently has become a successful children's book illustrator (as Sandy Turner).

Pablo Picasso: Although sadly no longer with us, he will always be there to remind me to push the barriers. Everyday before I start drawing I remind myself of one of his sayings, "Don't draw what you see, draw what you want to see."

Paul Hogarth: He once requested that I drew his portrait when he was chairman of the Association of Illustrators. In return he drew mine.

Milton Glaser: The other founder of Push Pin Studios in New York and an icon in illustration–I wish I had his brain.

Andy Warhol: THE commercial artist–a great drawer and self-promoter. The best.

Sir Peter Blake: The godfather of POP ART… now in his 80th year he still continues to inspire.

A spoof–the actual painting is much smaller and was done on holiday in Corfu.

Inspiration from years of collecting.

What do you collect?

Ever since I was a little boy I have collected things; a habit I inherited from my grandfather. I still have all my Dandy and Beano annuals along with most of my childhood toys. And the toy collection has continued to expand. I collect robots and space ephemera, as well as tin toys, skulls, books, Mickey Mouse, Noddy, camels, china parrots, Myott vases, monkey objects, Siurells (those wonderful multi-shaped whistles that inspired Miro and Picasso), and from a visit to China, Chairman Mao statues. The list is endless.

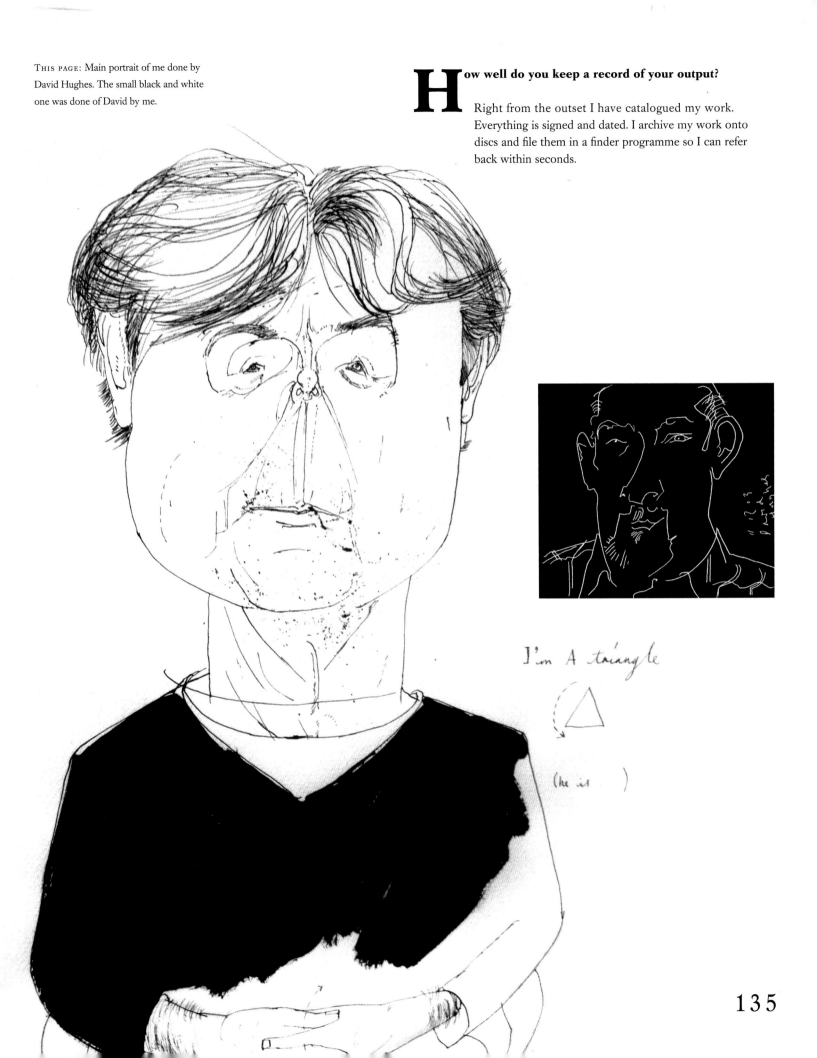

THIS PAGE: Main portrait of me done by David Hughes. The small black and white one was done of David by me.

How well do you keep a record of your output?

Right from the outset I have catalogued my work. Everything is signed and dated. I archive my work onto discs and file them in a finder programme so I can refer back within seconds.

I'm A triangle

(he is)

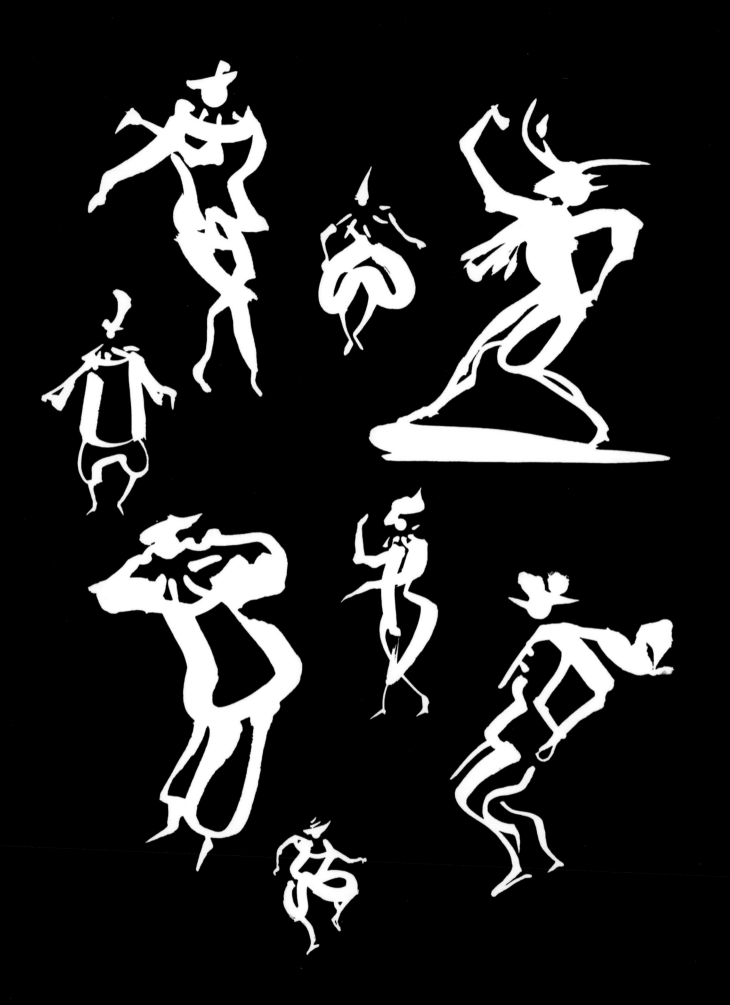

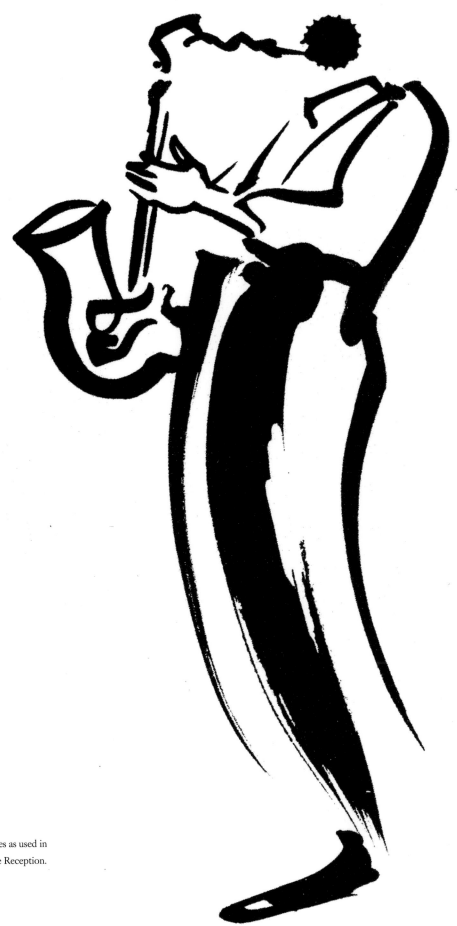

OPPOSITE: Various silhouettes as used in
The Theatre of Performance Reception.

One of a series of jazz cards.

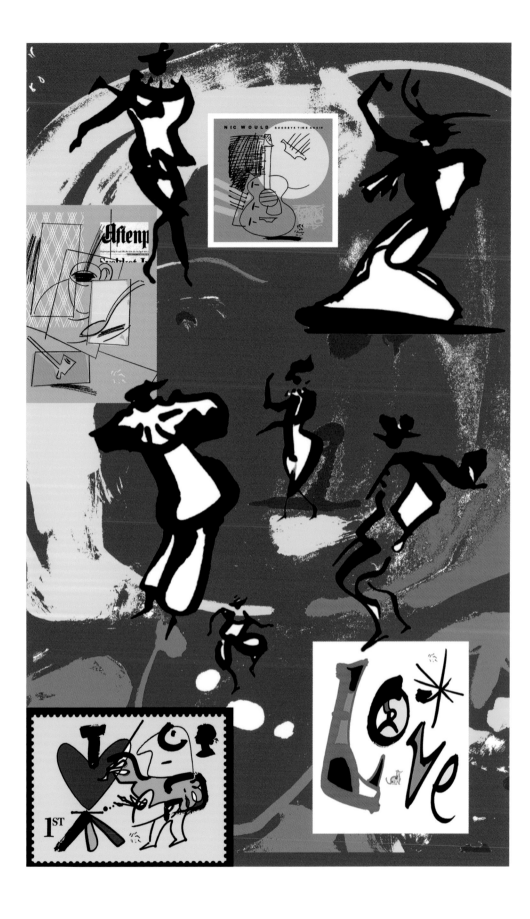

Using Spanish casks Bruichladdich
produces the finest whisky.

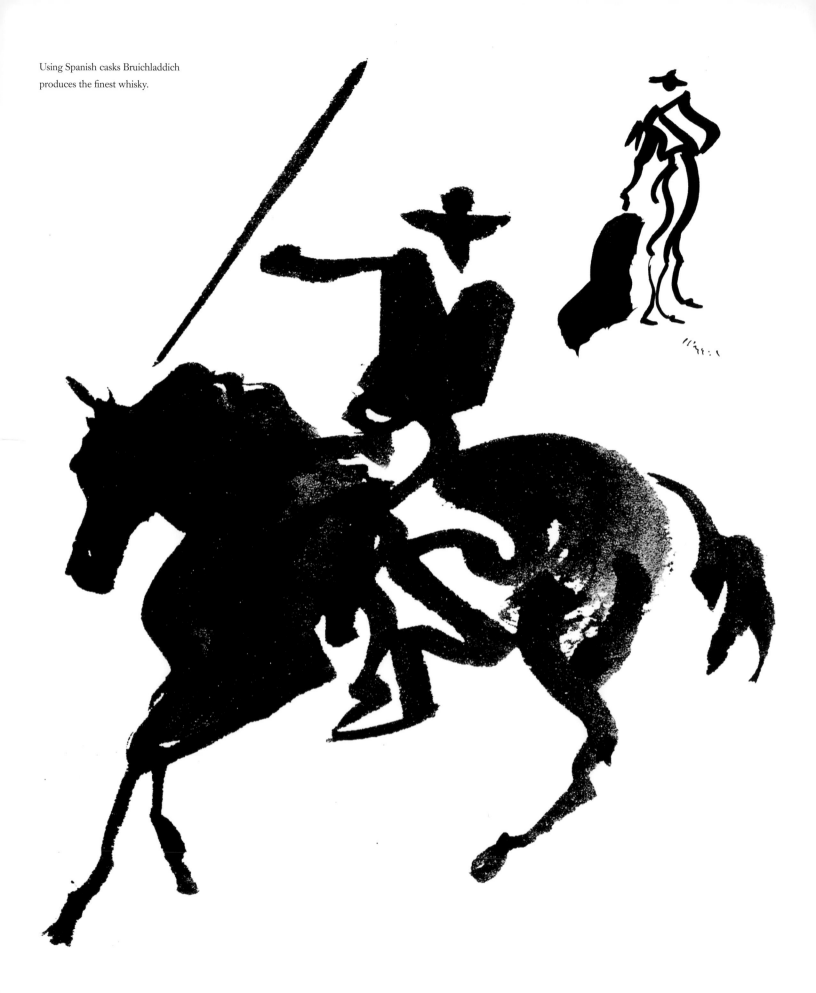

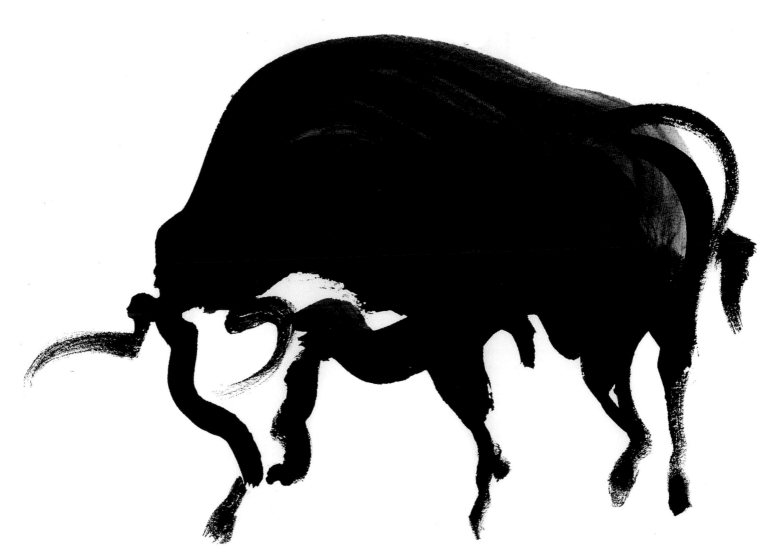

ASDA Sherry Labels.

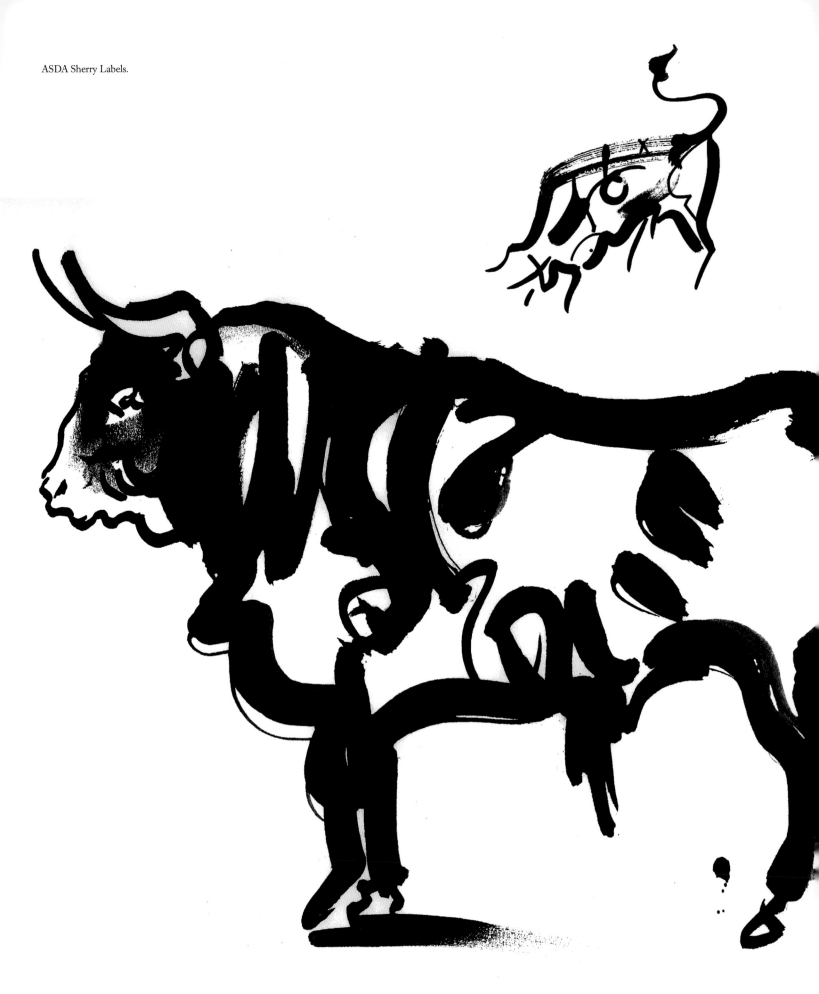

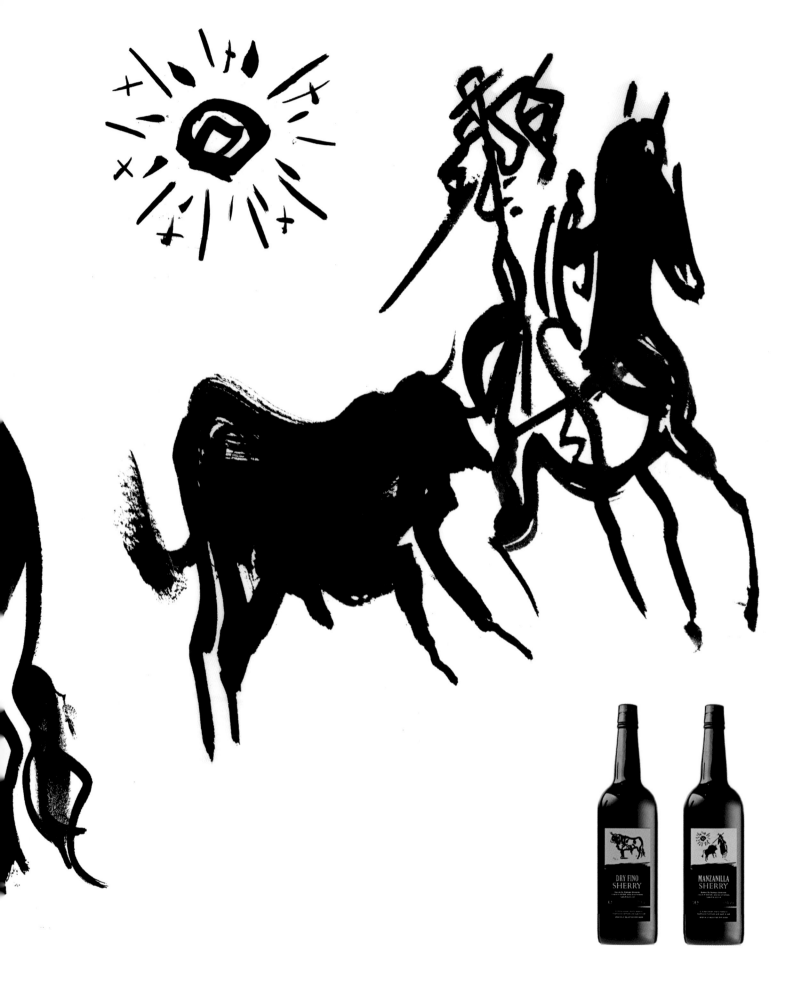

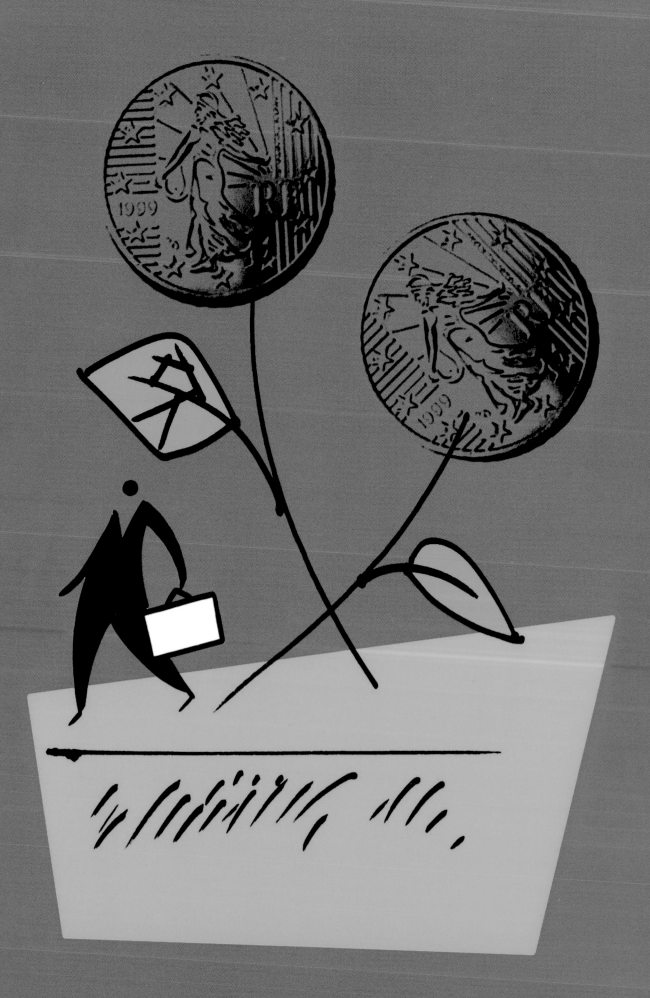

OPPOSITE: The Euro.

RIGHT: One of a series of
silhouette prints.

OVERLEAF: Proposals for a Royal Mail
commission for stamp designs on the
theme of 'Occasions'. They were never
taken up. My favourite was the nappy pin,
announcing a new born child.

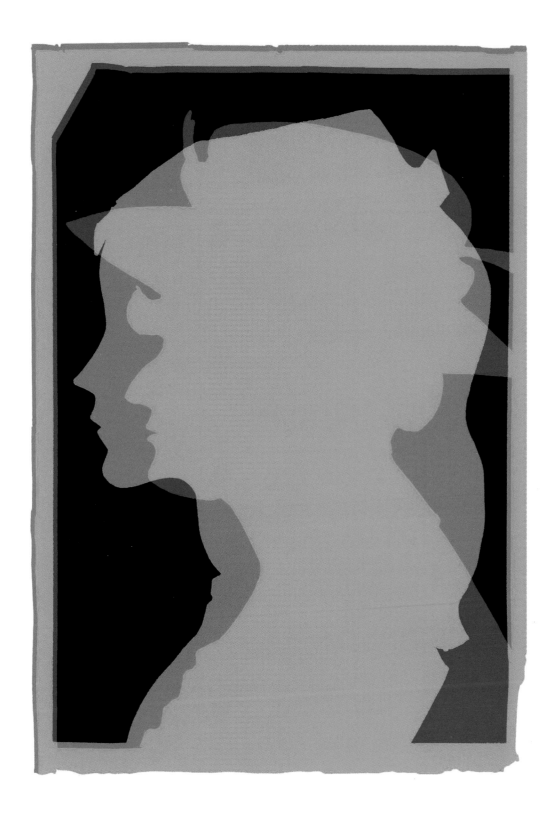

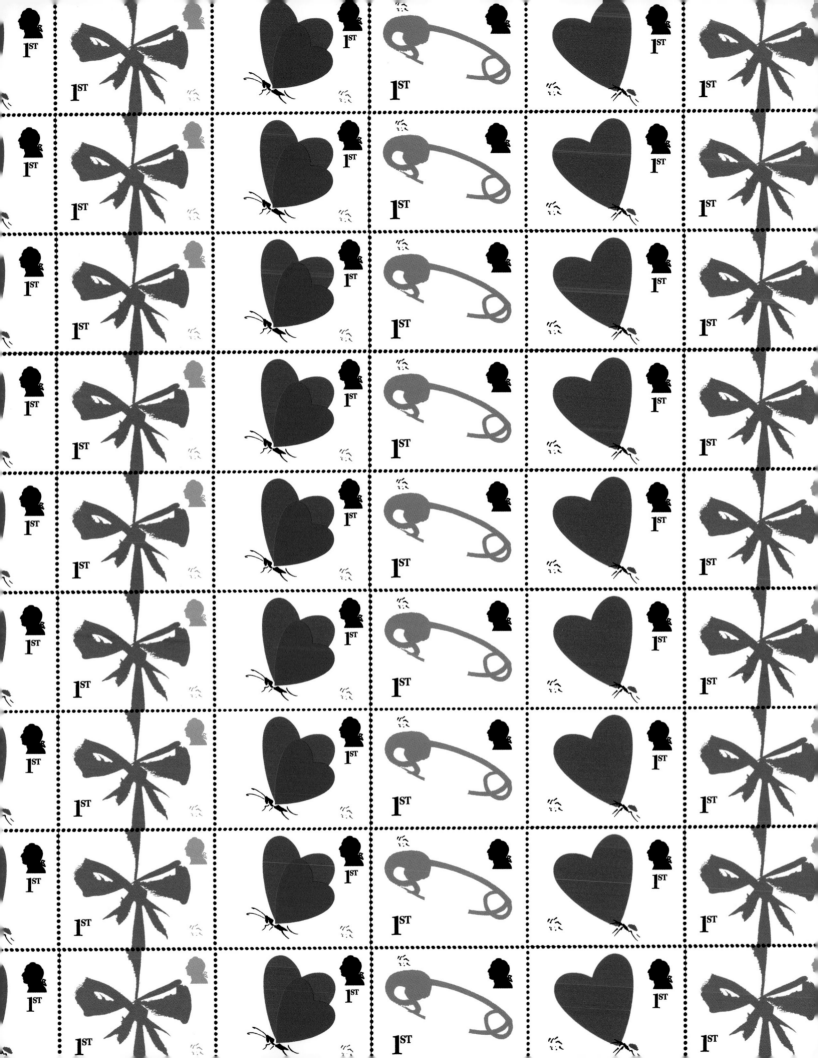

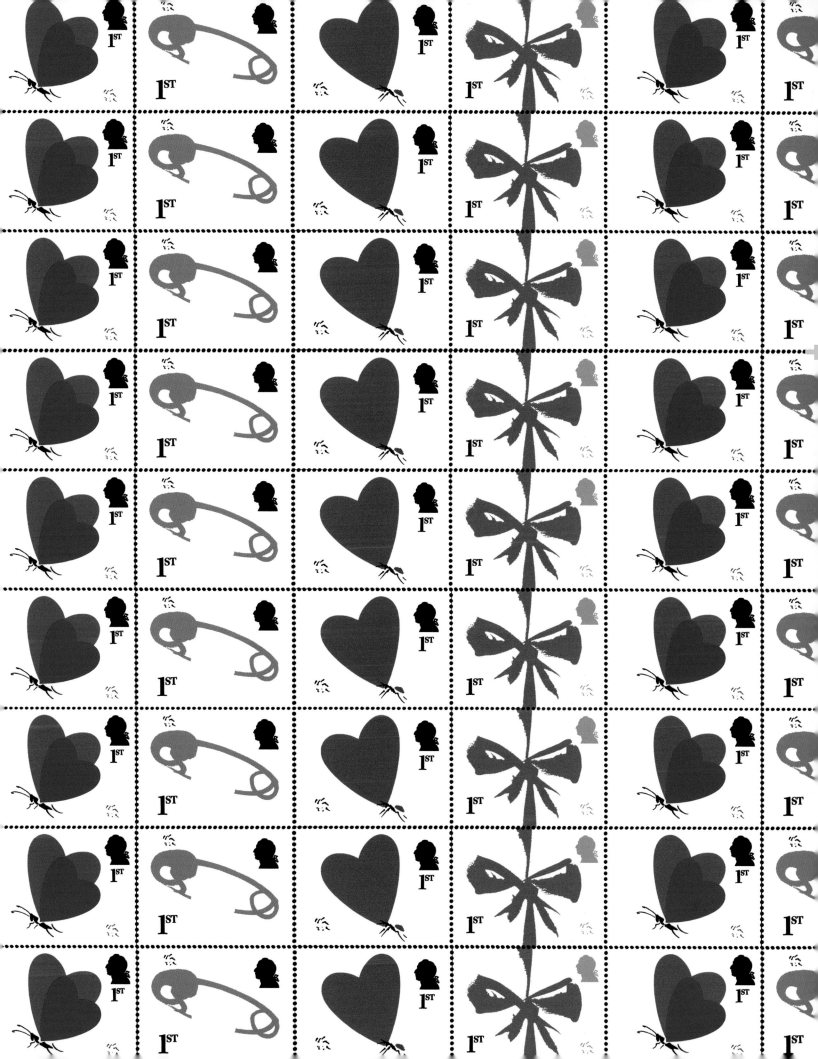

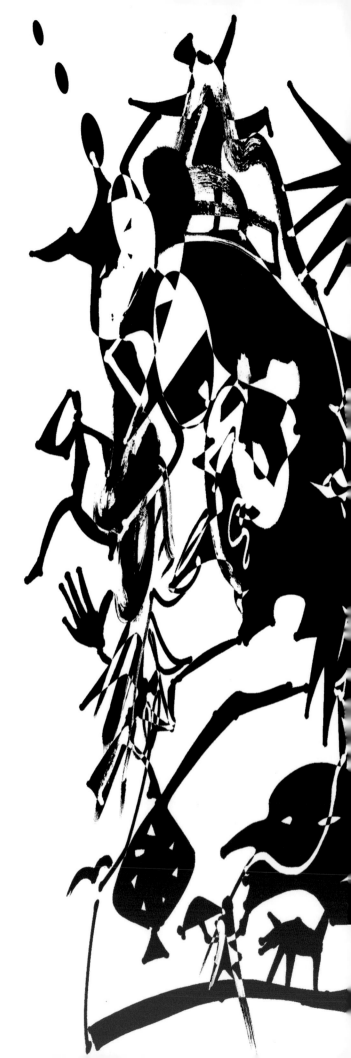

Main picture: An article about LSD.

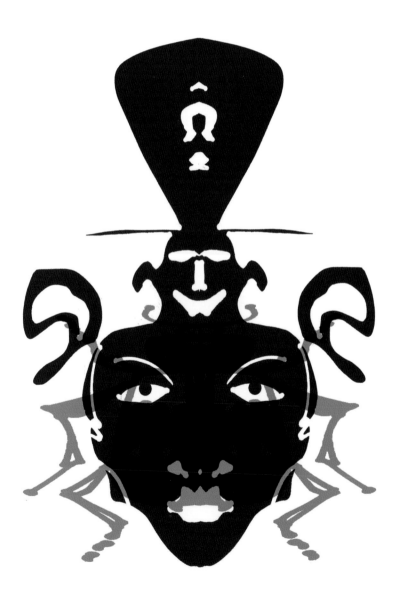

BRIAN GRIMWOOD
THE MAN WHO CHANGED THE LOOK OF BRITISH ILLUSTRATION

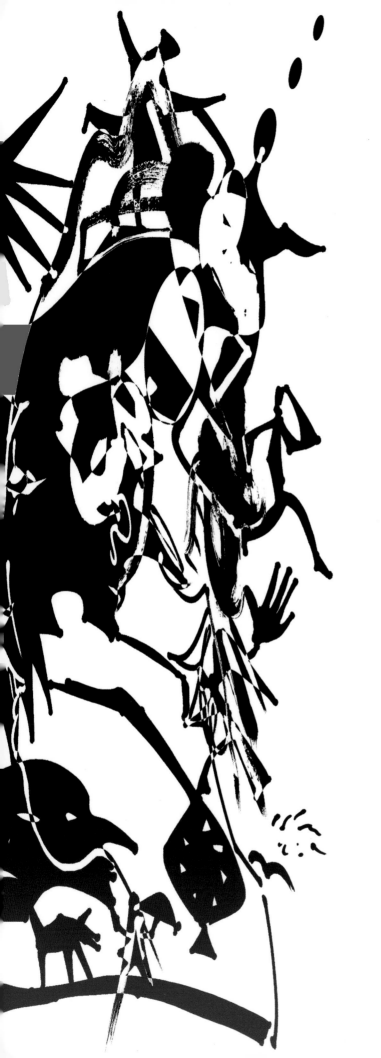

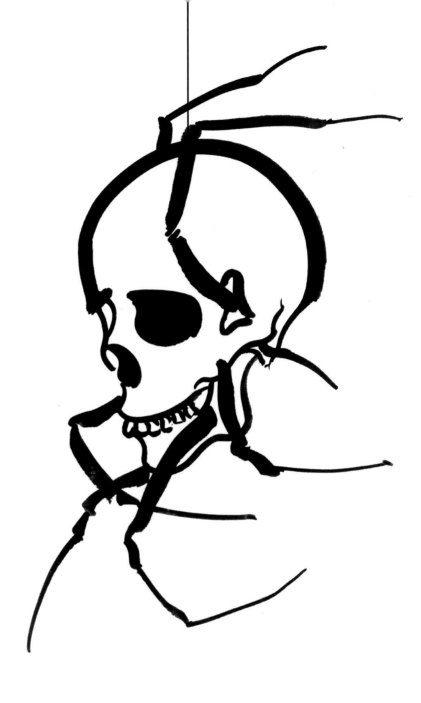

LEFT: A black and white issue,
The Guardian.

OPPOSITE: An editorial illustration for a
French magazine.

On a trip to Shanghai with Phil Cleaver,
he bought me a concertina sketchbook. I
filled it whilst there by doing his portrait
each day.

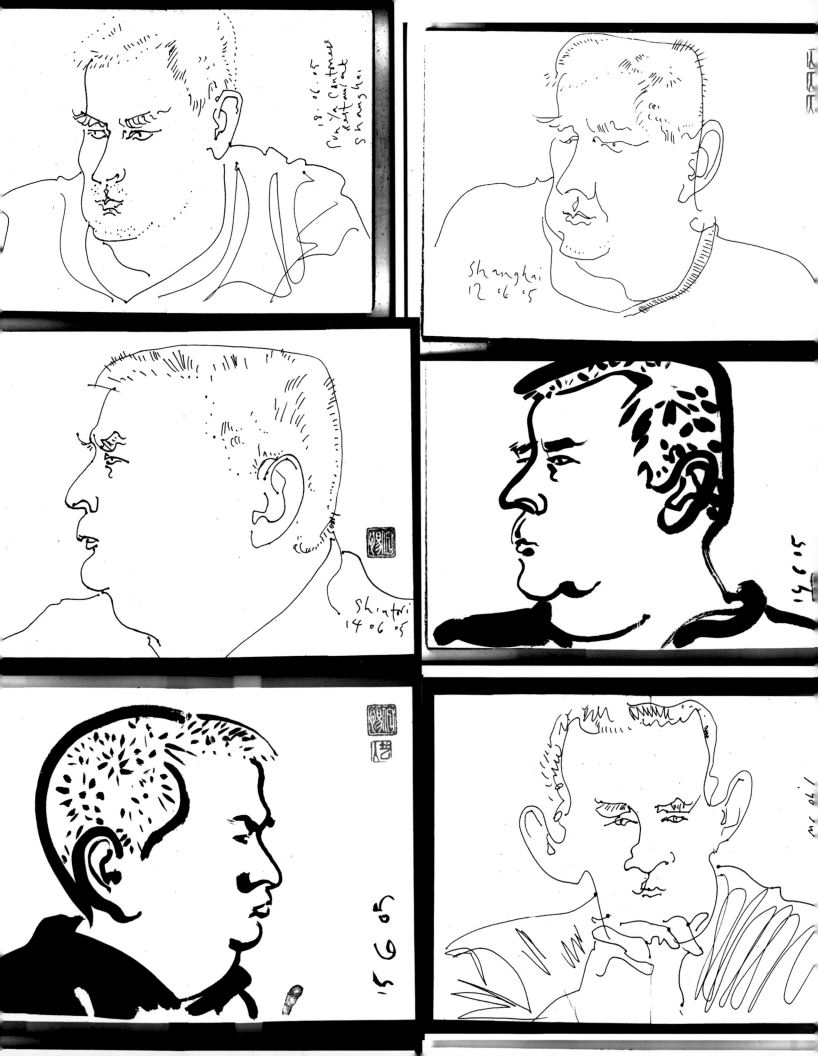

An outtake for *The Art Book* cover 2009.
The drawing was done with a mouse
directly into the computer.

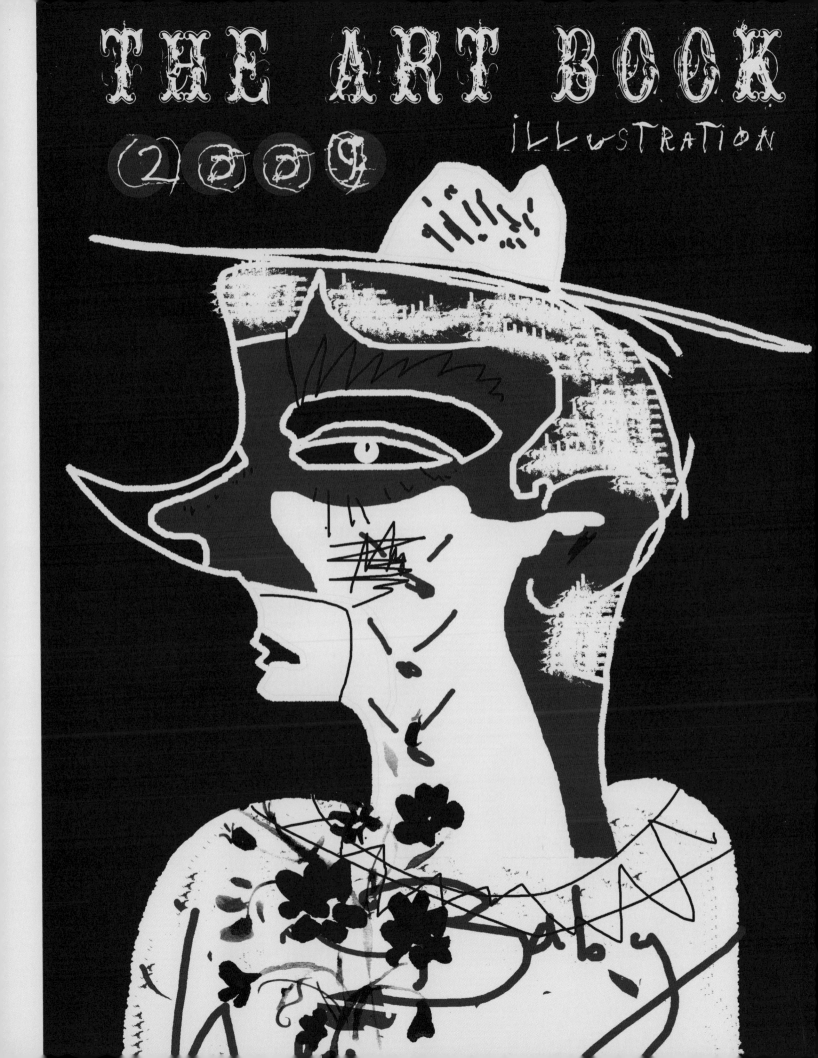

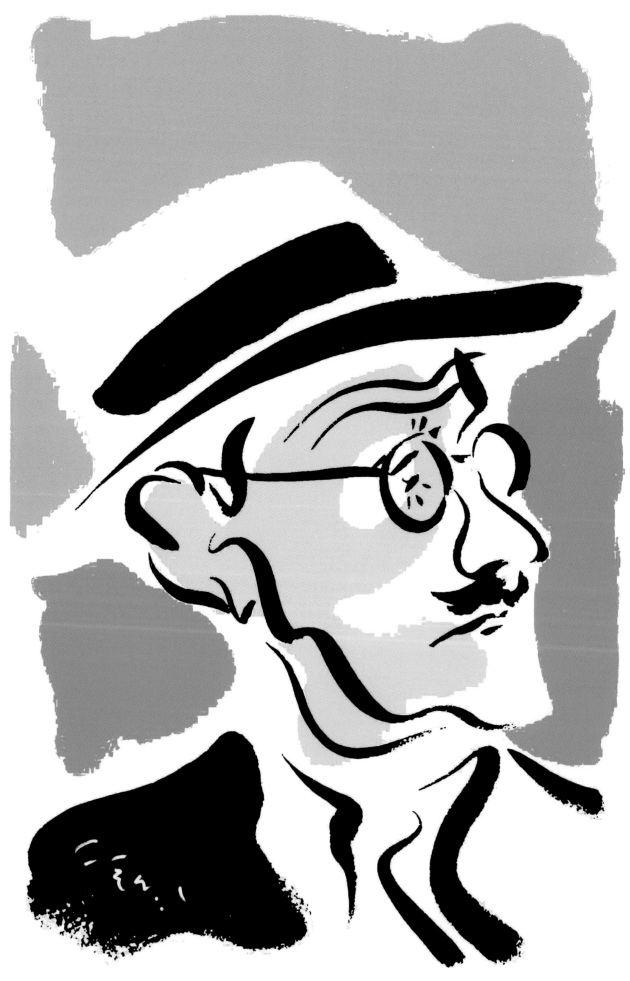

BRIAN GRIMWOOD
THE MAN WHO CHANGED THE LOOK OF BRITISH ILLUSTRATION

Do you know what a 'good' drawing is?

A good drawing has balance and a good artist knows when to stop making a picture. I am a big fan of children's drawings and outsider art. I have never been that interested in drawing itself. For me it is the idea and the way it is expressed that is important.

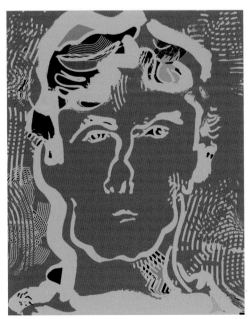

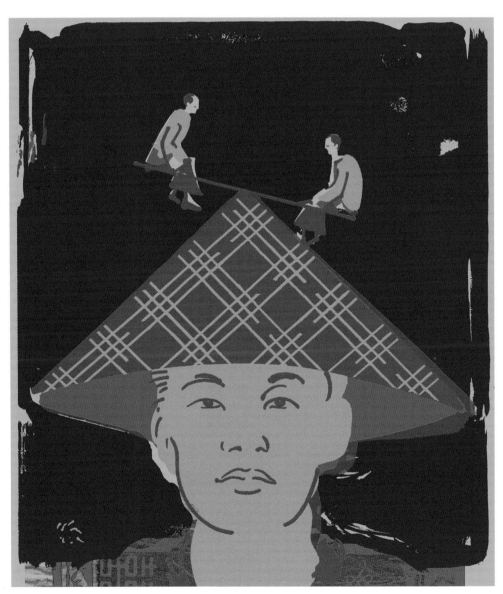

Being a huge Outsider Art fan, these are just some of my recent doodles playing around with shapes and expressions.

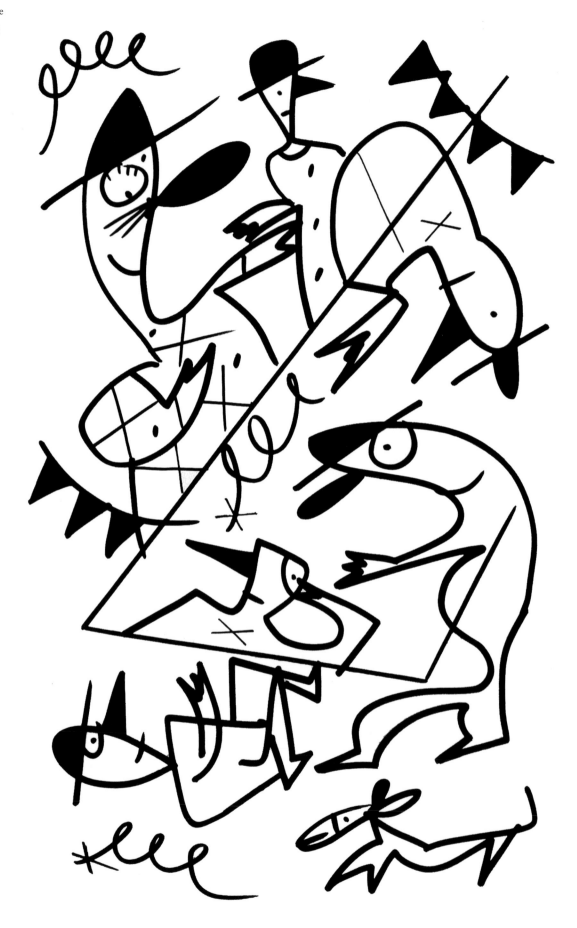

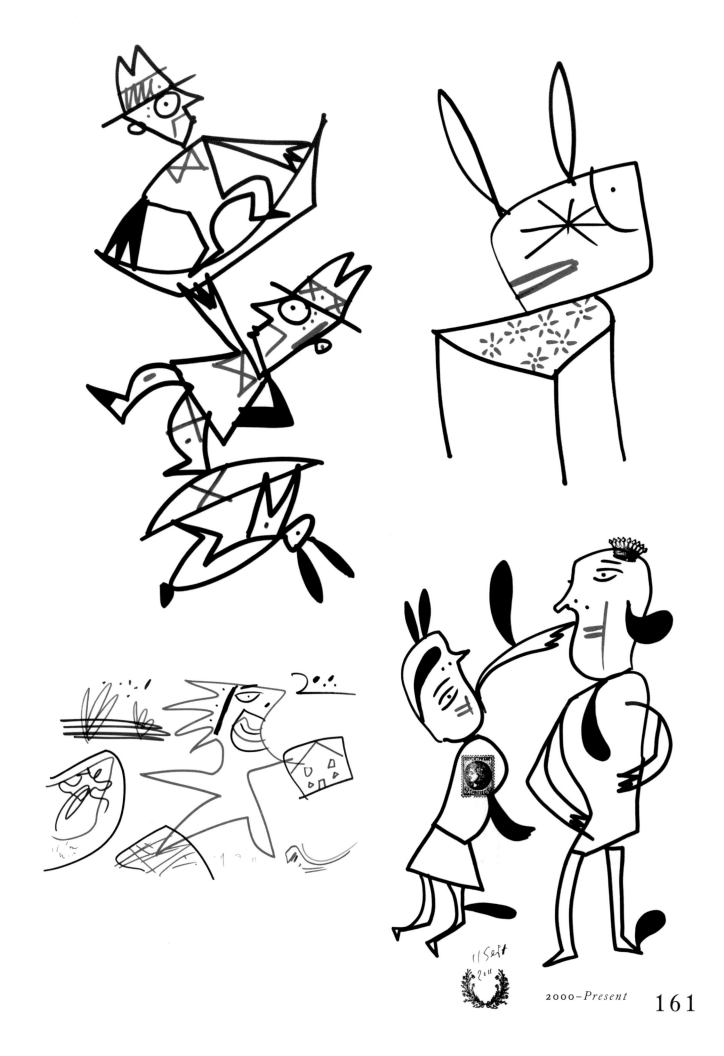

A promotional page showing a range of jobs
done in my loose style.

OPPOSITE: Visit London Zoo by Underground.

BRIAN GRIMWOOD
THE MAN WHO CHANGED THE LOOK OF BRITISH ILLUSTRATION

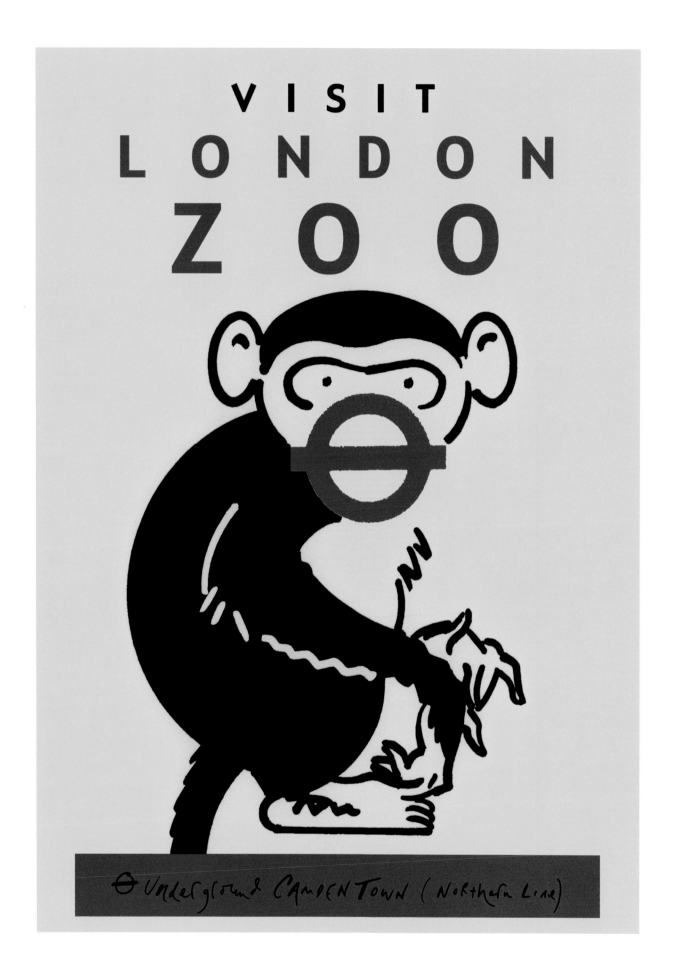

A few outtakes.

Opposite: The Art of Artisan Cheese. A
Picasso feel was briefed on this packaging
job, commissioned by Connect Group.

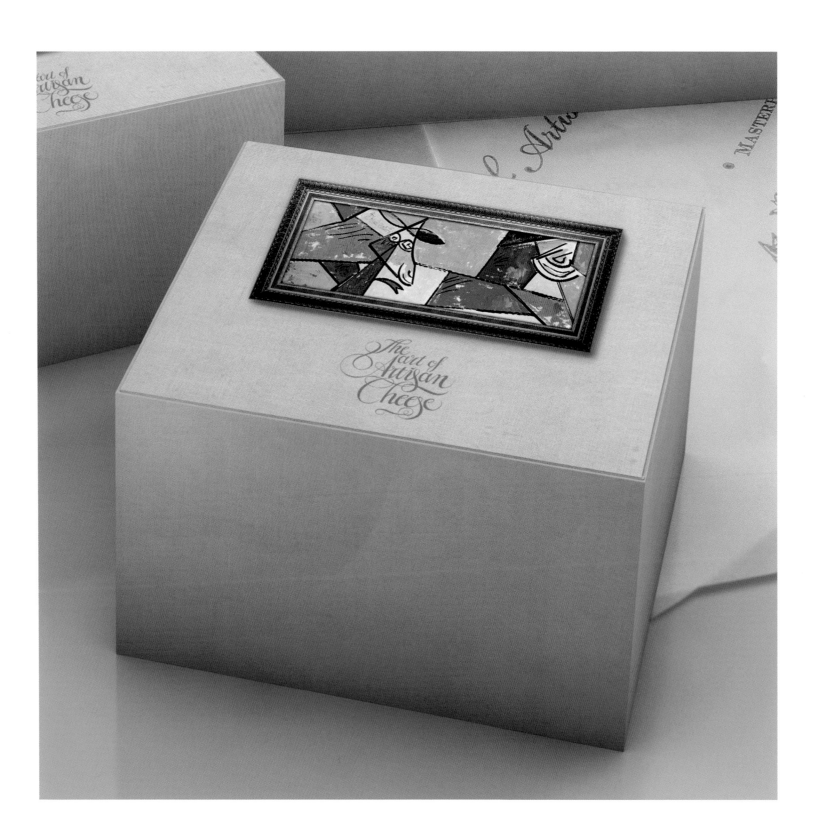

What do you think an illustration course should offer students today and do you think they are being well taught?

I think it is essential that illustration students are encouraged and inspired to draw, especially from life. Also they should be taught the history of illustration so that they are fully aware of the many talents and styles that have gone before. I believe that illustration students and graphics students should be integrated with each other so that each can gain an understanding of how the other works before they leave college. Graphics students need to learn how to think illustratively when problem-solving and how to commission illustration. Illustrators need to learn how they can benefit from the constraints imposed by a brief.

Of course, there are good and bad tutors 'teaching' illustration. I use quotes as I don't think illustration is taught. The best tutors inspire their students. Currently there are some great and inspiring tutors out there, people like Brian Love at Kingston; Bush Hollyhead, a great illustrator teaching at Newcastle; George Hardy teaching in Brighton; Debbie Cook at the Royal College, and many others.

Although the computer is a great tool, many courses focus too much on its usage and not enough on other skills. Anyone can achieve a slick result technically by using Photoshop, but it is what you have to say and how you communicate the idea that is the most important element of any illustration.

the *TES* magazine

You've seen something wrong. Are you going to peak out?

● Bagdg sch sbj djf xj s jdfdsdhs sdhdcs ● Wmkejddsn,m njxcc sx cc fu krjdsdh

COFFEE WITH

THE BUDDHA

JOAN DUNCAN OLIVER

FOREWORD BY ANNIE LENNOX

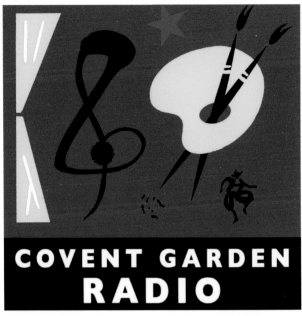

COVENT GARDEN
RADIO

ILLUSTRATION

WINTER 2011 ISSUE 30

GRIMWOOD & THE CIA: CHANGE AGENT

AN·ARROW·CLASSIC

Belle & Badge
George Louie

AN·ARROW·CLASSIC

CHILDS PLAY

TO ALL CHILDREN WHO LOVE TO SING

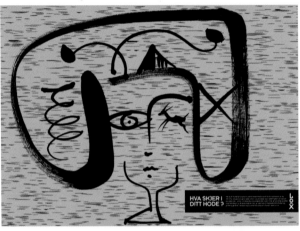

SAT 23 JULY
THE BAT & BALL
NEW POUND
WISBOROUGH GREEN
WEST SUSSEX

THE BUTCHERS
BLUES BAND
START 7.30

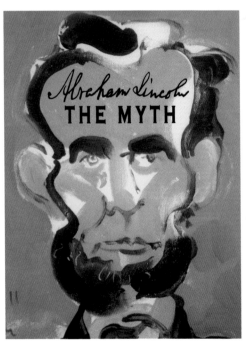

Abraham Lincoln
THE MYTH

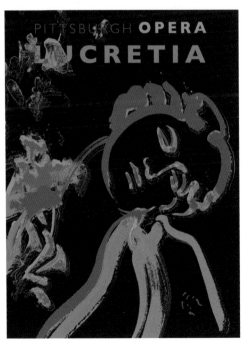

PITTSBURGH OPERA
LUCRETIA

David *Bowie*

I first met David in 1961 at Bromley Technical High School for boys. We were both in the 'ART' stream, run by Owen Frampton (who just happened to be the father of the legendary guitarist Peter Frampton). David was in the year above me. It was like being at art school at 13 but at the same time having a grammar school education. We were encouraged to use our imaginations and were given every opportunity to express ourselves in drawing painting and graphic design. The Art forms were also renowned for their mode of dress. Even before The Rolling Stones and The Beatles many of us had longer than average hair cut, in the style known as "a college boy".

David was no exception–even in those days he had his own unique style… tapered trousers, Chelsea boots… the school tie worn with the slim bit in the front and the end cut off… tab collared shirts, and in David's case 'the hair'. In 1961 he had a sort of crew cut version of a Tony Curtis–it was blonde… though in real life his

hair it is mousey–I remember him telling me he used "Stay Blonde" to lighten it. He certainly had charisma and was popular….

His best pal at school was George Underwood–who famously was the boy who hit David in the eye when they were in the cubs and caused the pupil in his left eye to stay dilated… giving him that from another planet look that he became famous for….

George, who is a very successful illustrator and painter (having done covers for David and Marc Bolan as well as many other artists), kept in touch with David even after we left school… and they still remain in touch.

In 1965 I was an art director for Pye Records based near Marble Arch in London. It was a very exciting time to be designing record covers, and being a huge 'Blues' fan it was great to be involved in doing covers for their affiliated label Chess.

One day I was walking down the corridor at Pye and who should I bump into but David. I was surprised to see him and he too was surprised to see me, and greeted me warmly. It turned out he was recording his first album with Tony Hatch (famous amongst other things for writing the TV soap theme music for *Crossroads*).

At this time David's songs were almost child-like with a clever twist–songs like "Rubber Band", "She's got Medals", "Little Bombardier", and at that time heavily influenced vocally by Anthony Newley. When released I don't think it was that successful–but there was no doubt in my mind he had something special.

I stayed at Pye for only one year as in those days the only way to increase your salary was to move on…. By coincidence it was George Underwood who took over my old job….

A year went by and I was on Victoria Station and who should I bump into again but David… he was friendly and asked me what I was up to… I mentioned that I was in a Blues Band and worked during the day as a commercial artist… he then out of the blue asked whether the band and I wanted to be the support act at the Marquee club in Wardour Street for one of his Sunday afternoon sessions… of course I jumped at the chance. He then invited me round to his parents house in Bromley to hear some of the songs he had recently been working on….

The house was very ordinary, quite small and normal… his mother offered me a coffee and he took me upstairs to his bedroom studio. It was about 12 foot square with a bed in the middle–there were two Vox speakers either side of the bed–under the window his father had made a unit to house two reel to reel tape recorders. There was a 12 string guitar on the bed and a bass guitar… also I remember seeing *The Observer* book of music and a book of poems.

He started to tell me of his recent experience at some retreat in Wales where he had met a guy called Chimay–who had taught him how to meditate, I remember David giving me an example of what he was learning… by clapping two hands together, then saying that is the sound of two hands clapping what is the sound of one hand clapping… all very deep stuff.

He was also raving about some music he had just discovered by The Stan Kenton Orchestra…. He played me a couple of songs he had just written–one was called "Silly Boy Blue", which I thought was amazing… and cheekily suggested maybe we could record it as our bands first single.

My memory then goes a little blurred and I cannot remember why it never happened. David at this time announced to me he had changed his name–because of David Jones of The Monkeys–and he was now calling himself David Bowie after the Bowie knife.

Rehearsal CD

19th

June 2006

LÖGIK

24 X

Blues

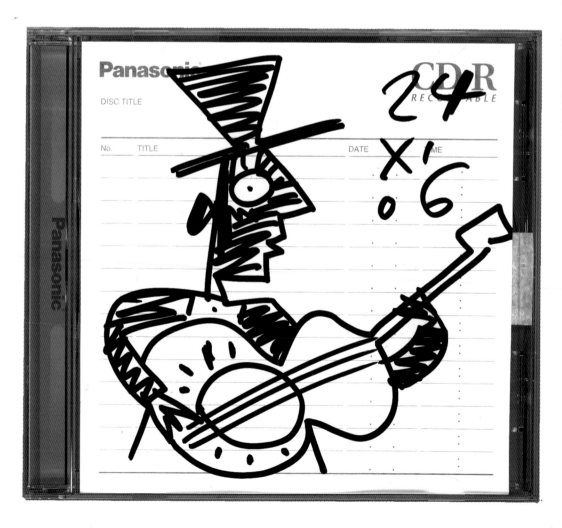

CD-R
RECORDABLE

24
X 6
0 6

ERIC CLAPTON

Sketches for the Coventry Building Society logo.

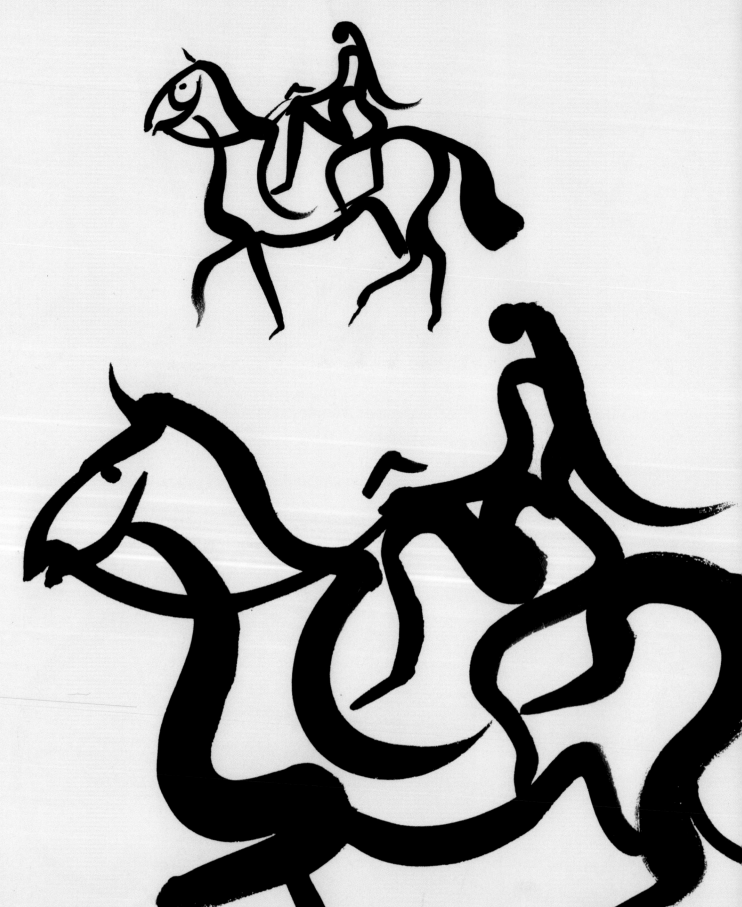

BRIAN GRIMWOOD
THE MAN WHO CHANGED THE LOOK OF BRITISH ILLUSTRATION

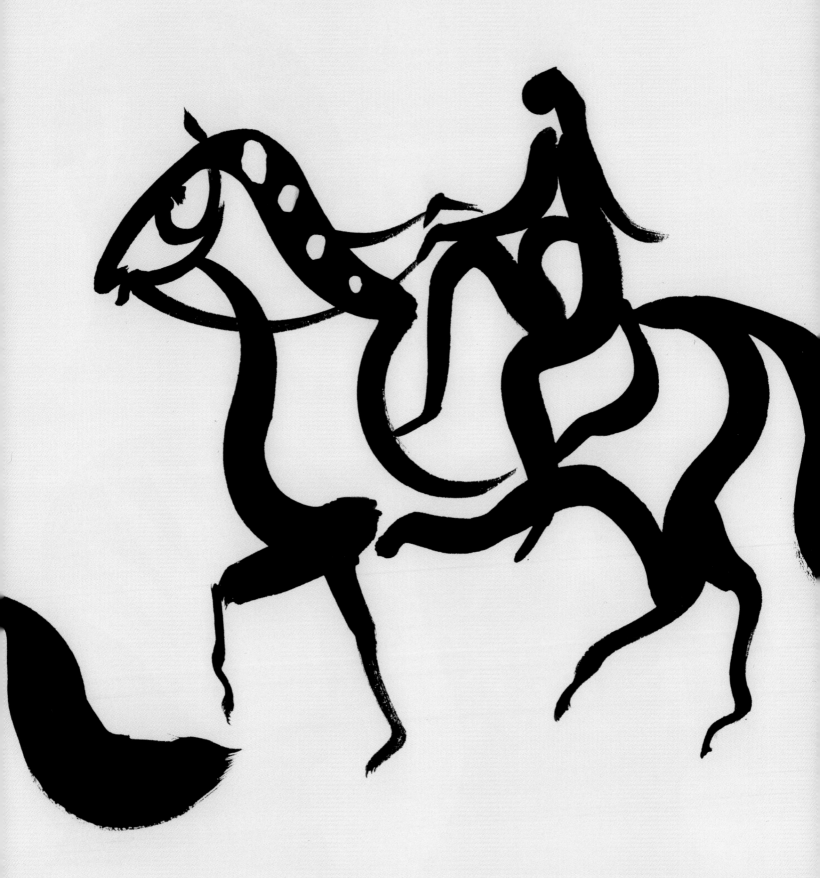

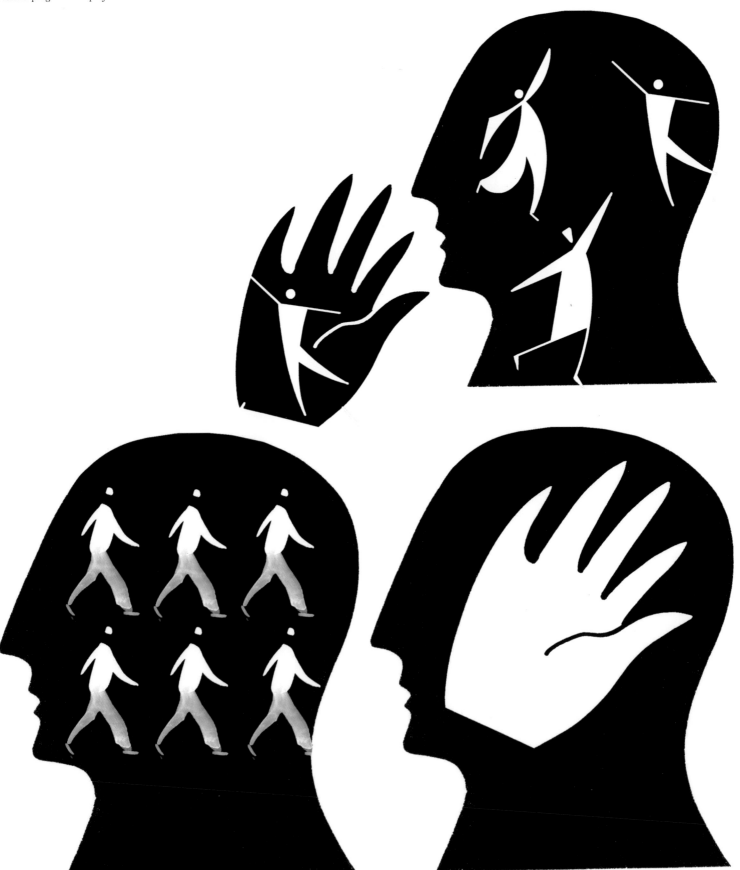

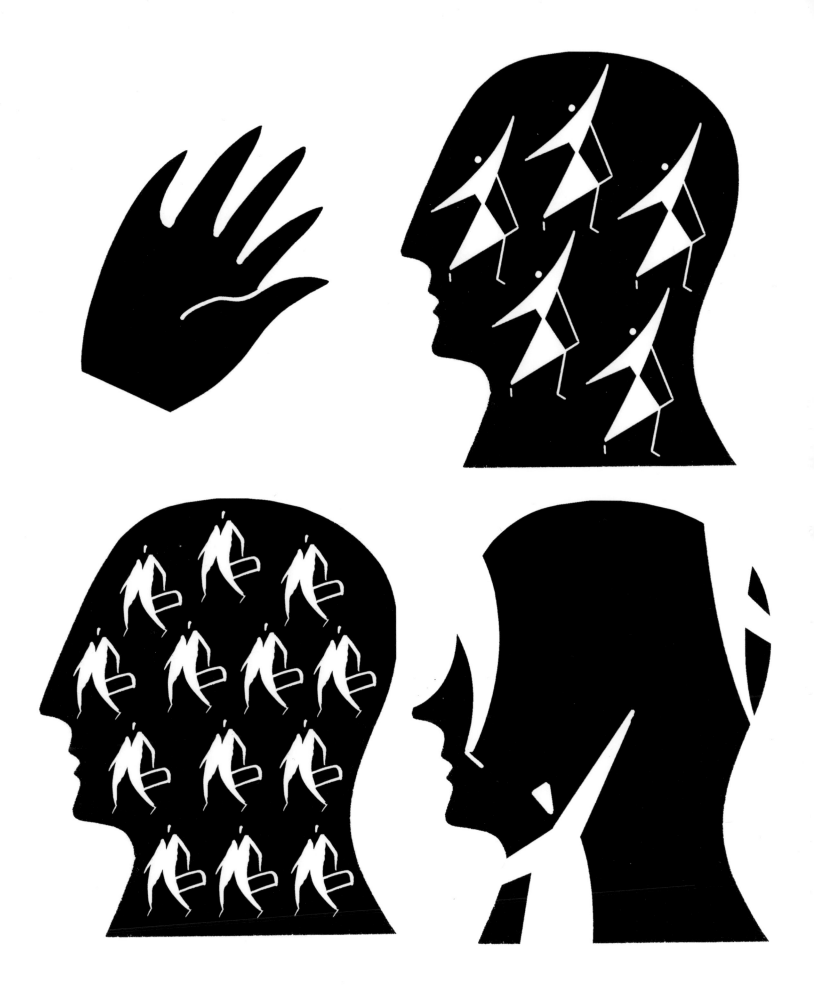

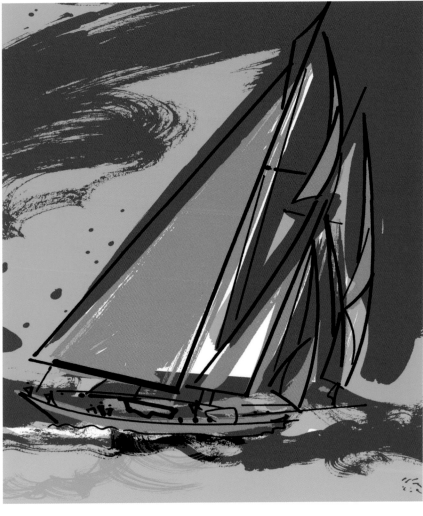

The Olympic bid 2012

Artist: Brian Grimwood
This poster is available to purchase from London's Transport Museum

LONDON

Platform for Art

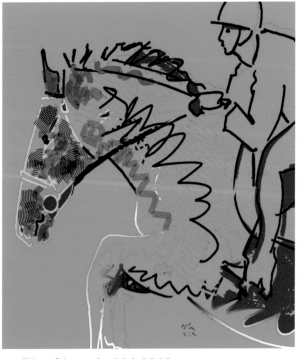

The Olympic bid 2012

Artist: Brian Grimwood
This poster is available to purchase from London's Transport Museum

LONDON

Platform for Art

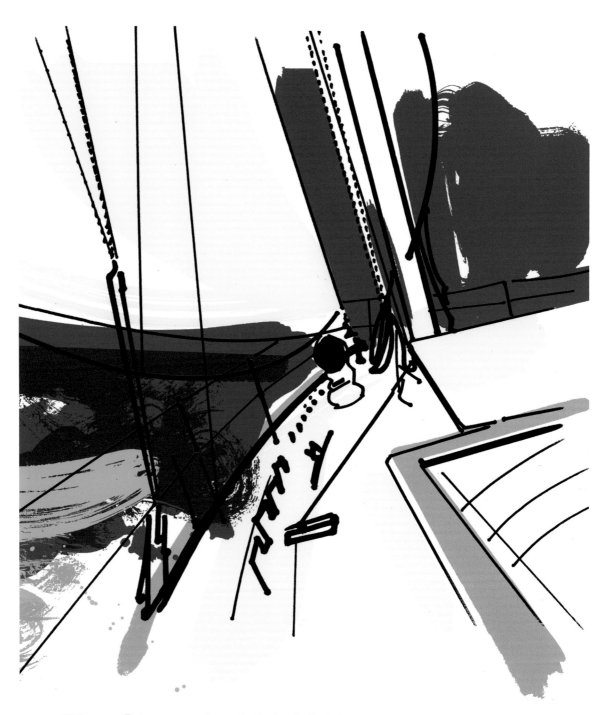

The Olympic bid 2012

Artist: Brian Grimwood
This poster is available to purchase from London's Transport Museum

LONDON

Platform for Art

The Famous Grouse whisky proposed
logo change—it didn't happen.

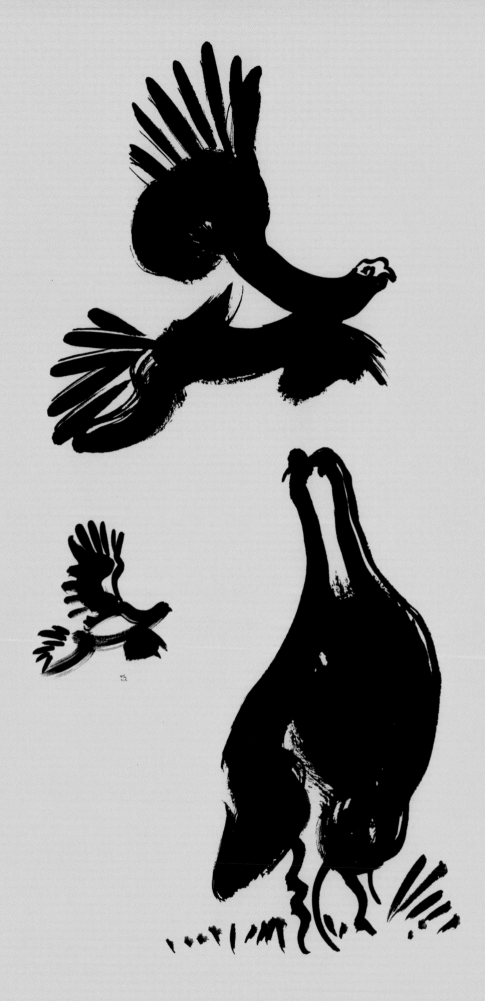

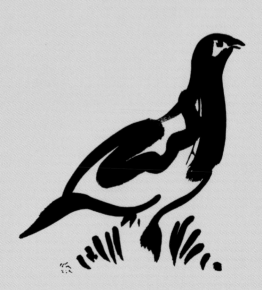

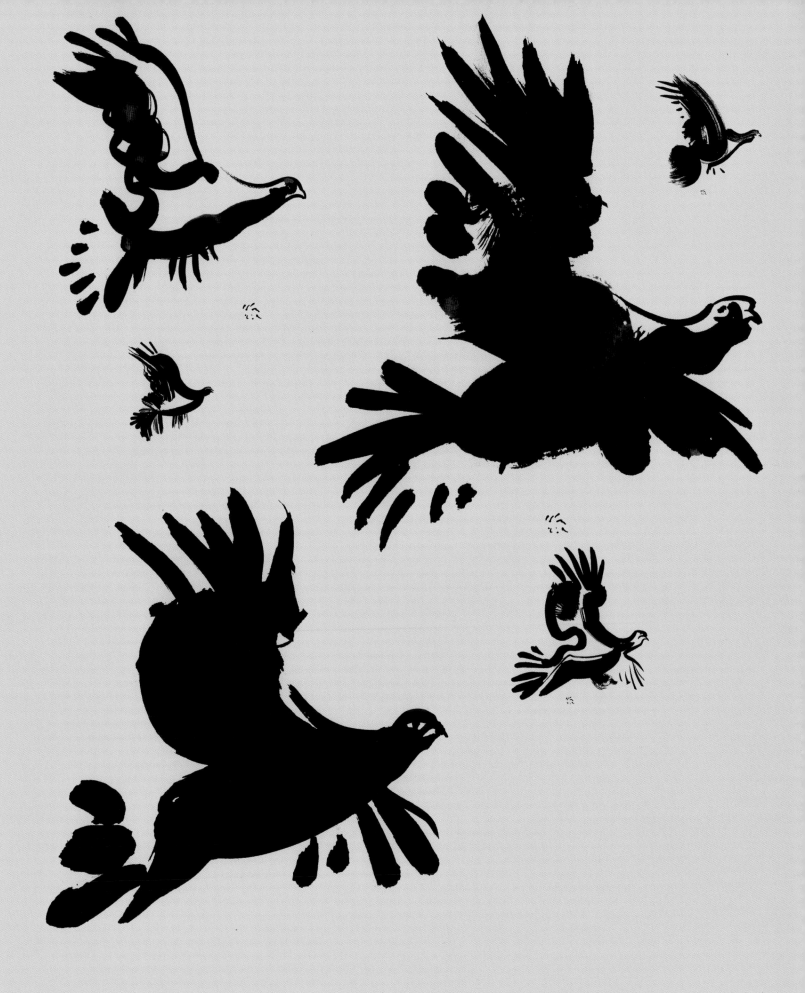

Portraits: Michelangelo from the Duncan
Baird "Coffee with" series.

John Lennon.

Charles Darwin.

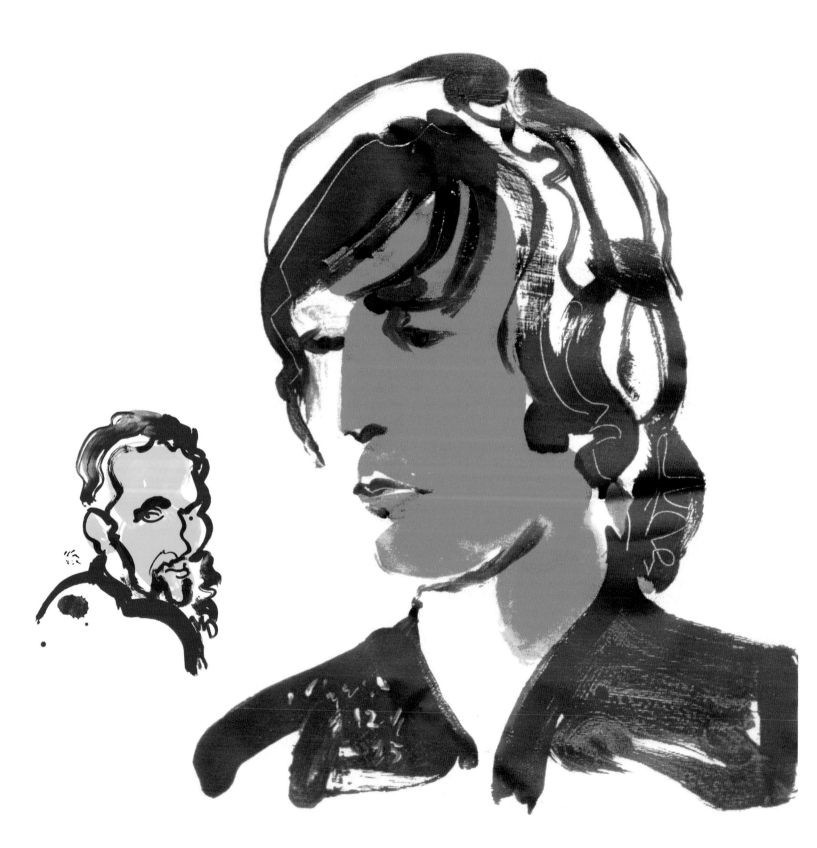

BRIAN GRIMWOOD
THE MAN WHO CHANGED THE LOOK OF BRITISH ILLUSTRATION

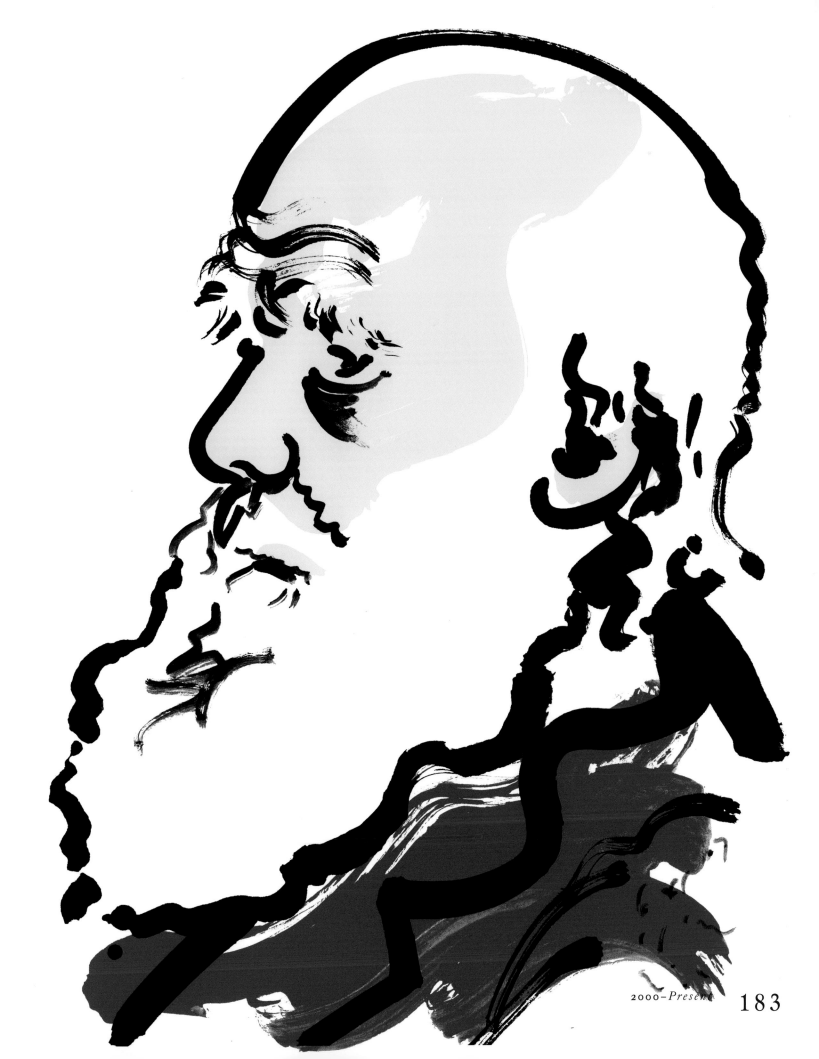

A painting I had done of John Lennon for
The Beatles Anthology was seen by a fine
art print publisher who asked me to come
up with another rock and roll icon so he
could publish the set. So I did this painting
of Mick Jagger.

FoxyLady.no

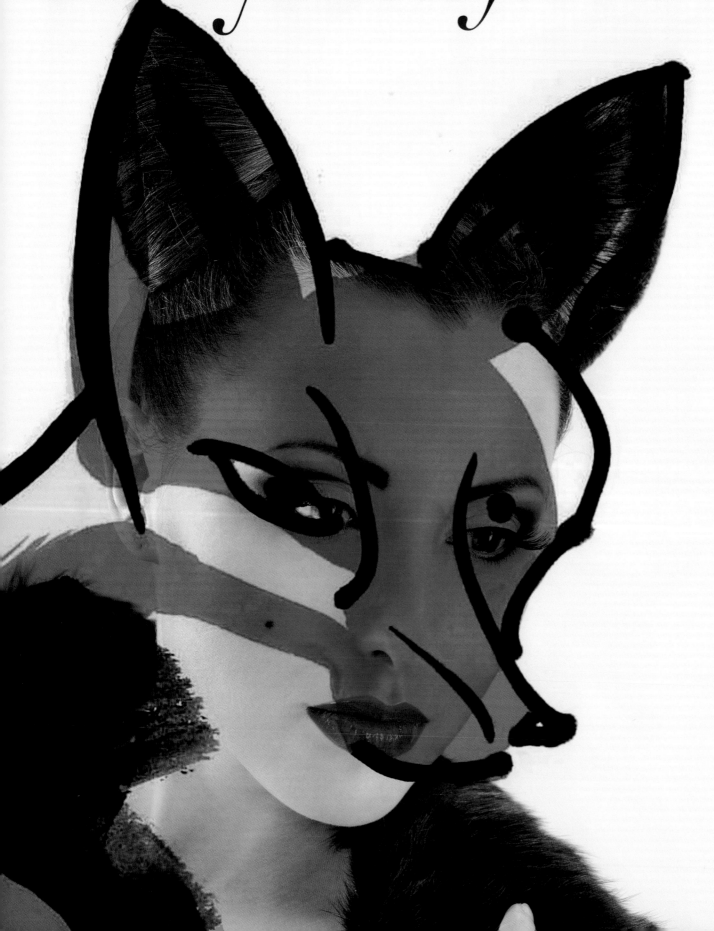

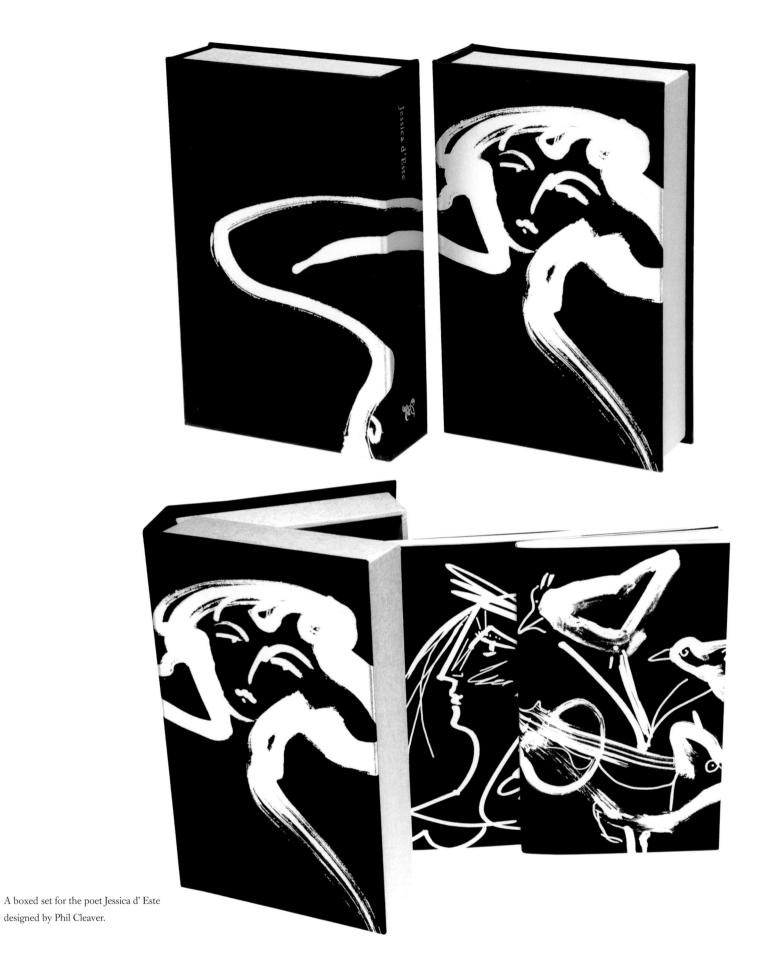

A boxed set for the poet Jessica d' Este
designed by Phil Cleaver.

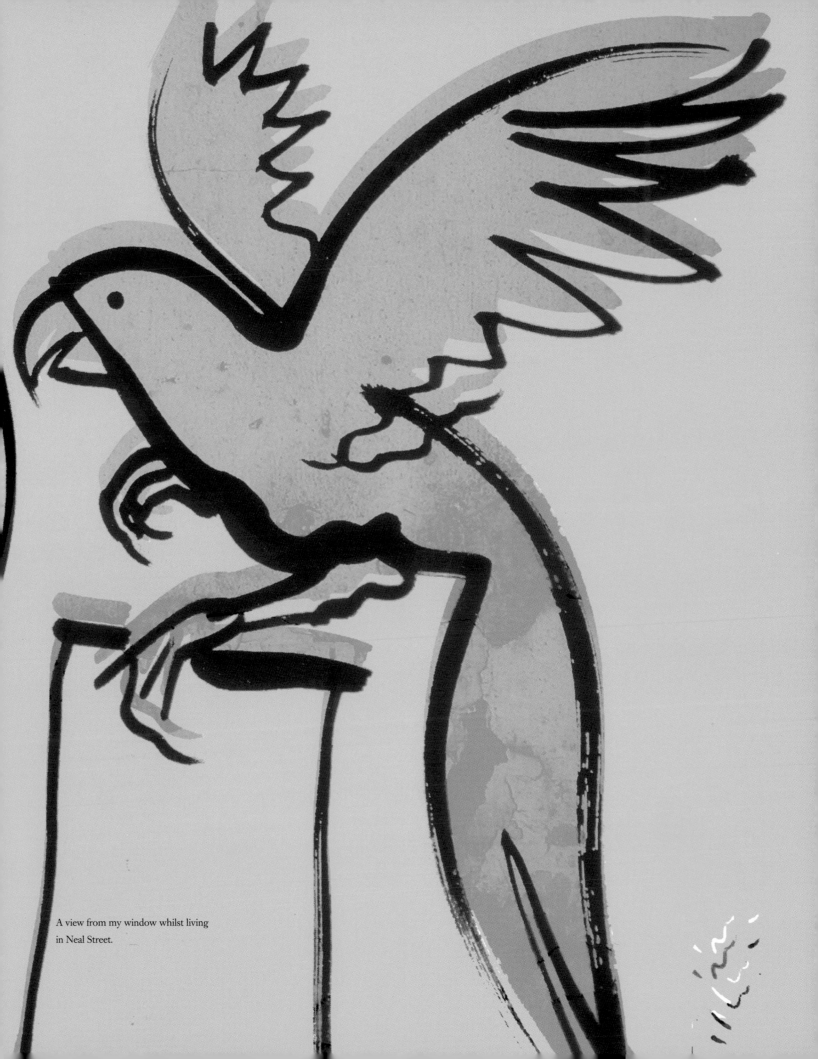

A view from my window whilst living
in Neal Street.

Koi Carp print.

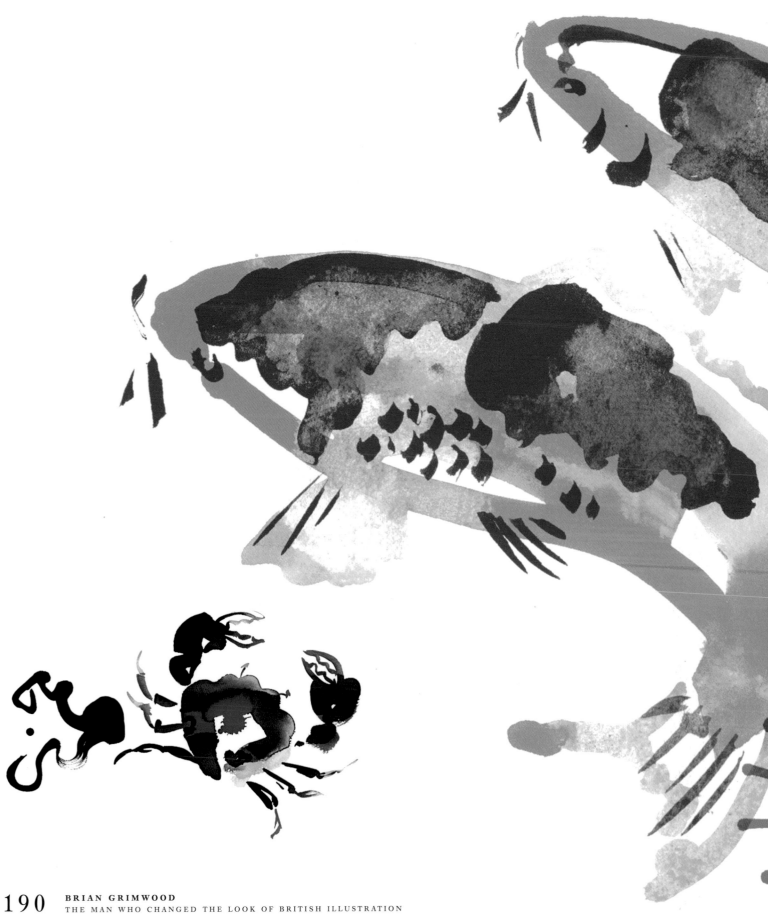

BRIAN GRIMWOOD
THE MAN WHO CHANGED THE LOOK OF BRITISH ILLUSTRATION

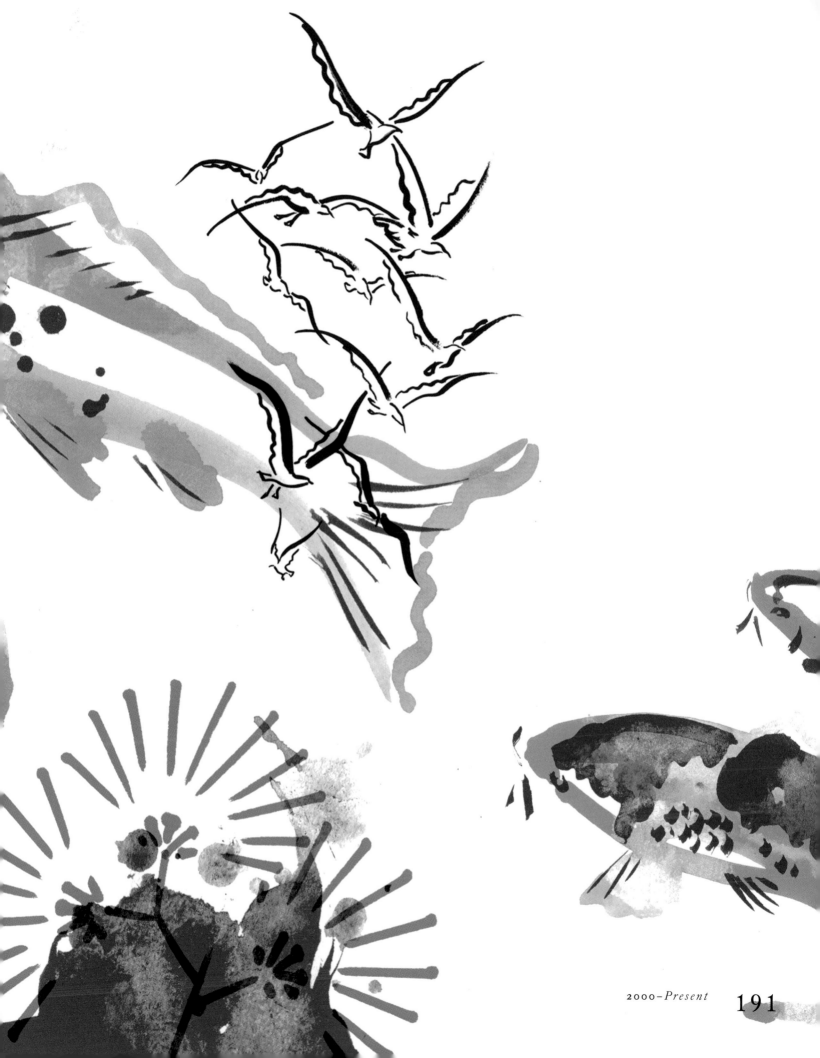

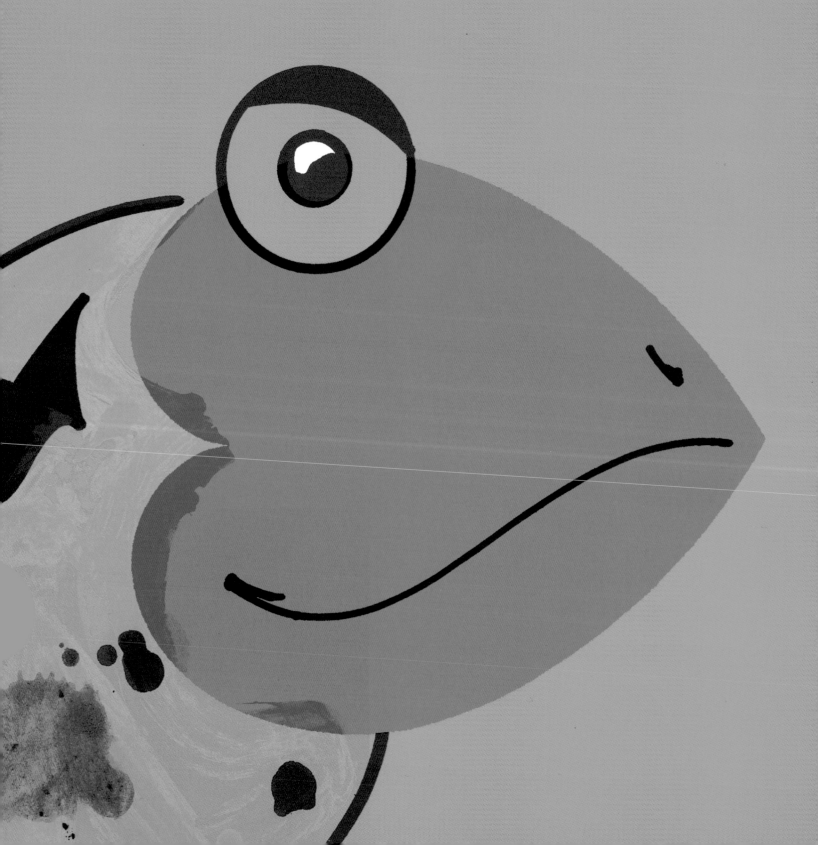

From a series of unpublished pictures for a children's book *Love/Animals*.

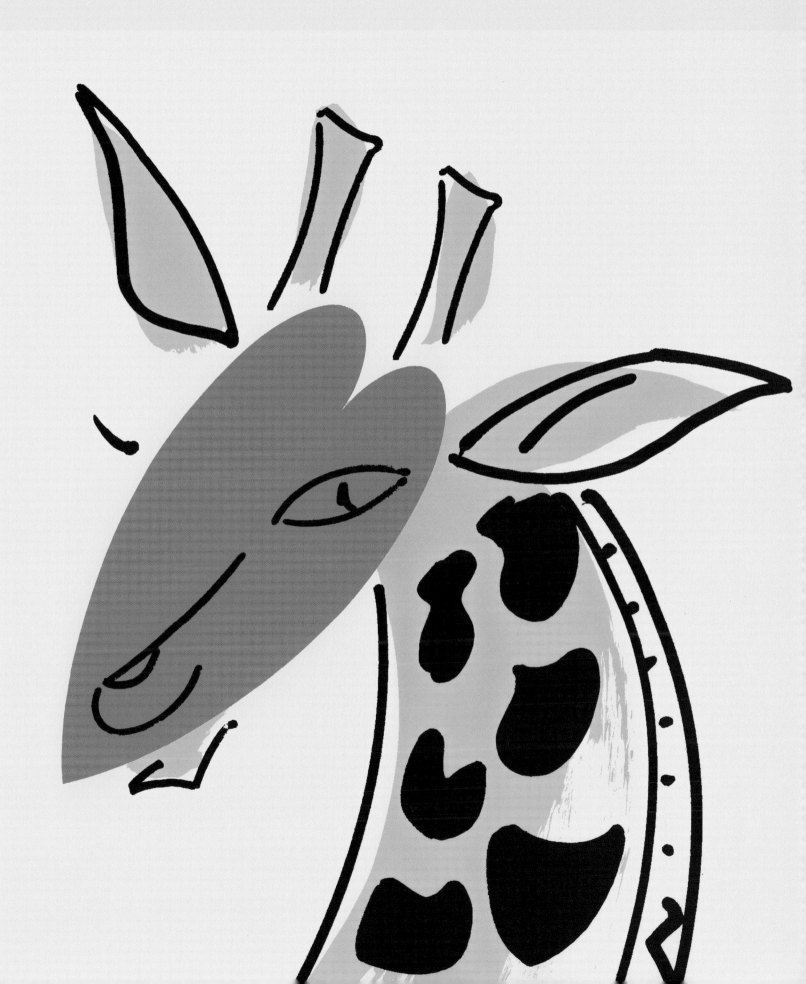

Lionel *Bart*

Around 1966/1967 I applied for a job as a designer… at Mountain and Molehill Studio based next door to Sadler's Wells in Islington.

The owner of the company was a larger than life character called Ken Sprague… and a brilliant exponent of making lino cuts. These he used to great effect producing some classic political posters of the 1960s. He recognised I had some talent and took me under his wing… as a gift he gave me a complete set of lino cutting tools… and my very own small hand press.

It was Ken who introduced me to John Gorman who owned the best screen printing company in the country: G&B Arts. They worked very closely with The Royal Shakespeare Company producing multicoloured layered award-winning posters of the day. G&B Arts stood for Gorman and Beglighter… a company started by John Gorman and Lionel Beglighter… Lionel Beglighter later became Lionel Bart who amongst other productions wrote the musical *Oliver*. Hence the name G&B Arts….

Through John Gorman I was introduced to Lionel Bart over lunch at Odettes in Primrose Hill. Lionel was very friendly and was full of showbiz stories… he told me of being at a party with Princess Margaret and telling her how she and her sister (the Queen) reminded him of The Ovaltine kids… she was not amused…. Also he mentioned that he wrote the early Cliff Richard single "Living Doll"… he then grabbed a linen serviette and wrote out the lyrics and autographed it as a memento….

A few months later I had a call from Lionel inviting me over to his house for breakfast to discus designing the costumes and scenery for his new production called *Gulliver*…. unfortunately it never got off the ground.
He lived at No. 7 Reece Mews in Kensington, next door to the artist Francis Bacon.

I was greeted at the door by his housekeeper and shown upstairs . The first thing he asked me was if I would like a sausage sandwich with brown sauce…. Whilst we were waiting he sat down at his upright piano and played me one of his all time famous songs "Food Glorious Food"… on top of the piano was a framed photo of himself with Noel Coward.

Experimenting on my new iPad 3–it is certainly the future and perfect for how I work.

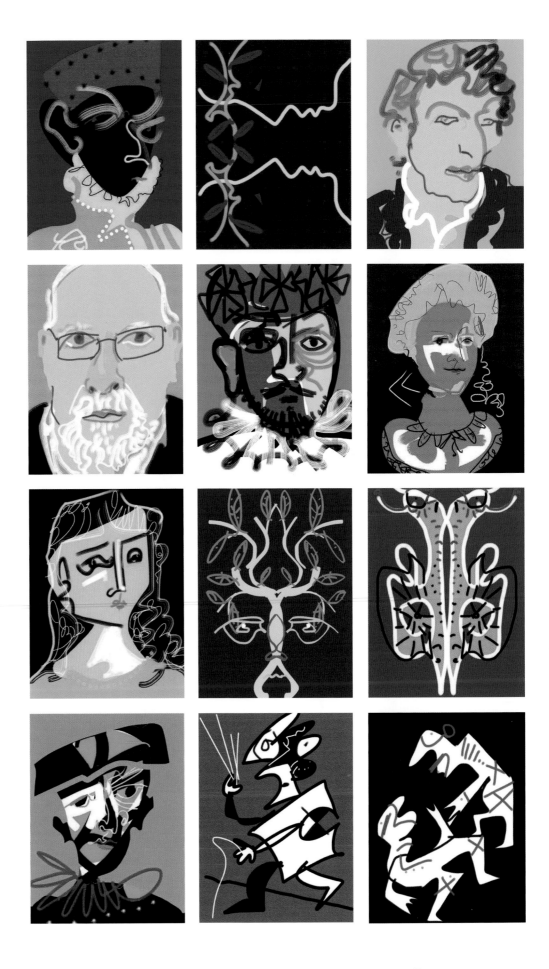

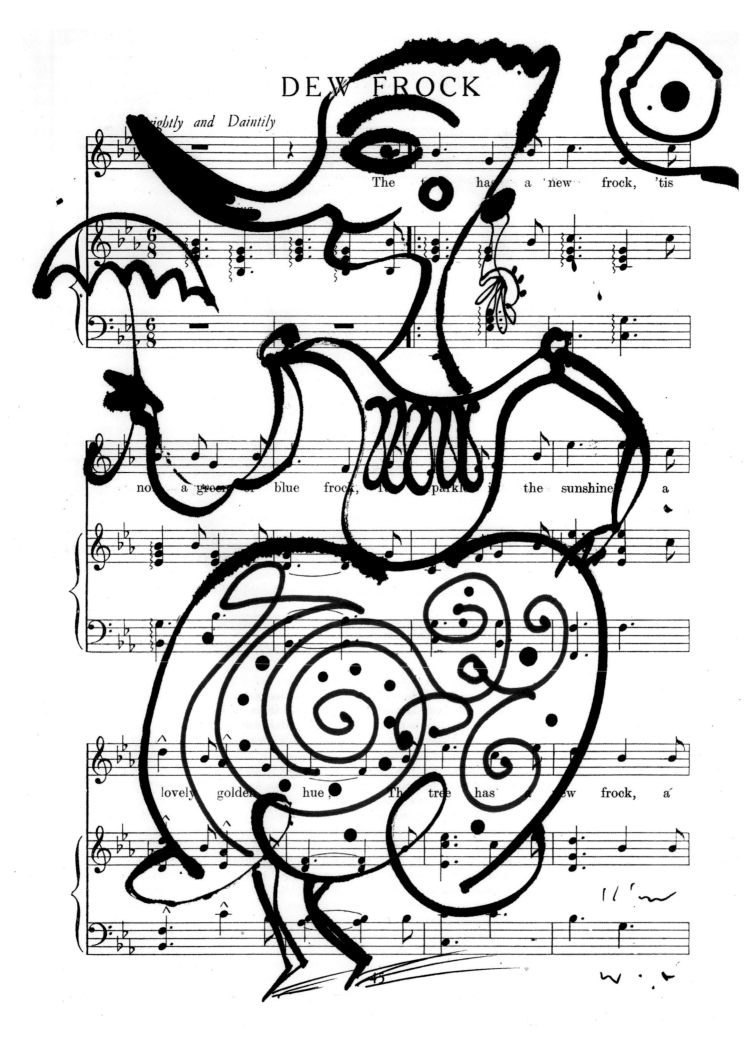

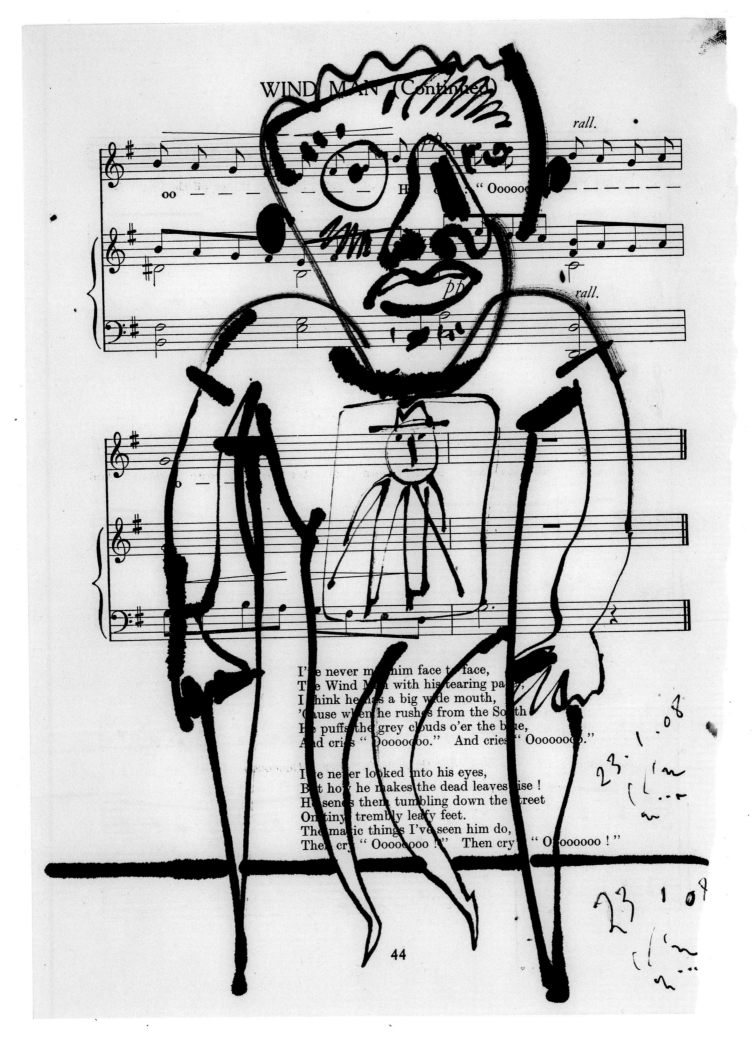

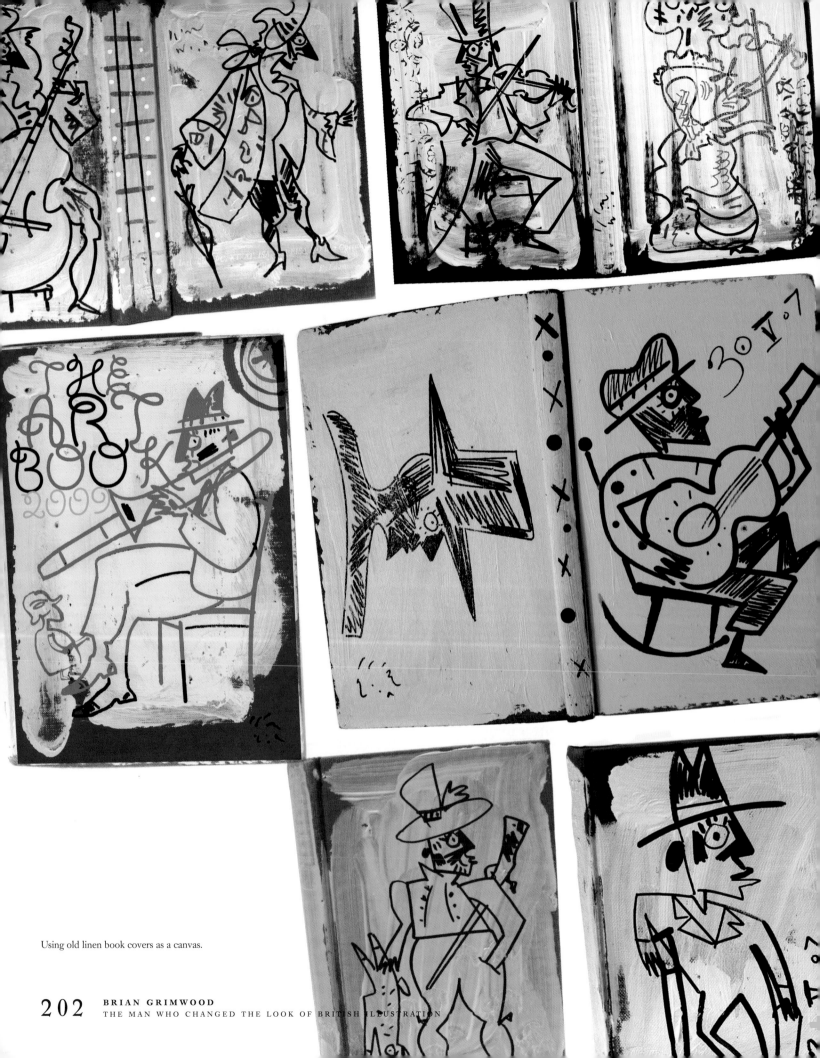

Using old linen book covers as a canvas.

BRIAN GRIMWOOD
THE MAN WHO CHANGED THE LOOK OF BRITISH ILLUSTRATION

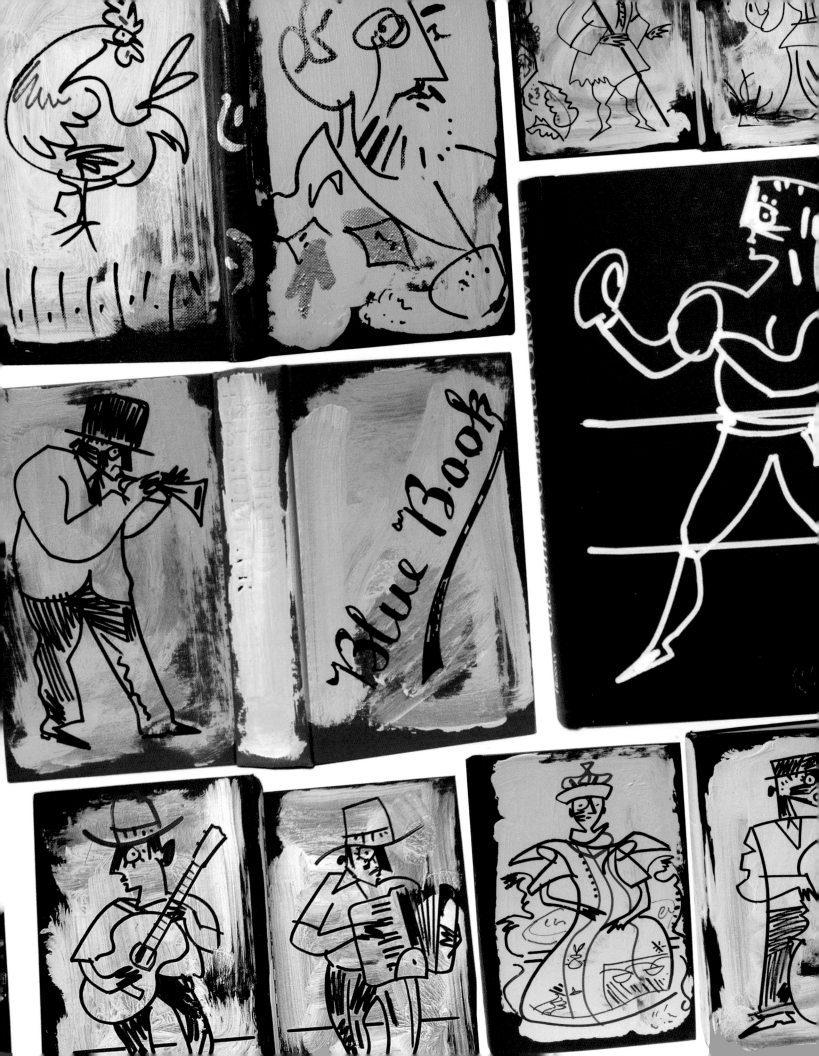

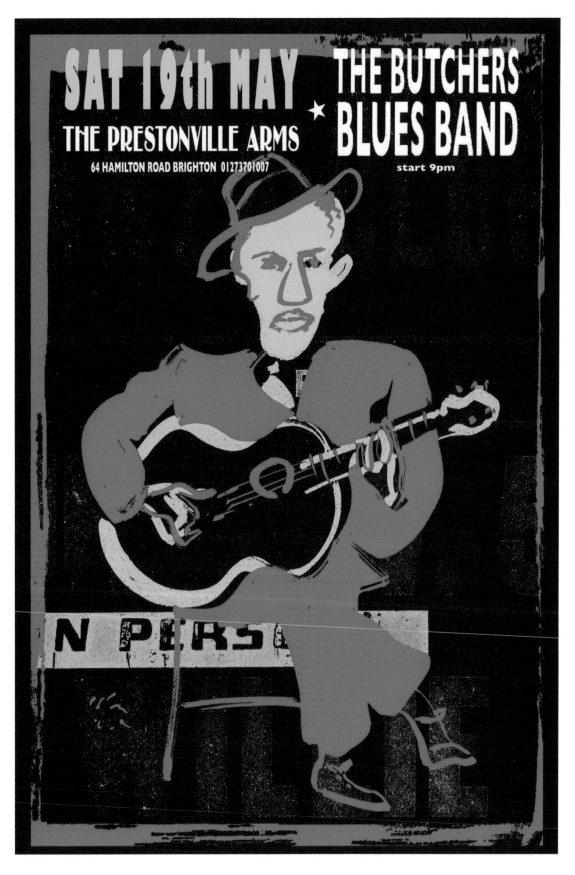

Paintings done for The Butchers Blues Band.

… more paintings to promote The Butchers.

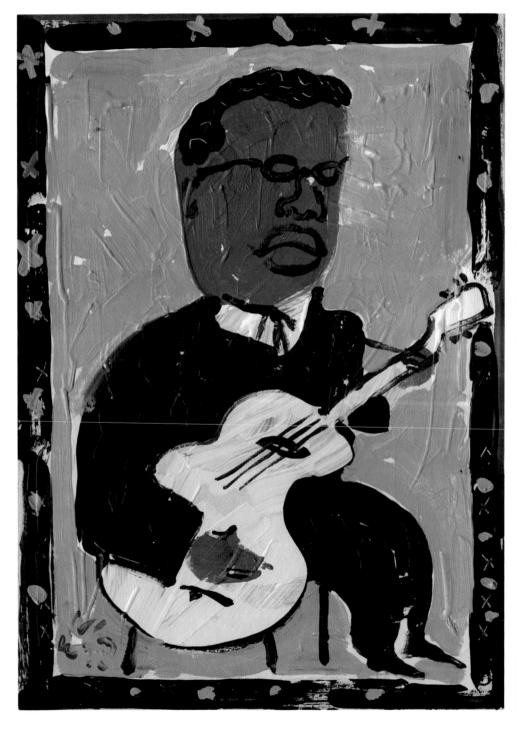

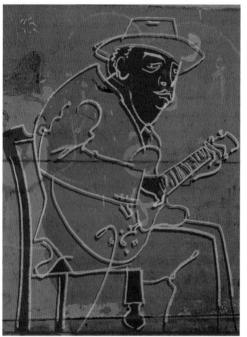

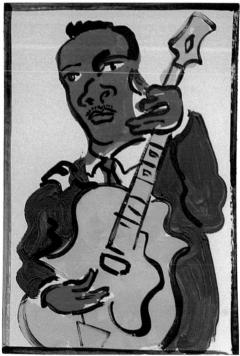

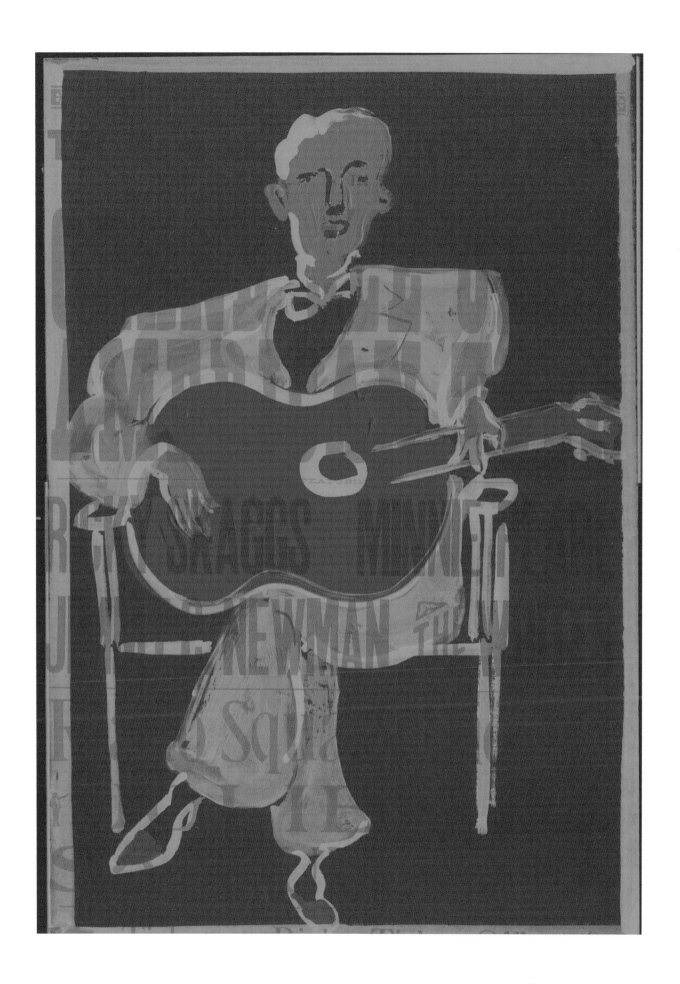

Tongsai Bay Resort in Koh Samui.
The graphics for their t-shirt range
and menu design.

Opposite: Producing paintings on site
whilst on holiday.

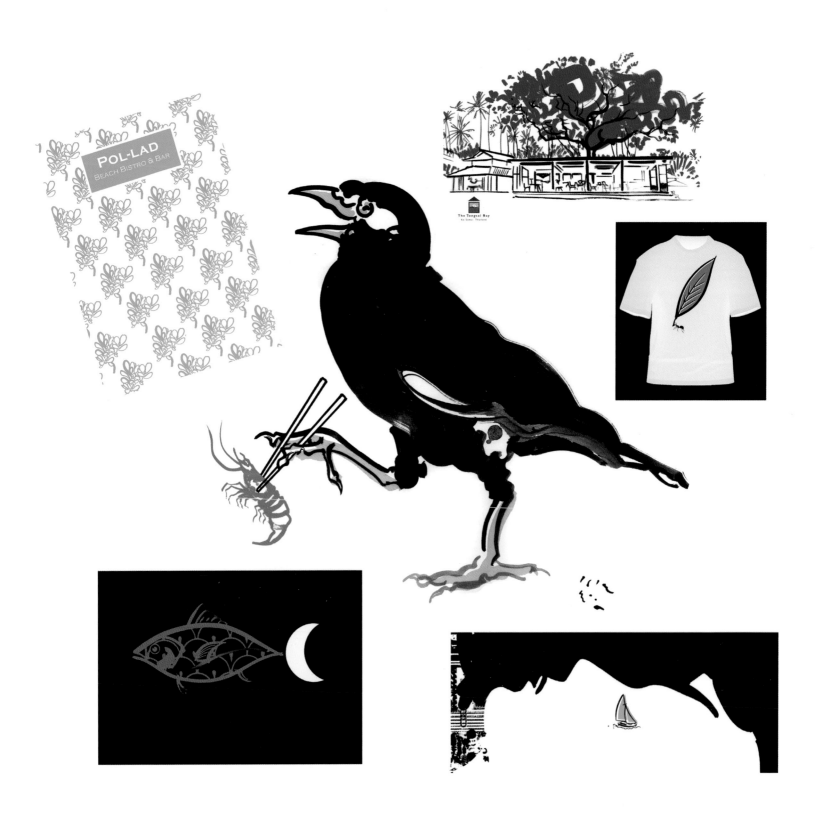

BRIAN GRIMWOOD
THE MAN WHO CHANGED THE LOOK OF BRITISH ILLUSTRATION

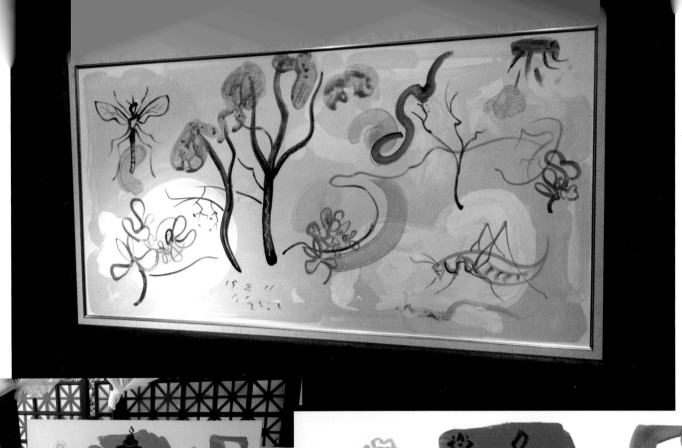

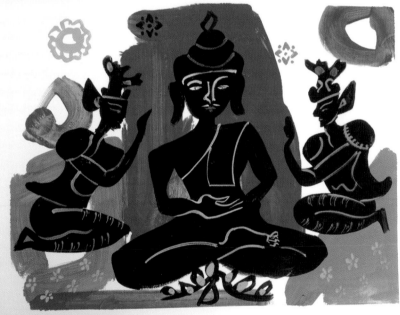
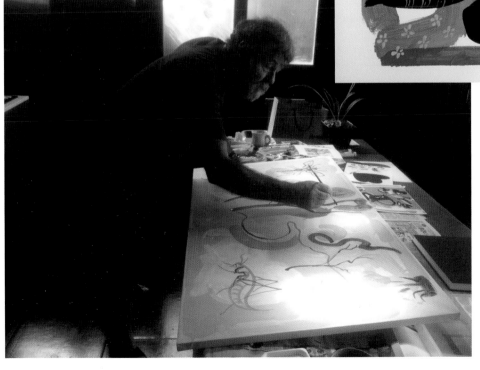

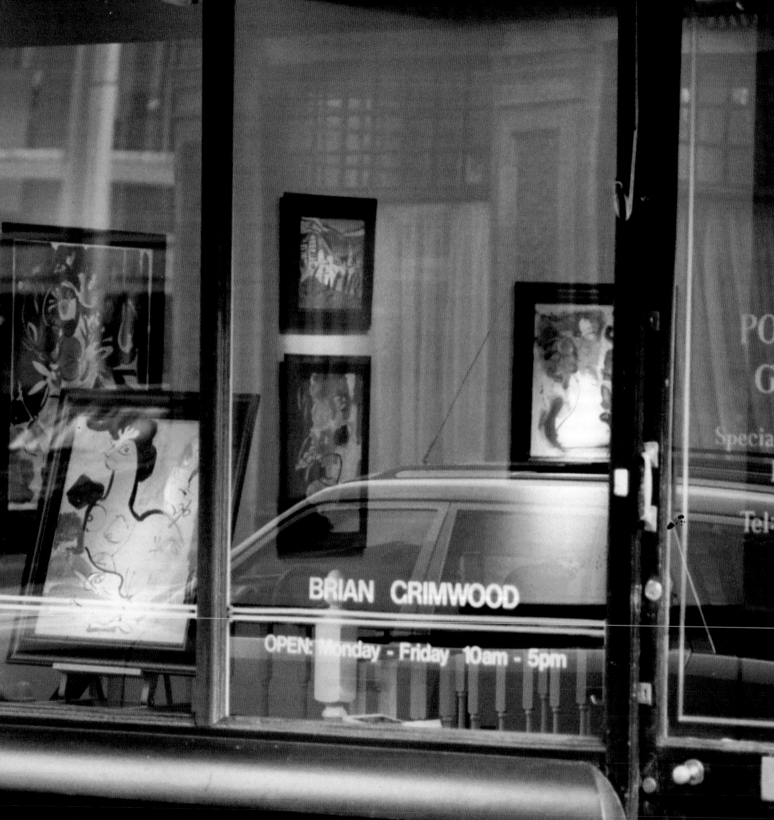

No.ITARTsULLI

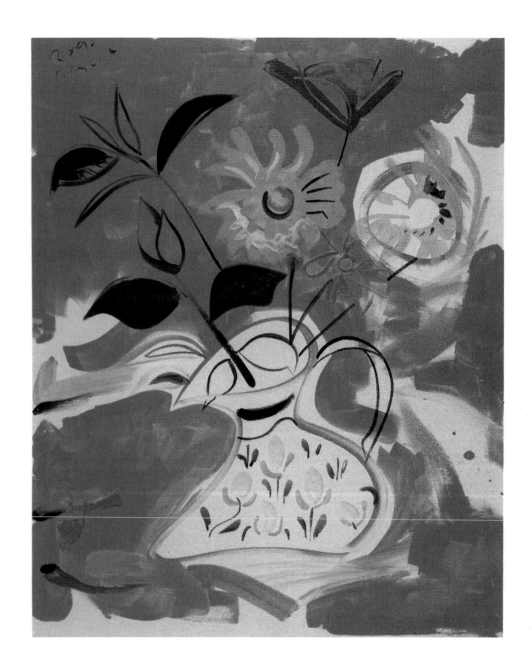

Exception to the rule
12.10.90, 916 x 760 mm.

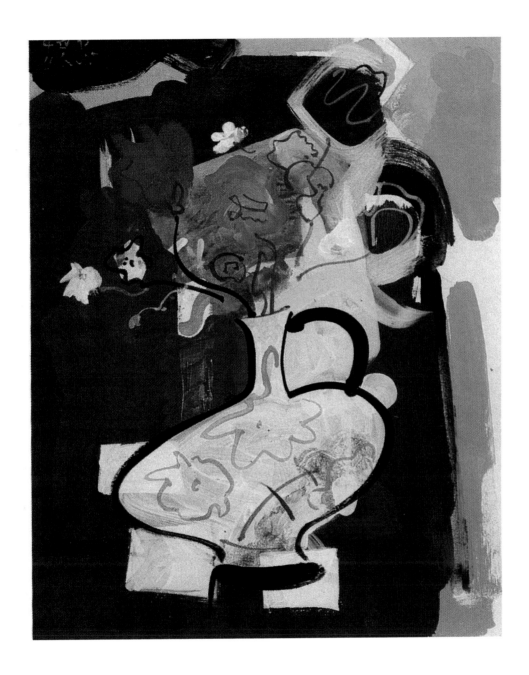

Cad's ally
4.4.93, 505 x 405 mm.

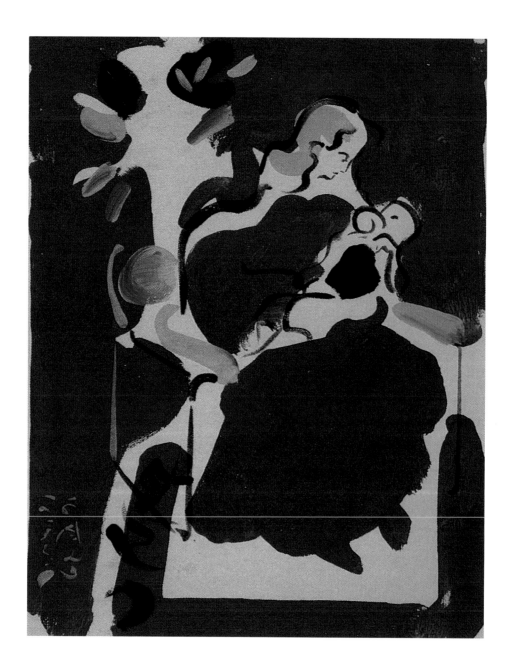

Mother and Child
16.7.89, 505 x 405 mm.

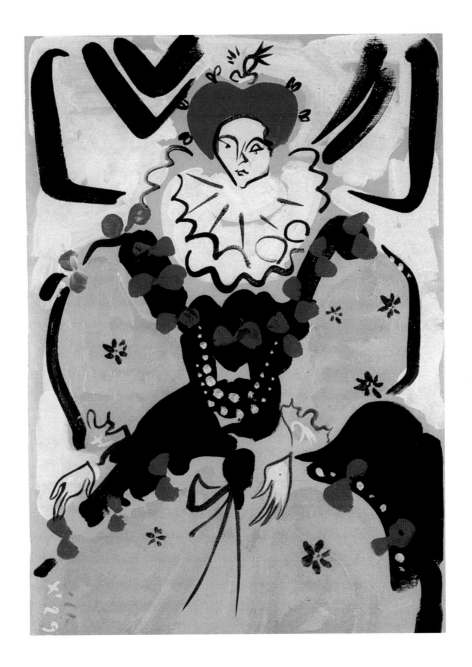

April 17th
11.02.90, 760 x 505 mm.

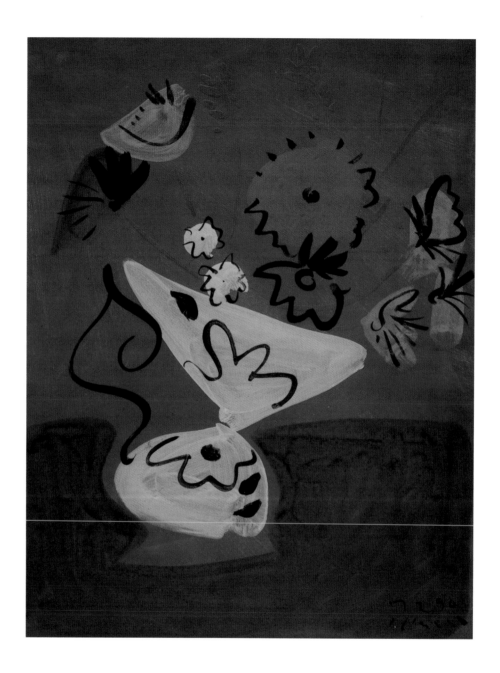

Simply Signed and Red
17.02.90, 380 x 300 mm.

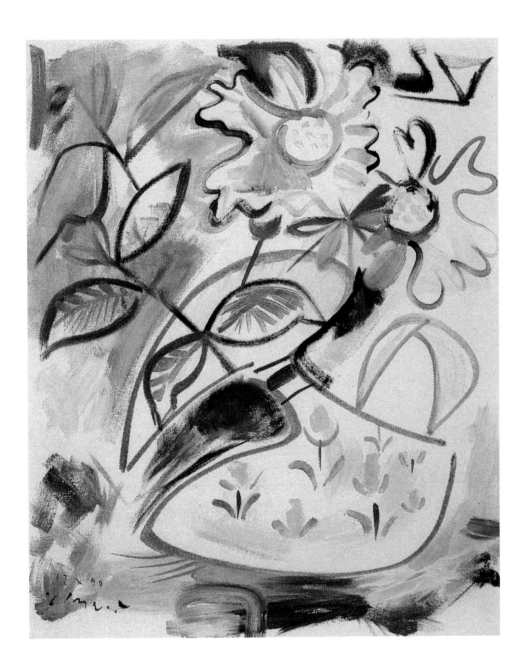

Pen Aside
12.10.90, 605 x 505 mm.

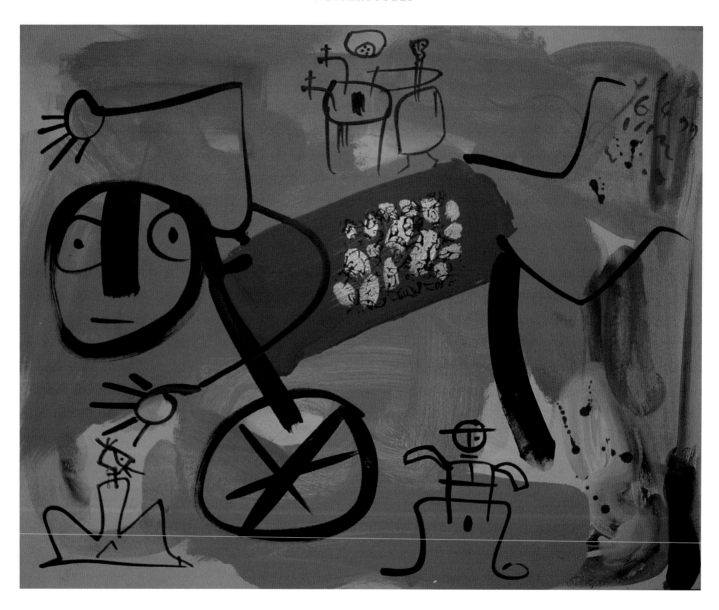

Poster Image for Inside Her Heart exhibition.

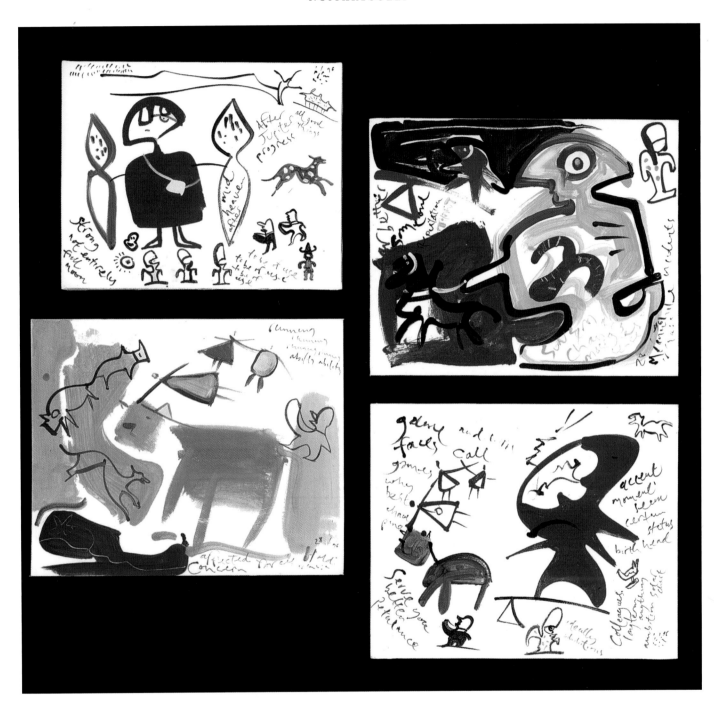

Paintings from the Inside Her Heart exhibition at
The Coningsby Gallery, London 1996.

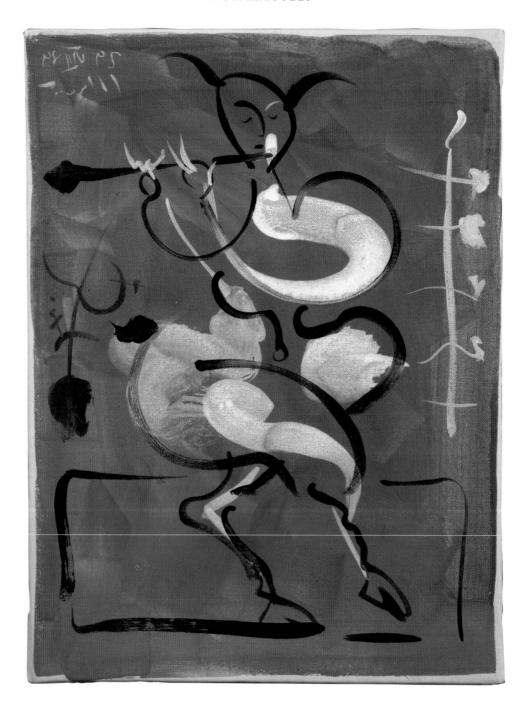

Pipes of Pan.

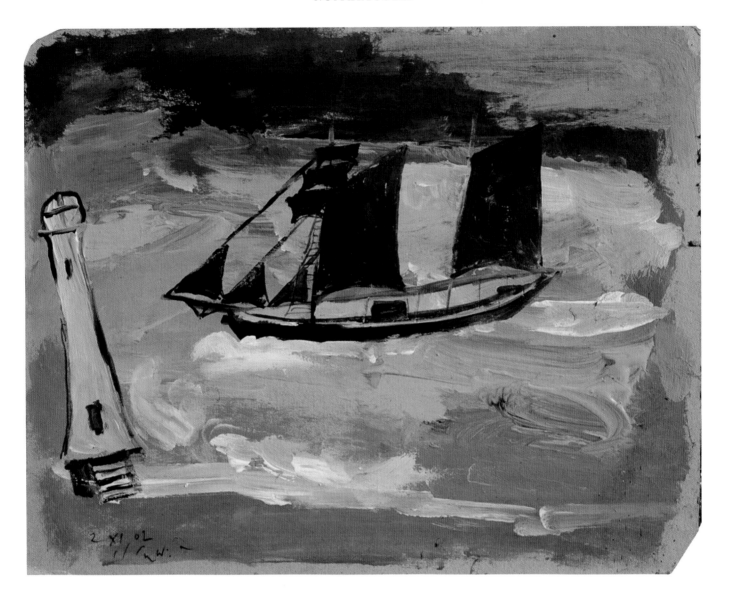

Homage to the late great Alfred Wallace
who said he "painted for company".

Acknowledgements

Peter and Chrissy Blake, thank you for your kind words. Thanks also to Alex Prior, who designed the book, and to Duncan McCorquodale and the Black Dog and WORK gallery staff and marketing.

Thanks to Roger and Caroline Walton who both supported me in getting this final version of the book together.

Many thanks to Ben Cox, Sarah Johnson, Alicja McCarthy, Charlotte Hanlon, Riona O'Shea at CIA and John Jones and Tracy, Owen Frampton, Pam Oskam, Joanna Marcus, Russell Walker, Mike Levy and Robert at Castor Pollux, Mark Harrison at Tongsia Bay, Koh Samui, John Johnson and the staff at Raffles Hotel, Singapore, and Hugo Weinberg in Paris. Also thanks to Donald Langosy (Jerry), Michael Walton, Roy and Hazel Webster, Clive Frampton, Neil French, Peter Parker, David Hughes, Chris and Carol McEwan, Rick Ward, Marc Bonnel, Mike Farmers, Tim Greenwood, Jessie Ford, Max Ellis, Jeff Fisher, John Hegarty, Phil Cleaver, Peter Hodges, Roger Barker, Phil Dewhurst, Ron and Leoni Mather, Jules Beazley, Ryder Ascot, Tony Andriulli, Howard Bernstein, Louisa St Pierre, The Butchers Blues Band, Simon Spillsbury, Pat Hammond, Nelly Dimitranova, Chris Corr, Linda Gray, Mike Terry, David Wakefield, Nigel Macfall, Geoffrey Parker, Alan Horlock, Roger Butler, Don Forsyth, George Underwood, Nic Would, Chris Dyer, Frank Sully, Jack and Julie Bowmer, Chris Brown, Howard Milton, Chris Smosarski, Mike, Lynette and Lucy Junghans, Mark Whatley, Steve and Liz Donoghue, Rex Holmes and Leonardo Collina.

Many thanks to Morten Saether for the book cover design and to my agent, and Co-Director of CIA Ben Cox, www.centralillustration.com.

COVER IMAGE: An outtake from a proposed Hegarty wine label.

KENT EDUCATION COMMITTEE
Beckenham Alexandra County Secondary School for Boys

REPORT on *Brian Grimwood* for *Christmas* Term, 19 *6 0*.

Form *2* House *Manor* Age *12.8* Average Age *12.9*

No. in Form *35* Position *1* Attendance *Excellent* Punctuality *Good*

3m 9/59 ca 22674

Subject	Term Mark	Exam. Mark	Max. Marks	Remarks of Teacher	Initials
Religious Instruction	B-		100	*Shows interest.*	*G.M.*
English	B	150	200	*Has worked hard to gain first position. Well done*	*G.M.*
History	B+	72	100	*Beautifully kept notebook. Excellent work*	*G.M.*
Geography	B	75	"	*He has worked well & hard for this result which he has deserved.*	*B.J.F.*
Mathematics	B	139	200	*Very keen. Good work throughout term.*	*R.J.M.*
Technical Drawing			100		
Science	B+	70	"	*He has made an effort to obtain many facts*	*J.D.*
Art and Crafts	A	89	"	*Very good indeed. he has worked excellently*	*G.M.*
Music	B	78	"	*He must learn to contain himself in class.*	*B.C.M.*
Physical Education	B	60	"	*Shows great keenness and makes the*	*of*
Organised Games	C		"	*most of his lessons*	
Metalwork	B	79	"	*Satisfactory*	*J.J.*
Woodwork		74	"	*6th in form a very good start*	*B.W.S.*
Pottery			"		
Vocational Guidance			"		

* A=Excellent. B=Good. C=Satisfactory. D=Weak. E=Very Weak.

Conduct *Fairly good*

GENERAL (including out of class activities.) *After a slow start Brian has worked hard to gain first place in the class, and I believe he has not yet reached the limit of his capabilities. He can always be relied upon to contribute orally during lessons, and participates with enthusiasm in all subjects.*

Joan Mason
Form Master

Excellent. Well done. R E Green
Head Master

- -

To the Head Master.
Remarks:

Designed by Alex Prior at Black Dog Publishing Limited.

10a Acton Street, London WC1X 9NG, UK
Tel +44 (0)20 7713 5097
www.blackdogonline.com

British Library Cataloguing-in-Publication Data. A CIP record for this publication is available from the British Library.

ISBN 978 1 907317 86 6

Brian Grimwood
www.briangrimwood.com
brian@briangrimwood.com

Agents

CIA (London)
contact Ben Cox
ben@centralillustration.com

17b Perseverance Works
Kingsland Road London E28DD

B&A (New York)
contact Louisa St Pierre
artinfo@ba-reps.com

58 West 40th Street
New York NY 10018

Hugo Weinberg (Paris)
h.weinberg@wanadoo.fr

32 Place Saint Georges
75009 Paris

art design fashion
history photography
theory and things

black dog publishing

www.blackdogonline.com london uk